TREASURES
of IRISH ART
1500 B.C.–1500 A.D.

from the collections of the
National Museum of Ireland
Royal Irish Academy
Trinity College, Dublin

G. Frank Mitchell, Peter Harbison, Liam de Paor,
Máire de Paor, Roger A. Stalley

photography by Lee Boltin and others

The Metropolitan Museum of Art
& Alfred A. Knopf
New York, 1977

The noblest share of earth is the far western world
Whose name is written Scotia in the ancient books:
Rich in goods, in silver, jewels, cloth, and gold,
Benign to the body in air and mellow soil.
With honey and with milk flow Ireland's lovely plains,
With silk and arms, abundant fruit, with art and men.

Worthy are the Irish to dwell in this their land,
A race of men renowned in war, in peace, in faith.

—Donatus, Bishop of Fiesole, mid-ninth century.
Translated by Liam de Paor.

Photographs by Lee Boltin except for those pages listed below.

7, 28, 40, 50, Figs. 3, 21, 30, 32, 36, 37, 39: National Museum of Ireland /
36, Figs. 16, 17, 41: Royal Irish Academy; photography by Green Studio Ltd. /
27, 35, 37/38, 43, Figs. 28, 29: The Board of Trinity College, Dublin;
photography by Green Studio Ltd. / **31:** Museum of Fine Arts, Boston /
Figs. 1, 4, 6, 11, 22, 25, 27, 33-35, 38: Commissioners of Public Works in Ireland /
Fig. 2: Cambridge University Collection: copyright reserved / Fig. 5: Brian Lynch, Irish
Tourist Board / Figs. 13, 15, 18, 31: reproduced by courtesy of the trustees
of the British Museum / Fig. 20: Historisk Museum, Bergen, Norway / Figs. 26,
40: reproduced by permission of the British Library Board / Fig. 42: Irish
Tourist Board / Technical aid in the color reproduction was generously given by
George Braziller, Inc., publisher of *Celtic and Anglo-Saxon Painting,* 1977.

Designed by Alvin Grossman
Edited and produced by Polly Cone
Maps and line drawings by Joseph P. Ascherl
Type set by York Typesetting Co., Inc., New York
Printed in Italy by Arnoldo Mondadori Editore, Verona
All rights reserved. Copyright 1977 under the International Union for the Protection
of Literary and Artistic Works. Published in the United States by The Metropolitan
Museum of Art and Alfred A. Knopf, Inc., New York, and simultaneously in Canada
by Random House of Canada Limited, Toronto. Distributed by Random House Inc.,
New York.

Library of Congress Cataloging in Publication Data
Main entry under title:

Treasures of Irish art, 1500 B.C.–1500 A.D.

Bibliography: p.
1. Art, Irish—Exhibitions. 2. Art, Prehistoric—
Ireland—Exhibitions. 3. Art, Ancient—Ireland—
Exhibitions. 4. Art, Medieval—Ireland—Exhibitions.
I. Boltin, Lee. II. Dublin. National Museum of Ireland.
III. Royal Irish Academy, Dublin. IV. Dublin. Univer-
sity. VI. New York (City). Metropolitan Museum of Art.
N6782.T73 709'.415'074013 77-8692
ISBN 0-394-42807-2

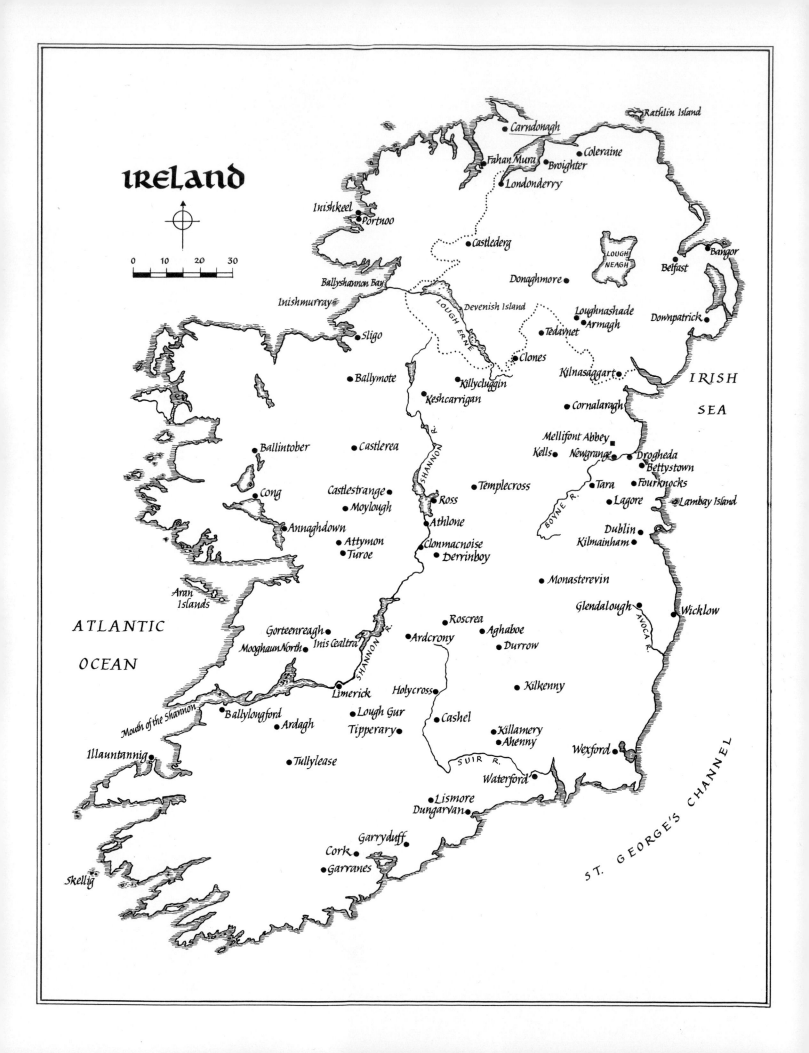

Contents

Catalogue entries by G. Frank Mitchell

Foreword

The occasion of this exhibition, which follows the bicentennial celebrations in America, reminds us of the marked influence that country has had on the course of Irish history. For two hundred years the Irish people have maintained close ties with the people of the United States, and it is with a view to the deepening of mutual understanding that they now send their most precious treasures to a series of museums across the American continent. The exhibition demonstrates the international standing of early Irish art and the universality of all great artistic expression. I am deeply grateful to all the American friends of Ireland who have made *Treasures of Early Irish Art, 1500* B. C. *to 1500* A. D. possible.

John Wilson
Minister for Education, Ireland

The patrimony of the extraordinary Irish civilization has been made available almost in its entirety for this exhibition. The profound feelings that the people of Ireland have for their treasures is something that we all understand, and their lending these precious possessions to us is an exceedingly generous act. It might never have transpired, but "Ireland . . . is like no other place under heaven." George Bernard Shaw saw that the impossible in Ireland was an everyday occurrence. The impossible, therefore, has happened and is very welcome.

This significant exhibition was created by an extraordinary group of people. Individuals on both sides of the Atlantic have labored with unequaled dedication to make it happen. Thanks must go to so many, visible and invisible. Foremost: Professor G. Frank Mitchell, President of the Royal Irish Academy, and his associates Peter Brown, Librarian of Trinity College, Dublin; Professor David Greene, Institute of Advanced Studies, Dublin, and an early supporter; and James White, Director of the National Gallery of Ireland. At the Metropolitan, Karl Katz, Chairman for Special Projects; Charles Little, Assistant Curator of Medieval Art; and Penelope K. Bardel, Associate Counsel, worked with colleagues within the Museum and the four participating museums to insure that the exhibition become a reality.

Thanks also go to Walter J. Curley, former Ambassador from the United States to Ireland; Prime Minister of Ireland, John Lynch; the former Minister for Education, Richard Burke, his successor, Peter Barry, and the present Minister, John Wilson; John G. Molloy, Ambassador from Ireland to the United States; Eamonn Kennedy, Ambassador to the United Nations from Ireland; Gearoid O Clerigh, Consul General of Ireland; Patrick Collins, Deputy Consul General; Edward Smyth, First Secretary of the Embassy of Ireland; Dr. F. S. L. Lyons, Provost of Trinity College, Dublin; Dr. D. I. D. Howie, Vice Provost of the College; Dr. A. T. Lucas, former Director of the National Museum of Ireland; and Dr. J. Raftery, the present Director. Cheers to all at Aer Lingus, especially David Kennedy and Niall Weldon in Dublin and Denis Hanrahan and Tom Kennedy in New York, and to Patrick Lynch for his counsel. Special assistance came from the Cultural Relations Committee, Department of Foreign Affairs, Ireland.

Our gratitude must also go to the SCM Corporation and its Chairman of the Board, Mr. Paul Elicker, for supporting this exhibition in New York.

Finally, to all the contributors to the catalogue go our profound appreciation.

As in the Book of Kells, there are intricacies and subtle features that are unseen. They are there, as are the unwritten names of countless individuals whose efforts brought this show to America.

Thomas Hoving
Director, The Metropolitan Museum of Art

Preface

Only a very few of Ireland's early treasures have survived, and almost all that have are included in the present exhibition. In committing her most treasured possessions to an extended tour of American museums, Ireland is paying tribute to the American people for the generous help she has received throughout the past two hundred years.

The illuminated manuscripts owe their survival to having been jealously treasured in churches and monasteries; nearly all the other objects are of the noble metals—gold, silver, and bronze—and so resisted destruction from both exposure to the air and burying in the ground. The many objects of wood, iron, leather, and fabric that must have been their companions have disappeared.

Those objects that did survive the attacks of nature had to face other constant perils in the course of Ireland's long and turbulent history: to be buried hastily without much chance of recovery; to be stolen and used to decorate the hall of a different lord or the altar of a rival monastery; to be plundered, broken up, and divided among a marauding gang who might mount the fragments as trophies; to be melted down and vanish forever in a pool of bullion metal.

Safe places for the conservation and display of the national treasures did not exist until comparatively modern times. Although a certain number of wealthy families in Ireland always had an appreciation of the past and built up private collections, these were constantly at risk of fire and theft or of dispersal in time of financial straits.

Trinity College, Dublin, was founded in 1591, and it was a matter of extreme good fortune that during the early part of the seventeenth century the well-known scholar and bibliophile Archbishop James Ussher made extensive purchases of books for the college library. Later in the century his own collection, including the Book of Kells, came to rest there.

When the British Museum was founded in 1753 Ireland was within its province, and many important Irish antiquities are now in its collections. The Royal Dublin Society was founded in 1731 "for the advancement of agriculture and other branches of industry and for the advancement of science and art"; its scientific collections passed to the National Museum when it was founded in 1877. The Royal Irish Academy was incorporated in 1785, and its library quickly built up a notable collection of Irish manuscripts. In 1841 it was resolved "that the formation of a National Museum of Antiquities is an object which the Academy should continue steadily to pursue"; this goal was achieved by the foundation of the National Museum of Ireland, and the Academy's collection was transferred to the state. St. Patrick's College, Maynooth (founded 1795) is another repository, and the Ulster Museum, Belfast, has large and important collections.

With one exception the objects in the present exhibition come from the National Museum of Ireland (abbreviated NMI in the catalogue), Trinity College, Dublin (TCD), and the Royal Irish Academy (RIA). In addition, the Museum of Fine Arts, Boston, has generously placed the Emly shrine (**31**) on loan to the exhibition. As author of the catalogue I have drawn on two chief sources of information. One is the magnificently illustrated two-volume *Christian Art in Ancient Ireland,* whose second volume was edited by Dr. Joseph Raftery, now Director of the National Museum. The other is the comprehensive trilogy *Irish Art,* which contains the fruits of a lifetime of devoted, perceptive, and pioneering work in this field on the part of Dr. Françoise Henry. The Bibliography contains a key to these and other titles that have been abbreviated in the catalogue entries.

G. Frank Mitchell
President, Royal Irish Academy

Introduction

G. Frank Mitchell

Prehistoric Foundations

To the earliest men stretches of water were formidable barriers; while the paleolithic hunters and artists of France and Spain did struggle as far as the south of England, they never succeeded in reaching Ireland. But as men mastered the skill of boatbuilding, they began to venture forth in craft of a light wooden frame over which watertight hides were stretched. Such rowboats, lacking keel or rudder, still survive in the western isles of Ireland, chiefly in Aran, where they are known as *currachs,* and legend tells us that it was in such a boat that St. Brendan ("Brendan the Navigator") crossed the Atlantic in about A. D. 550 to become the first European on the American continent.

About 6,500 years before Christ the first adventurers landed on Irish shores. They found there a land of endless forests threaded through by sluggish rivers, which widened here and there into lakes and provided the only routes for inland travel. The first Irishmen were what the anthropologists call hunter-fishers; they had no domesticated animals, no knowledge of crops, and no heavy tools with which to clear the timberlands. Nor did they make works of art; or, if they did, no trace of their efforts has been found. They were in effect prisoners of the forests that surrounded them.

Three thousand years later the first knowledge of agriculture, in its slow progress from Asia, reached the French shores of the English Channel. That early farmers actually crossed to England in currachs is almost miraculous; except in the calmest weather crossing open waters in skin-covered boats is a hazard. But the primitive farmers did reach England with their precious cargoes of livestock intact and apparently pressed on immediately across fiercer currents to Ireland. Once safely ashore there, they quickly located rich soil in the lowlands and their farming culture flourished.

Communal burial—or rather communal deposition of cremated remains—had been the rule among the farmers of northwestern Europe, and soon capacious tombs were being erected in the new land. As enormous stones were employed, the burial places are called "megalithic." The finest example of such a tomb is at Newgrange in the Boyne Valley of Ireland. Newgrange, built about 4,500 years ago, is a wonder of the ancient world, not only because of the size of the stones used and of the precision with which they were placed, but also because of the elaborate symbolic designs carved on many of them (Fig. 1). It seems certain that by the time Newgrange was constructed travel between Europe and Ireland—probably in plank sailboats with keel and rudder—was common;

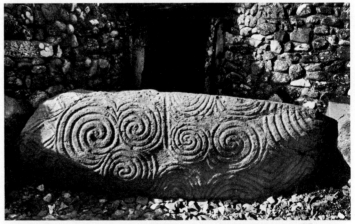

Fig. 1. Entrance stone, megalithic tomb, about 2500 B. C., Newgrange, County Meath

megalithic tombs related to the one at Newgrange were found all along the Atlantic seaboard from Ireland to Spain.

Knowledge of metalworking, like that of agriculture, started in the Middle East, and, as the qualities of the miraculous new materials became widely known, the demand for ore multiplied rapidly. Soon the corners of Europe were being ransacked, and even Ireland came under scrutiny. The prospectors fanned out across Europe,

just as the farmers had done, but their quest was different. The search was not for easily worked, low-lying farmland but for ore-laden rock often concealed in mountain ridges. The rich Spanish deposits were quickly found; mining started in Spain possibly as early as 4,500 years ago. The prospectors then pushed on up the Atlantic coast of France to Brittany and across the Channel to Cornwall. There a bonus awaited them: tin. Its discovery heralded the Bronze Age. Copper is soft and is bent and blunted easily. However, if a proportion of tin is added to it—bronze—a harder and tougher metal, is formed. Cornwall was the only area in northwestern Europe where tin was available in reasonable quantity, and prehistoric working of the metal probably began there about 3,800 years ago. Tin ores are much rarer than those of copper, and the demand for them escalated as the superiority of bronze became apparent.

It is tempting to reconstruct Ireland's rise to prominence as a mining center. Perhaps the finds in Cornwall led the prospectors to further search—in Ireland. If the adventurers landed on the southeastern tip of the island, a short trip west would have brought them to the copper on the coastal cliffs of Waterford; if they turned north they would have reached the gold-rich Avoca River, which had copper in the walls of its valley. In the nineteenth century, when large-scale mining took nearly all the superficial ore deposits in Ireland, evidence of prehistoric working was revealed at almost every site. That the early prospectors did discover metal deposits, which were exposed in only a few places, indicates that they searched thousands of square miles to make their precious finds. By 1500 B. C. metallurgy was firmly established in Ireland, and copper weapons and gold ornaments were being produced both for export and domestic use.

By 1200 B. C. central Europe had supplanted the Mediterranean area as the center of world metalworking. Ireland shared in the wealth and technical advances, as her copper was relatively abundant, and she had gold to finance the import of tin for the production of bronze. Metal objects were now cast in sophisticated clay molds, and skillfully made gold ornaments, found singly and in hoards, give clear evidence of increased prosperity and technology.

In the eighth century B. C. central Europe was invaded from the east and its output of metal was drastically reduced. The demand for Irish copper thus increased, and Ireland was brought into still more intimate contact with Europe. Numerous caches of gold ornaments and bronze implements from this period show that there was a corresponding increase in wealth.

As a result, the whole way of Irish life changed. Warriors now used slashing swords and protected themselves with shields of bronze, leather, or wood. Feasts were served from buckets and cauldrons and were accompanied by trumpet interludes. Ornaments of Irish gold became still more numerous and were complemented by necklaces and other pieces of Scandinavian amber. Hoards of bronze and gold were hidden throughout Ireland, perhaps for safety, perhaps as sacrificial offerings. A simple type of plough came into use and farming became more stationary; semipermanent fields restrained the farmers from migrating from one woodland clearing to another.

Throughout the Bronze Age Ireland had critical supplies of copper to offer Europe, and she had an important place in the European scene. But by about 600 B. C. the craft of ironworking began to be widely practiced in central Europe. As the knowledge spread, the demand for copper—and contact with Ireland—diminished.

Foreign Influences and the Beginnings of Christian Art

Knowledge of ironworking meant more wealth and power for those who had it, and a new power elite arose in central Europe in the eighth century B. C. The emerging tribes were united by a common language, Celtic—an

ancestor of a language still spoken in Ireland—and by various other characteristics of their appearance, dress, and lifestyle. As their sphere of influence broadened, they migrated west to Spain, east to Asia Minor, and even challenged the Mediterranean powers, sacking Rome in 390 B. C. and raiding Delphi a century later.

The Celts were slow to reach Britain and Ireland. Tin and copper were no longer vital, and there was no need to seize the sources of supply. The early Celtic art styles are almost unknown in Ireland, but the later one, a splendid curvilinear abstract style first documented in the fourth century B. C. at La Tène in Switzerland, appeared in Britain in the third century B. C. and in Ireland a hundred years later.

With the collapse of her export trade in copper, Ireland seems to have fallen into obscurity again. Lands formerly under cultivation seem to have been abandoned. With copper unsalable, the price of bronze may have dropped to such a low level that it continued in use, inefficient as it was compared to iron.

If Ireland had seemed unattractive to the Celts in their first wave of expansion, when even Rome was not safe from them, the tide turned, and, as the Roman Empire grew, the Celts were pushed back into the remoter corners of Europe. One can imagine bands of Celtic warriors, displaced from Gaul by the Roman conquest, invading the Irish countryside either directly from France or from England and quickly establishing dominion over a people dispirited by economic collapse. If in addition to their weapons and ornaments they brought the knowledge of ironworking to Ireland, they may have won ready acceptance, for it was the new technology that was to aid Ireland's struggle to become again a member of the European community.

Ireland's earliest iron tools were clumsily forged axeheads, but even those were sufficient to herald the extinction of her woodlands. Bronze Age Ireland was still wooded, and wood was the universal building material. The farmers cut clearings in the forests and erected log cabins in the corners of the fields; when the soil was exhausted, they moved on to new clearings, and another generation of trees invaded the abandoned fields. Now iron axes made woodland clearance quicker; iron spades made cultivation easier; iron-tipped ploughs could turn the soil to greater depths and so delay the process of soil exhaustion. Soon established fields covered large areas.

The disappearance of timber as a ready building material dictated a new style of homestead. This was a cluster of buildings inside a circular enclosure, which could also serve as a corral for livestock when danger threatened. In stony districts the enclosing wall, or cashel, would be built of dry stone; where the ground was clayey, a bank and encircling ditch provided a rath (Fig. 2). Unlike the wooden structures of the Bronze Age people, the stone walls and the earthen banks were very durable, and today cashels and raths are the commonest field monuments in Ireland; their total number is estimated at about 30,000.

Roman legions invaded Britain in 55 B. C., and soon the primeval natives and their Celtic overlords were

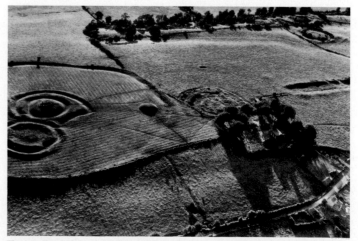

Fig. 2. Raths on the hill of Tara, about A. D. 400, County Meath

pushed back into Cornwall, Wales, and Scotland, where various versions of the Celtic language still survive. Roads and towns were built, coinage came into general circulation, and large farms dominated by villas were established in the fertile areas. Ireland was still in a relatively depressed state. Her soil and climate were poorer than those of Britain. Not only was she incapable of posing a serious threat to the Romans, but even if she were conquered, there was little prospect of her ability to sustain a Roman garrison, much less to supplement the imperial exchequer. Finds of Roman material are few in Ireland but are plentiful enough to show that there were contacts—some peaceful, some violent. Roman coins were scattered at Newgrange. A seal from a Roman letter was found at Tara. A group of British refugees reached Lambay Island, where one of them was buried in native warrior style. One typical Roman burial was found in County Kilkenny.

The contacts were reciprocal; Irish raiders plundered Roman villas in Britain, as is shown by fragments of ornamented silver dishes found in Ireland (Fig. 3). Slaves were also taken, and it was in this fashion that the boy Patrick, later to become the national apostle of the country, first arrived in Ireland. The raiders cannot have failed to notice that the farming techniques of the Roman British were superior to their own, and both ploughs and ploughmen may have been carried back to Ireland. Under such external influences, and perhaps under others not yet understood, farming methods gained new inspiration about A. D. 300. Individual farmsteads centered around the cashel or rath were widely established. Where the countryside was dotted with lakes, artificial islands, or crannogs, were built, and the surrounding water provided natural moats.

The population, at least in the south of Ireland, must have increased rapidly, and there was clearly an overspill from this area into Wales and Cornwall. The art of writing was introduced via Roman Britain, but, instead of

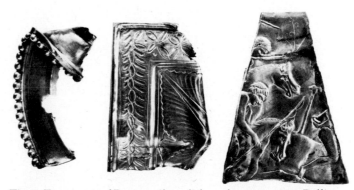

Fig. 3. Fragments of Roman silver dishes, about A. D. 375, Balline, County Limerick. NMI

adopting the Latin alphabet, the Irish developed a clumsy cipher version called ogham. Standing stones with simple ogham inscriptions became common in the south (Fig. 4); similar stones, often with the Latin version of the inscription added, exist in southwest Britain. By A. D. 314 the Christian faith was firmly established in Britain, to the extent that the roster of bishops who attended the Synod of Arles in that year contains the names of three British churchmen.

It may have been through these southern contacts that the Christian faith reached Ireland. By the year 431 the number of converts in Ireland had risen to the point that Pope Celestine sent a bishop to the Irish. These were the circumstances of St. Patrick's return to Ireland, and, as his mission was largely confined to the north of the island, it is reasonable to suppose that the south had been evangelized before his arrival.

The potter's wheel was unknown in fifth-century Ireland. Finds of wheel-made pottery imported from France and the Mediterranean indicate more distant contacts, which also brought more new motifs. An impressive rath at Garranes, County Cork, produced not only Mediterranean-type pottery but also rods of *millefiori* glass and a small bronze button enameled in the curvilinear La Tène style (Fig. 14, p. 58).

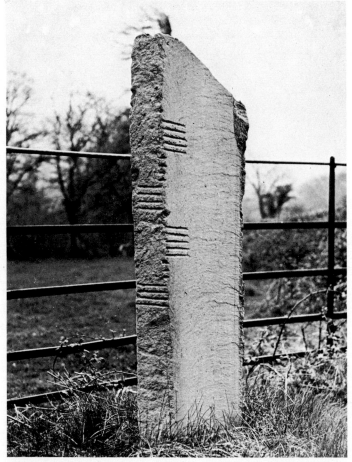

Fig. 4. Dunloe ogham stone, about A. D. 375, County Kerry

The La Tène style was submerged beneath provincial Roman styles early in the third century A. D. and re-emerged in the sixth century. Certain millefiori work continued in northern Britain in the fourth century, and the Garranes button suggests that the La Tène style continued to flicker in the Celtic west. It sprang into rich flower again as soon as the Christian church in Ireland was sufficiently established to demand ornamented altar furniture, vestments, and jewelry.

Throughout the Roman Empire, in which provinces were headed by separate governors, was the parallel Christian organization of dioceses and their bishops. The church introduced into Ireland by Patrick and others followed this pattern originally, but it was unsuited to the Irish lifestyle—a loose civil society of petty kings surrounded by family groups. In Ireland in the sixth century the monastery, with its abbot surrounded by his family of monks, seemed more appropriate. The monastic movement, which had originated two hundred years earlier in the eastern Mediterranean, grew rapidly. It was nourished by contact with the Mediterranean: motifs that had their origin in Egyptian and north African art became incorporated in early Christian art in Ireland.

These vital contacts came none too soon, as the barbarian invasions of Europe at the beginning of the fifth century and the Anglo-Saxon invasions of England not much later brought about on the one hand final collapse of the Roman order and on the other a reversion to paganism. But, just as the Romans had failed earlier, the Anglo-Saxons also failed to overrun Cornwall, Wales, and Scotland and succeeded only in reaching the shores of the Irish Sea around the Bristol Channel and northwestern England. Like the Romans, they never reached Ireland, who stood rich in her isolation, in the Christian faith, and in the European civilization that had accompanied the religion to her shores.

The Irish monasteries played an important part in the restoration of faith and learning in western Europe. Here the work of St. Columba was of fundamental importance. His primary monastery was founded at Derry in A. D. 546, and from there sprang a chain of daughter houses in Ireland, among which Durrow would become particularly prominent. St. Columba appears to have been a man of impetuous nature; he was involved in litigation because an illegal copy was made—some say he wrote it himself—of a borrowed psalter. It is indeed possible that the sixth-

century copy of the psalms in the library of the Royal Irish Academy, the *Cathach*, is that copy. Later he was involved in battle, a man was killed, and St. Columba withdrew to Scotland. In A. D. 563 with twelve companions he arrived on the island of Iona, where he founded the first of several monasteries from which he pursued the conversion of the Picts. After his death the missionary influence continued to grow. The king of Northumbria took refuge on Iona, and after his return to his own kingdom asked that a mission be sent to his people; in 635 the monk Aidan and twelve companions founded the island monastery of Lindisfarne.

Rome itself had already begun the conversion of the pagan Anglo-Saxons. St. Augustine had started his mission at Canterbury in A. D. 597, and thus in the mid-seventh century the pagans were trapped by a pincers movement as the Roman church pushed north from Canterbury and the Irish church moved south from Lindisfarne. The churches were different, having been separated by time and space. Isolated by paganism, the Irish church had continued the rituals brought by its founding fathers and considered itself the repository of true practice. The revitalized Roman church had evolved in many directions, at least one of which was of great practical consequence: the reform of the calendar. When contact was reestablished, the two churches found themselves celebrating Easter on different dates, and it was to be a long time before all the centers of Irish influence conformed to the Roman model.

St. Columba was not the only missionary Ireland produced. In the late sixth century many similar groups reached Europe (see map, above). Columbanus was perhaps the most active; in Bobbio, Italy, he reached his farthest limit, but he founded many other centers on the way. (He seems to have been a man of St. Columba's temperament, and the number of monasteries he founded may reflect impetuosity as much as missionary zeal.)

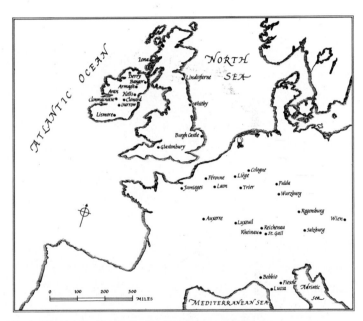

Early Christian sites in Ireland, Britain, and Europe

If there were conflicts between the pagans and zealots, there were also cultural affinities: in the powerful Anglo-Saxon kingdom of Northumbria what may be called the Early Christian style of northern Britain and Ireland was born. As we know from Bede's history, contacts with Ireland remained strong, but powerful European influence also was felt when the Benedictine order was established in the northeast of England. Accomplished Germanic animal ornament appears on one page of the seventh-century Book of Durrow (**27d**). This and elegant ultimate La Tène spirals together with Mediterranean-influenced ribbon interlace are the basic motifs of the superb eighth-century work that was to follow. Whether we call the style early Christian, insular, or Hiberno-Saxon is of little importance; it originated in Northumbria, and from there accomplished artists carried the techniques to other ateliers throughout Britain and Ireland, where groups of craftsmen equaled, and

15

on occasion surpassed, anything that Northumbria had produced.

Contacts with the Anglo-Saxon world were not confined to the ecclesiastical and artistic realms. Ireland's first contact with advanced agriculture had been with the practices of Roman Europe, where the climate was warmer and drier than that of her Atlantic island; in Roman Britain agriculture did not advance beyond the warm south. The Anglo-Saxons came from harsher northern lands, and their practices may have proved more suitable to the Irish than those of the sunnier south. Crop yields may have increased, wealth and population grew, more land came under cultivation, and the woodlands shrank still further. The larger monasteries shared in the growth and prosperity and began to commission works of art.

The Christian Triumph: The Golden Age

Peace and prosperity continued throughout the eighth century, and the monasteries grew in wealth and prestige. The Tara brooch and the Book of Kells were the glorious products of this time (32, 37/38). The monasteries also functioned as urban centers. Since the native kings and their courts were far from sedentary and there was as yet no Irish coinage, no commercial towns existed in Ireland, though there was a network of roads and tracks. Outside the monasteries powerful families controlled many of the petty kingships, and each family sought to install its leader as the high king of all Ireland. Furthermore, each leading ruler had his own establishment of lawyers, historians, genealogists, and poets. Travel between Ireland and Northumbria was easy; books, both sacred and profane, circulated widely; knowledge of writing, both Irish and Latin, was widespread.

The Viking Impact

The museums of Scandinavia today give clear evidence of the wealth of Ireland at the opening of the ninth century. The Golden Age was rudely shattered when the marauding Vikings appeared first at Lambay in 795 and then ranged widely along the coasts and rivers in the early ninth century. Pagans, and greedy for precious metals, they found the monasteries, which lacked all military protection, easier targets than the royal courts, where the king's bodyguards would have offered some resistance. But if the Vikings came to raid, they stayed to trade. They also established warehouse facilities and a medium of exchange. (The first Irish coinage was struck at the Viking mint in Dublin.) The Norsemen built the first towns in Ireland in the river mouths at Dublin, Wexford, Waterford, Cork, and Limerick. In western Europe the concept of the hired mercenary was well established by the ninth century, and in Ireland uneasy alliances between Irish and Viking groups were formed, sometimes linked by a temporary common interest, sometimes by a cash arrangement. There were as many factions among the Viking invaders as there were among the natives, each as ready to quarrel as cohere. Gradually the differences between the two communities became blurred, especially after the tenth century, when the Vikings in Ireland became, at least nominally, Christian.

Contact between Ireland and Scandinavia was not confined to trade; artistic concepts were also exchanged, which led to a blending of styles. In the ninth century a Hiberno-Viking style emerged from the early Christian one.

Irish Art in the Romanesque and Gothic Periods

Although by the eighth century the church in Ireland had abandoned many of the minor practices that had set it apart from Rome, it was still, at the opening of the eleventh century, a church of abbots and monasteries, not one of bishops and dioceses. Many of the richer monasteries were ruled by a family of lay business managers

rather than by priests. The powerful urban churches found such an arrangement distasteful and began to send their bishops-elect to Canterbury to be consecrated with a formality beyond challenge.

At the opening of the twelfth century Canterbury—and Rome—decreed that the church in Ireland adopt the European practice. Delicate and complicated negotiations took some fifty years to complete, and it was not until 1152, at a national synod convened at Kells, that the bishops of the four archdioceses of Ireland—Armagh, Cashel, Dublin, and Tuam—each received their insignia of office from the hands of the papal legate.

But throughout the first half of the twelfth century reform ideas had been pouring into Ireland—ideas about church architecture as well as doctrine and organization. Now even small churches were decorated in the Romanesque style, and the irregular huddle of small monastic buildings and sanctuaries gave way to the majestic abbey church surrounded by imposing communal buildings.

Even before the consecration of Mellifont, the first great Cistercian house in Ireland, in 1157, other reform orders had been established. But 1157 stands as the symbolic year by which most eccentricities of the church in Ireland had come to an end. Only twelve years later, in 1169, the political isolation of Ireland symbolically ended, for in that year a handful of Anglo-Norman knights and their supporters landed at Wexford. Reform of the church had taken fifty years; military conquest took no more than eighty. By 1250 three-quarters of the country had been overrun by the invaders, and for the first time in Irish history a centralized government, from Dublin, controlled the country.

The Anglo-Normans were interested in rich lands, which they organized into feudal manors, and from which they expected to draw sufficient revenue to live grandly. For relaxation, the Normans had their courts filled with servitors and minstrels. In the hope that good works in this world might provide ease in the next, some money always went to erection, embellishment, and endowment of abbeys and churches. In these churches and their ornaments (64, 66) the Romanesque gave way to the Gothic style.

The invaders' power peaked in about 1250, after which the native Irish realized that if unity of purpose gave strength to the Anglo Normans, the same sort of unity on the Irish side might repel them. At Bannockburn in 1314 Robert Bruce had raised hopes of an independent Scotland, and a year later his brother Edward came to Ireland to emulate his success. Though his four-year campaign ended in failure, Bruce's zeal undermined the whole colonial fabric. During the next two hundred years English power and influence dwindled while the Irish lords, together with many of invader stock who had been assimilated into Irish culture, regained their strength and arrogance.

In 1485, when the Tudors seized the English throne, they had also to recapture Ireland—or lose it altogether. As such a loss would have meant the risk of a hostile country on England's western flank, she clipped the wings of the Irish parliament in 1494. In 1534 she attempted to force a reformed state church. In 1556 she began massive seizures of land. Irish art was overwhelmed by the Renaissance influences that the Tudor noblemen brought with them and never regained its earlier vitality.

1 The Bronze Age
Peter Harbison

Ireland did not have one golden age; it had a number of them. This remarkable circumstance was made possible by the amount of gold in the country in early times. Yet, at the time of Ireland's first "golden" age, the uses of gold were not even known.

Of the three great ages—stone, bronze, and iron—that preceded the Christian era in Ireland, only the Stone Age did not involve metal as its primary working material; nevertheless, it too may be described as a golden age because of the splendid design and scale of its building projects. Agriculture had been introduced into the country by 3500 B. C., and by 2500 B. C. the farmers had sufficient resources to embark on the construction of great stone megalithic tombs such as Newgrange (Fig. 5)—one of the wonders of the ancient world. Such tombs convey the noble architectural concepts of which Stone Age man was capable in Ireland. By contrast, the houses of the living were so frail that they have long since disintegrated. Through excavation, Newgrange has revealed such structural refinements that we can only conclude that its builders, far from being the "primitive savages" that many imagine, were a people of great intellectual capacity who were already in the possession of a sophisticated technology. Their religious beliefs, too, must have been highly developed. A tomb as large as Newgrange must have taken a million sackfuls of material to build; surely any society prepared to expend such energy on housing its dead must have had a very strong belief in life after death.

In some of the tombs in the east of Ireland the stones are decorated with geometrical patterns like spirals (Fig. 1, p. 10), zigzag forms, and diamond shapes. We cannot unlock the meaning these symbols had for those who carved them, but one recurring motif—a circle with radiating lines—suggests that sun worship may have played a part in the ritual of the period, as it probably also did in the subsequent Bronze Age. Some of the stone-carved patterns may have been derived from woven cloth, of

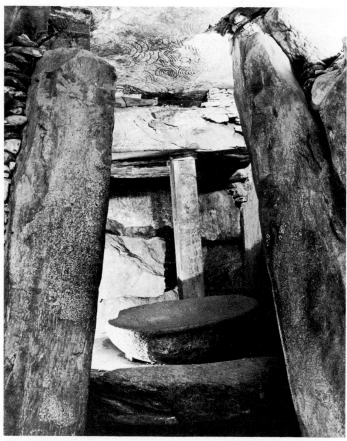

Fig. 5. Side chamber, megalithic tomb, about 2500 B. C., Newgrange, County Meath

which none survives, and in a few instances they may possibly be the stylized representations of a face or part of a human figure (Fig. 6).

The Bronze Age began before 1800 B. C. and continued until at least 600 B. C. However, during this time a great many gold ornaments were also made, and today Ireland is the repository of the richest collection of prehistoric gold in central or western Europe. The gold ornaments are remarkable for their striking beauty—the simplicity of their shapes and geometrical decoration.

About 2000 B. C. a difference in material cultures gradually became apparent between the western and the eastern halves of Ireland. Which half began to practice metallurgy first is a matter of debate. In the west the people were building the last of the Irish megalithic tomb-types —the wedge-shaped gallery grave. We do not know if the builders of these tombs were the descendants of some of Ireland's Stone Age population or whether they migrated, along with their tomb-type, from somewhere in northwestern France. Gallery graves can be seen today in the western part of County Cork, near some of the few remaining Bronze Age copper mines. The copper ore mined there was known as *fahlerz,* from which many of Ireland's earliest metal implements and weapons were apparently made. There is thus a possibility that the people who buried their dead in the gallery graves were among the first in Ireland to exploit and trade copper or to allow it to be exploited and traded in their territory.

The other people who have been claimed as the first to practice metallurgy on any scale in Ireland were the beaker folk, named for a type of pottery often found in their graves. While their ultimate origins are still disputed, it is reasonably certain that they migrated from the Rhineland to Britain and on to Ireland shortly before 2000 B. C.; the speed of their dispersion is perhaps due to their having been among the first people in Europe to tame horses. They must have carried metal weapons and trinkets with them, much like modern gypsies, to whom they have been compared.

To judge from the products of archaeological excavations, the beaker folk settled largely in the north of Ireland, and in the east as far south as Dublin Bay. They probably crossed the Irish Sea in several waves from southwestern Scotland and to a lesser extent from Wales. But as it appears they never reached the southwest of Ireland where the fahlerz deposits lay, they are unlikely to have been the first to exploit the copper ore in the area. Perhaps when they arrived in Ireland the beaker folk began to usurp an already active metal trade which drew much of its raw material from the southwest of the country.

It was the arrival of the beaker folk that had ultimately caused the division between the eastern and the western halves of Ireland. Their descendants—who made a type of pottery called food vessel—became the dominant element in the eastern half of Ireland during the early Bronze Age, and they buried their dead in single graves in stark contrast to the communal burial custom of the people in the west (see map, p. 20). It is in the eastern half of the country, too, that the majority of bronze implements and weapons of the early Bronze Age have been found. These include graceful halberd blades mounted at right angles to a wooden shaft, as well as axeheads bearing geometrical decorations such as hatched triangles. Their predominance in the east suggests that at least at the height of the early Bronze Age, about 1600 B. C., the descendants of the beaker people had already taken effective control of the metal-casting industry in Ireland and were trading the finished products with places as far away as Germany and Denmark.

The people who lived in the eastern half of the country also made gold jewelry. The earliest gold ornaments were small discs of sheet gold, often decorated with a cross motif hammered in from the back in repoussé. A similar motif is occasionally found on the bottom of pottery vessels and also occurs on pottery in eastern Europe, from whence the inspiration for these discs may have come. However, as is the case with so much Irish art, ideas were received from outside but were adapted by the local smiths to produce a form that was characteristically Irish. The gold discs are often found in pairs, and two small perforations near their centers suggest that they were attached to leather or to garments and were probably displayed on the chest. Two such discs have been found in

19

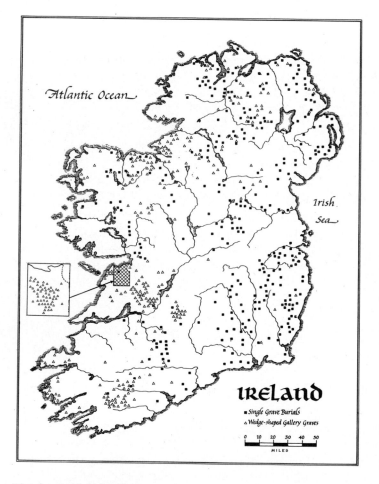

The ends, or "horns," are decorated with incised geometrical decoration including hatched triangles similar to those on the roughly contemporary bronze axeheads; hatched or crosshatched bands and herringbone designs also appear. The carving in a megalithic tomb at Fourknocks, County Meath, shows a stylized human form wearing around its neck what may be a lunula (Fig. 6). As the megalithic builders of eastern Ireland appear not to have known the use of metal, it is unlikely that whatever this object was meant to depict was made of metal. It does, however, suggest that gold lunulae may have

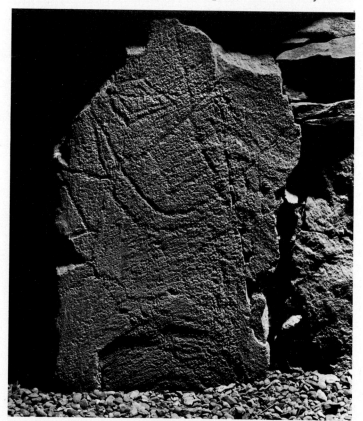

Fig. 6. Stone figure, about 2500 B. C., from megalithic tomb, Fourknocks, County Meath

England with beaker pottery; perhaps it was the beaker people in Ireland who were responsible for the discs. The pair from Tedavnet (**1**) are two of the most advanced specimens of the type. The round form may indicate an association with the cult of the sun, which was common in the Bronze Age.

By curious contrast, the most popular shape of the gold ornaments of the early Bronze Age is the half-moon. The lunula (**2**) was presumably worn around the neck and, like the discs, was made of thin, hammered sheet gold.

been adaptations in gold of ornaments of another material (leather?) already known in the Stone Age. Gold lunulae, many of them similar to the Irish examples, have been found in Scotland, Cornwall, France, Germany, and Denmark. Although the two Danish examples are not very close stylistically to the Irish specimens, they appear to have been made with Irish gold. It was probably the descendants of the beaker folk who exported it.

The gold of the Irish lunulae is similar in composition to that of the discs and to that of gold nuggets discovered in the eighteenth and nineteenth centuries in tributaries to the Avoca River. It is a reasonable assumption that much if not all of the gold that went into the making of the early Bronze Age jewelry emanated from rivers in County Wicklow.

The middle Bronze Age began about 1400 B. C., when the custom of burying food vessels or urns with the dead began to dwindle. This indicates a change in burial rites and possibly also a shift in religious attitudes. But the lack of gravegoods in subsequent burials unfortunately deprives the student of the period of an important source of material for the study of everyday life; metal products must serve as the chief indicators of developments in Ireland in the middle and later Bronze ages.

The eastern Mediterranean area is the source of inspiration for the few gold objects that can be ascribed to this phase. Earrings of twisted gold (3) are imitations of a type known from Palestine and Cyprus, or possibly the Carpathian basin, as early as the fifteenth century B. C. The Mediterranean earrings were made by soldering two *V*-shaped strips of gold together to produce an *X*-shaped cross section which was then twisted. The Irish smiths did not know the technique of soldering but managed to produce the same effect by their own methods—cutting a lengthwise *V*-shaped groove on each face of a long square-sectioned bar of gold.

Such items were to be Ireland's last contact with the Mediterranean world for some centuries. About 1200 B. C. widespread disturbances plunged the eastern Mediterranean into chaos; Ireland and Scandinavia, isolated from that market, revived their previous trading relationship. Beginning in the twelfth century B. C., Scandinavian smiths produced decorative objects which were imitated in Ireland at the beginning of the late Bronze Age, also called the "Bishopsland phase." During this time, which covers the twelfth to tenth centuries B. C., Ireland produced new bronze types such as socketed axeheads and sickles based on northern Germanic and Scandinavian models. In addition, the twisted arm or neck ornaments of Scandinavia inspired such Irish gold ornaments as the waist torc from Tara (4); the Irish smiths showed their inventiveness by adding the reflexed ends. The Scandinavian prototypes had been bronze, but the Irish could afford to imitate them in gold. The considerable amount of raw gold that went into the making of such solid gold ornaments shows that Ireland—after a lull of some centuries—was again beginning to indulge seriously in the hunt for gold. Sites in Britain and France have also produced twisted gold torcs with smooth recurving ends like the Tara example, and they were probably all made with gold from a common source.

The unusual ribbed bracelets from Derrinboy (5) must also have been influenced by the same wave of Nordic ornamental influence, though they derive from armbands produced in central Europe beginning in about 1400 B. C. The Derrinboy armlets may also probably be assigned to the Bishopsland phase. The twisted ribbon torc from the north of Ireland (6) must, however, have been a British or Irish innovation, as no convincing continental prototypes have been discovered. Such torcs probably remained staple products of goldsmiths' workshops for a number of centuries after their first appearance during the Bishopsland phase.

By about 900 B. C. the Scandinavian contact would

seem to have slackened once more while that with the Atlantic coast of Europe was strengthened. The production of gold ornaments declined, though at the same time the demand for bronze swords modeled on types from central and western Europe increased. Unsettled social conditions as well as a period of intense rains caused the shift of some of the troubled population to the hilltops.

Actually this turbulence was a prelude to the most dazzling and prolific of all Ireland's prehistoric golden ages, the Dowris phase of the late Bronze Age, which had its finest expression during the eighth to sixth centuries B. C. The weight of the solid gold ornaments produced then indicates great wealth, and surplus gold must surely have been exported to Britain. The links with the Nordic metal industry, which had contributed to the expanded Irish repertoire during the Bishopsland phase, now re-emerged to determine the type and style of the many personal adornments produced. The renewed contact may have been due to an increased export of Irish copper to Scandinavia. And links with the Mediterranean world were established once again too; peace had returned to the countries bordering its eastern shores, and Phoenician and later Greek merchants again extended their trade westward.

The extraordinary richness of this period is best exemplified in what is known as the great Clare find—a hoard of gold ornaments uncovered at Mooghaun North when the West Clare Railway was built in 1854. Many of the pieces had already been melted down before Sir William Wilde, father of Oscar Wilde, made an inventory: "5 gorgets, 2 neck torcs, 2 unwrought ingots and no less than 137 rings and armillae." The weight of the surviving gold was 174 ounces, the greatest find of prehistoric gold ornaments ever discovered in western Europe.

What Wilde described as "armillae" are otherwise known as dress fasteners, heavy gold ornaments with cup-shaped ends joined by a bow (7). These are simply pinless versions of the bronze fibulae or brooches of northern Europe and were used to join two sides of a garment. The gold collar from the great Clare find (8), with its faintly incised "fir-tree" decoration, was evidently modeled on the so-called "oath rings" from northern Germany, which may date to about the seventh century B. C. Another characteristically Nordic type of dress fastener was the sunflower pin. Its disc head (9), placed at right angles to a bronze shank, was decorated with concentric circles surrounding a central conical boss and was sometimes also ornamented with radiating lines. A number of these pins were copied in Ireland, particularly in the seventh and sixth centuries B. C.

Perhaps the most splendid of all Ireland's prehistoric gold ornaments is the gorget (10). It consists of a crescent-shaped sheet of gold with a gold disc at each end. The crescent has a series of almost concentrically placed raised ribs between which are usually thinner, recessed ribs of rope molding, all having been formed by repoussé tools while the sheet metal rested face down on some yielding material. As on the Gleninsheen gorget (Fig. 7), the terminal discs are decorated with a ring of symmetrically arranged concentric circles enclosing a ring of small bosses; in the center is a conical spike surrounded by more concentric circles. All these motifs were copied from Nordic metalwork, and indeed the ribs of the crescentic part of the gorget must have been made in imitation of the northern European fashion of wearing several different-sized bronze rings around the neck. The gorget is made up of a number of separate pieces folded over one another, and the discs are sewn to the main crescentic sheet with gold wire (Fig. 8). Almost all the gorgets known from Ireland have been found in the counties bordering on the mouth of the Shannon River and seem to be original creations of this part of Ireland.

The same lower Shannon area has also produced a number of "lock rings," such as those from Gorteenreagh

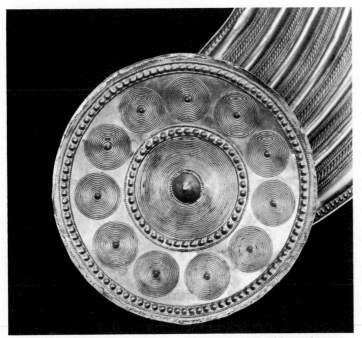

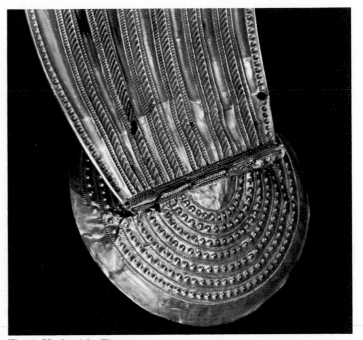

Fig. 7. Terminal disc, gold gorget, about 700 B. C., Gleninsheen, County Clare, NMI

Fig. 8. Underside, Fig. 7

(11), which may have been hair ornaments. These probably originated in Britain or Ireland—possibly they too were made in the area around the mouth of the Shannon, where so many have been found and where production must have started by about 750 B. C. In strange contrast to the gorgets, one of which was found in the Gorteenreagh hoard, the use of solder is evident in the joints of the ring; one wonders why the same method of construction was not used on both types, if indeed they emanated from the same workshops. The biconical faceplates of these lock rings are ingeniously composed of concentrically placed gold wires, sometimes so close together that there are as many as five to the millimeter. Possibly this was an attempt to reproduce the granulation work practiced at about the same time by the Etruscans. Technically the decoration of the lock rings is superior to that of the

gorgets and represents the highest achievement of the goldsmith's craft in western Europe during the late Bronze Age. As no foreign models for these lock rings are known, they represent an outstanding native Irish contribution to goldwork in prehistoric Europe and are proof of the ingenuity of the workshops of the lower Shannon area in the eighth century B. C.

A "bulla" of lead covered with sheet gold (Fig. 9) is another uniquely Irish contribution to the goldsmith's art, although the shape may have originated in Phoenicia. Besides the familiar boss and concentric circle motif and "fir tree" decoration, this piece bears what may be the only representation of the human face from the Bronze Age in Ireland. The interpretation, however, is difficult; the decoration may have been meant to represent a mask or a Corinthian helmet.

A variety of distant influences may be seen in decorative motifs on bronze implements produced in the late Bronze Age in Ireland. The bronze shield from Lough Gur (12) is one of only a few examples known from Ireland of a type decorated with concentric rings and bosses extraordinarily reminiscent of the back of the disc of the Gleninsheen gold gorget. The thinness of the shield suggests that it was made for ceremonial purposes. The prototype of such shields is from northern Europe, as are the forerunners of the roughly contemporary Irish bronze trumpets. These were derived from the Nordic *lurer,*

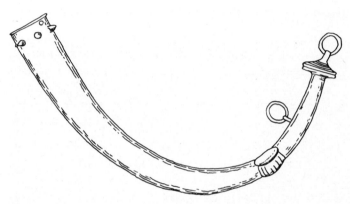

Fig. 10. Bronze trumpet, about 700 B. C., Derrynane, County Kerry. NMI. Drawing after George Eogan

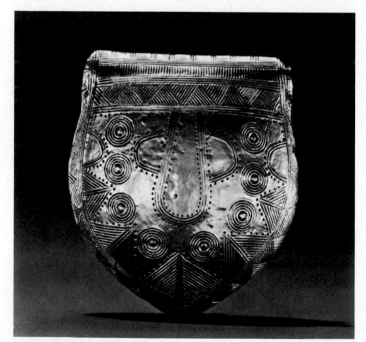

Fig. 9. Gold-plated lead "bulla," about 700 B. C., Bog of Allen, County Kildare (?), NMI

though in some of the Irish examples the blowing hole is on the side (Fig. 10), as on the modern flute.

The influences of both the Nordic and Mediterranean worlds are seen in Ireland in the great bronze cauldrons

of the late Bronze Age. Like others of its type, the spectacular example from Castlederg (13) is made of gently rounded rectangular sheets of bronze joined by conical rivets. The inspiration for these came from central Europe by way of Scandinavia, but the cauldron form itself is of eastern Mediterranean origin. Oriental cauldrons must have been peddled by Phoenician traders westward through the Straits of Gibraltar before finding their way to Ireland in the eighth century B. C. Such cauldrons may have served a ritual use in Irish life. An old Irish tale tells of a cauldron that is never emptied no matter how much of its contents are removed, and certainly the capacity of the vessels must have been regarded with awe when they were introduced into Ireland.

The distribution patterns of the objects produced by the Irish gold- and bronzesmiths toward the close of the late Bronze Age show that Ireland was then divided into northern and southern parts, in contrast to the east/west division of the early Bronze Age. This new partition seems to have foreshadowed developments in the ensuing Iron Age which were only dimly discernible when Ireland's earliest recorded political "history" was first set down after the coming of Christianity.

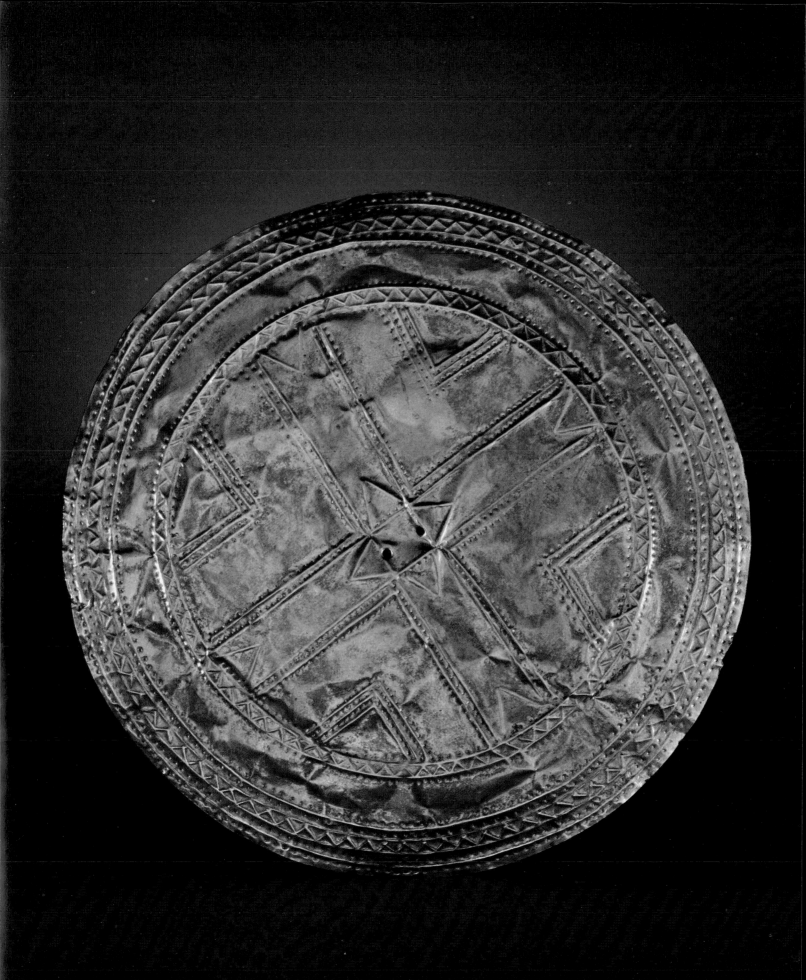

1. Gold disc, Tedavnet, County Monaghan

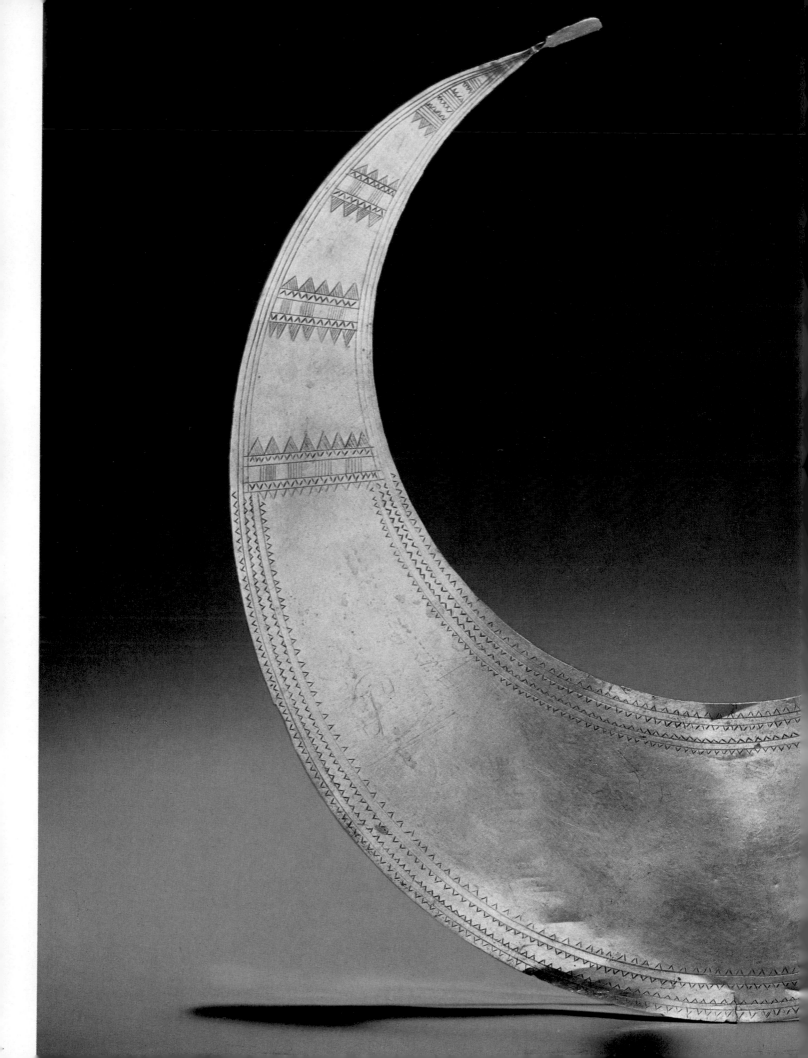

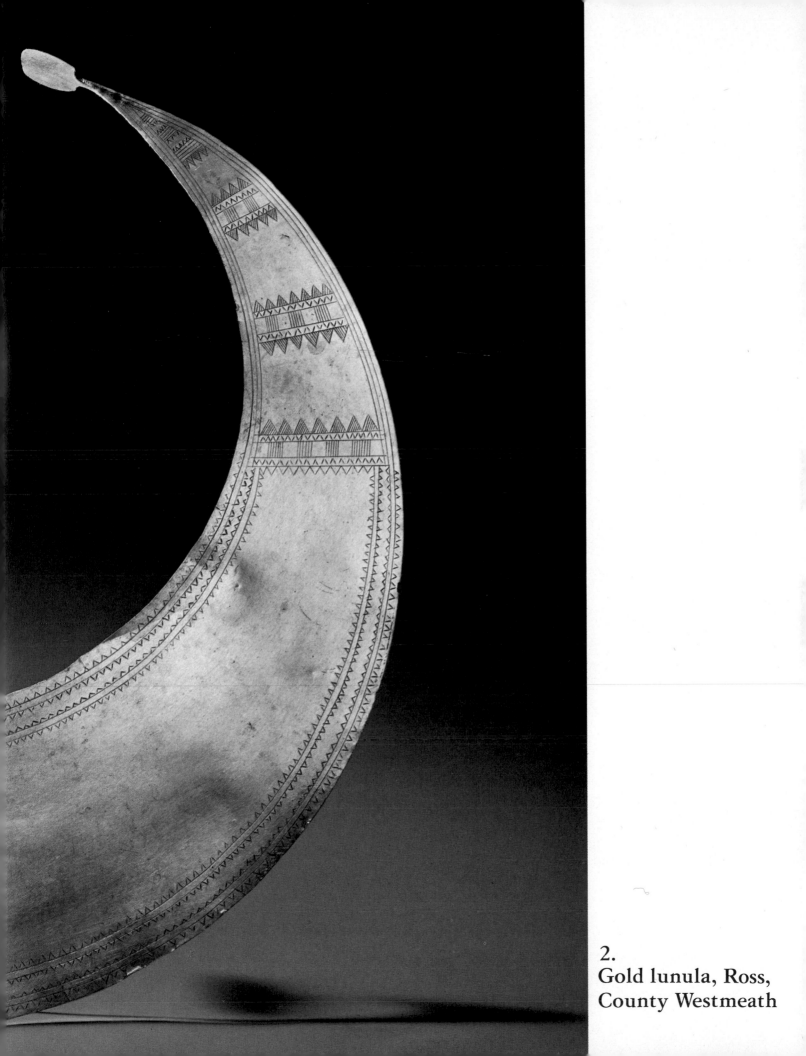

2.
Gold lunula, Ross,
County Westmeath

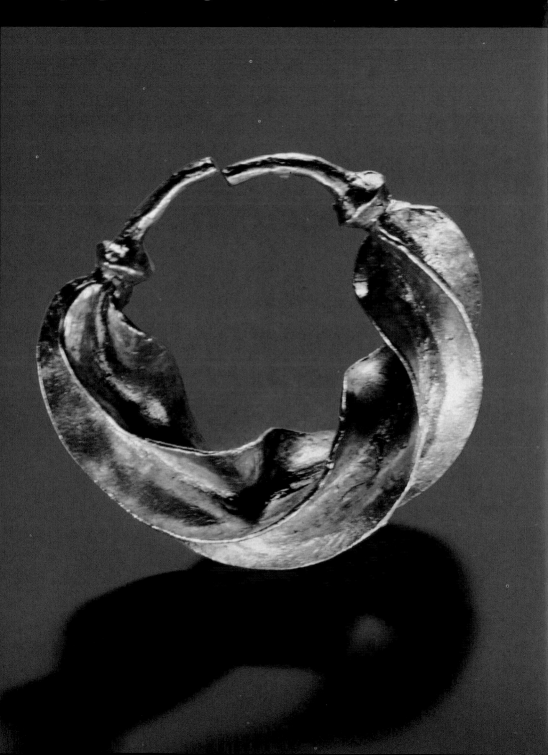

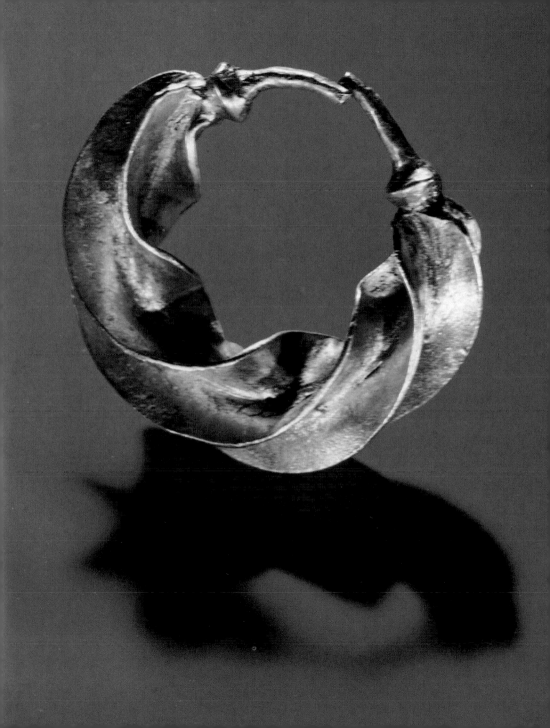

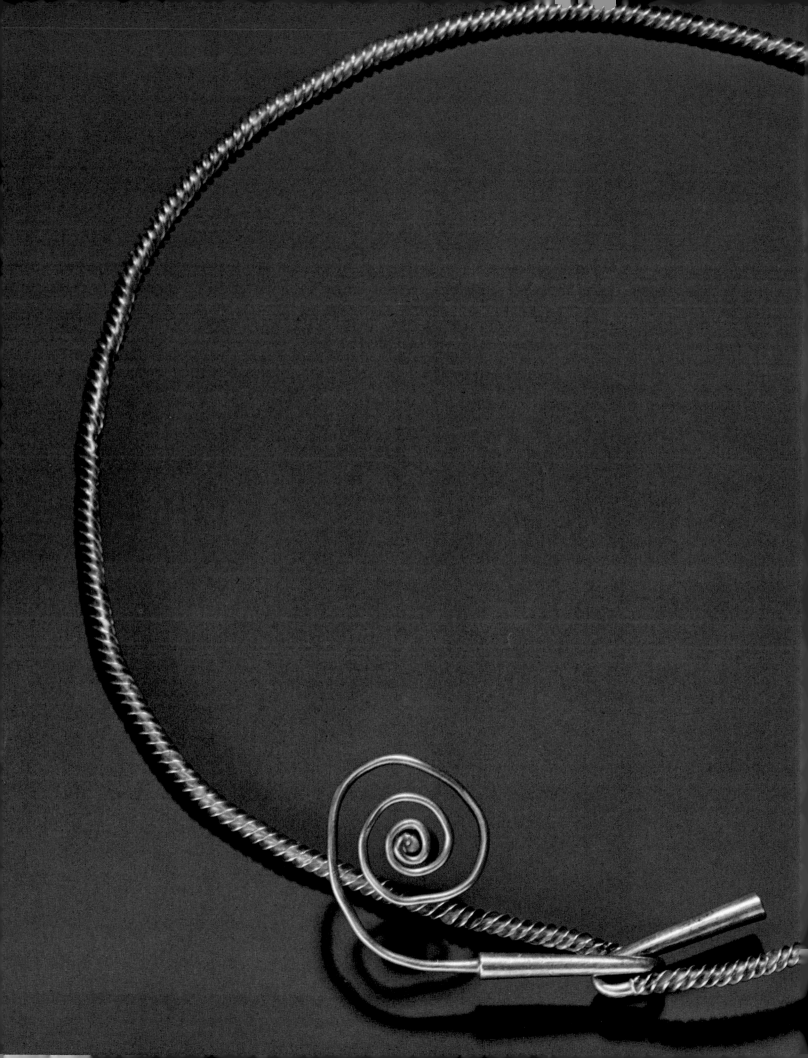

4.
Flanged gold torc,
Tara,
County Meath

5. Gold armlets, Derrinboy, County Offaly

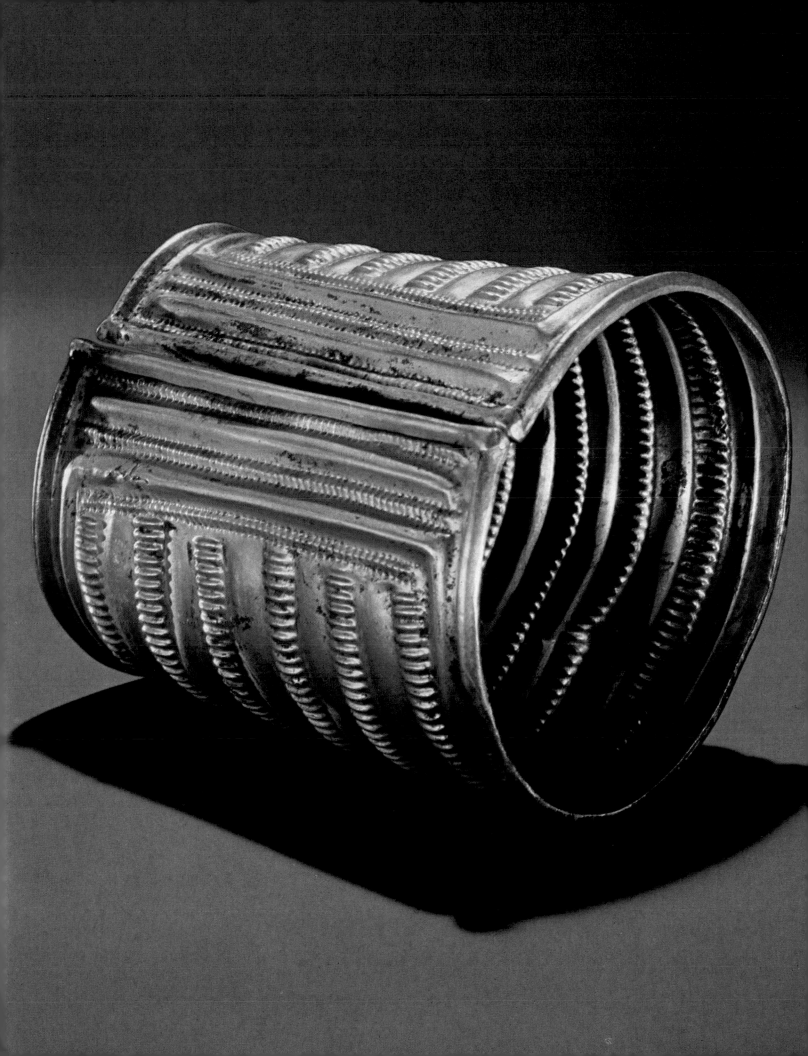

6. Gold ribbon torc, near Belfast, County Antrim

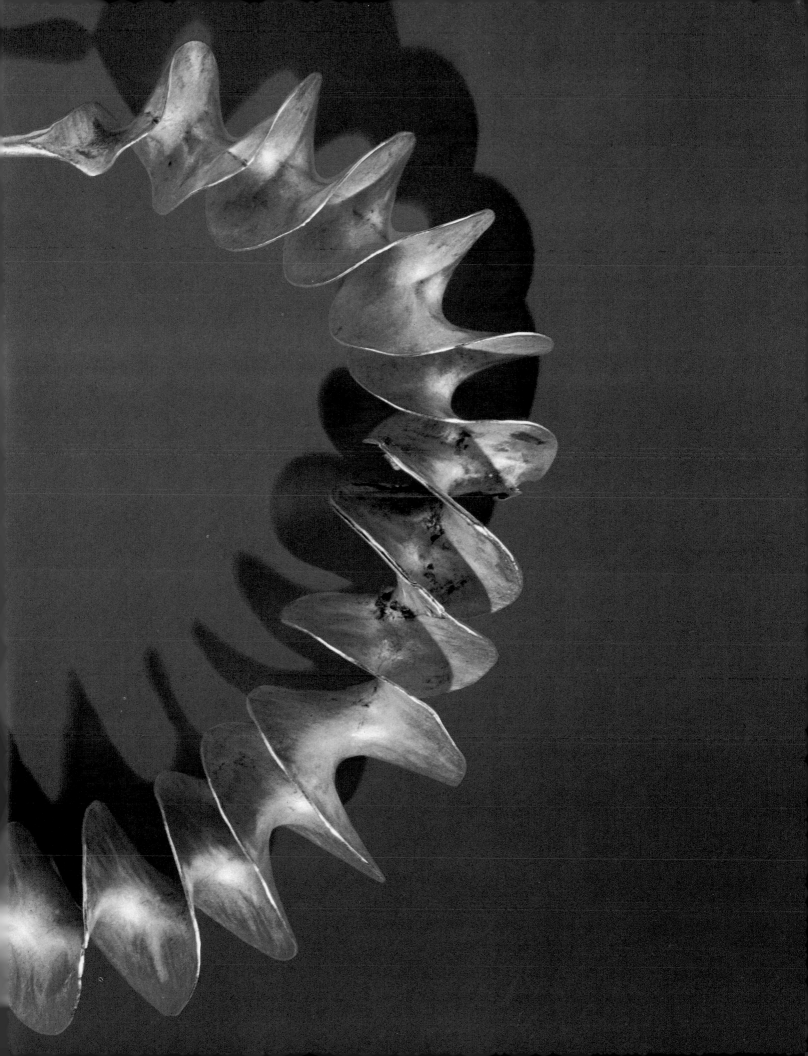

7.
Gold dress fastener, Clones,
County Monaghan

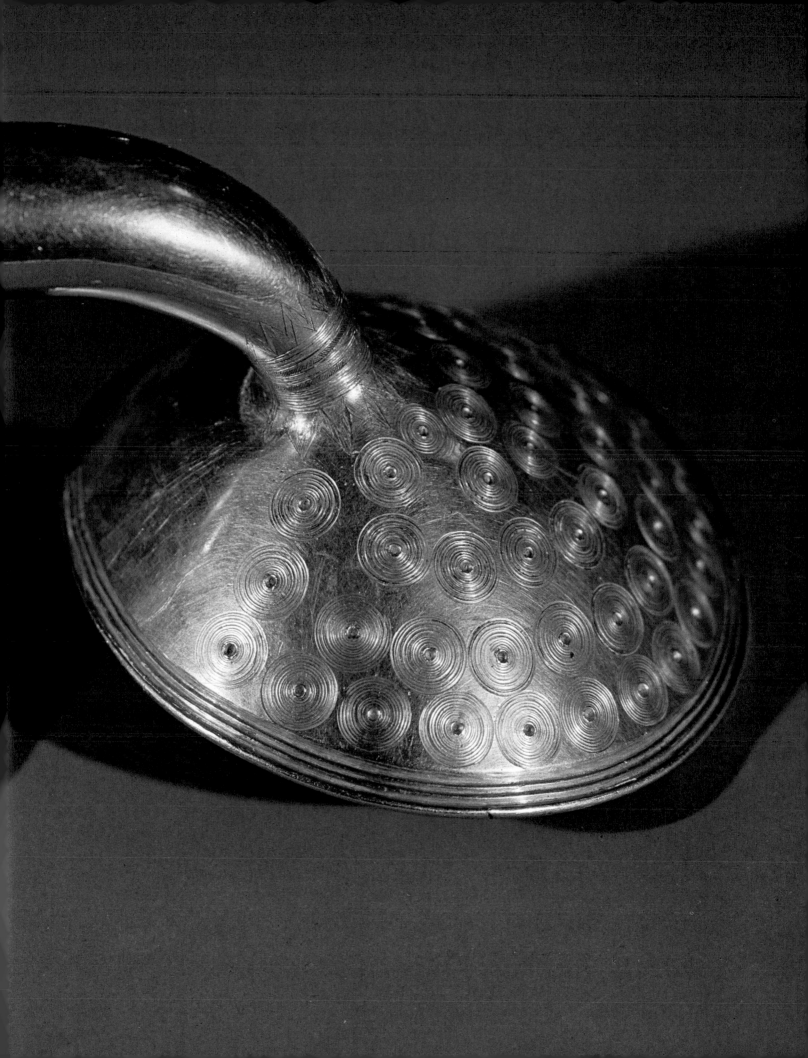

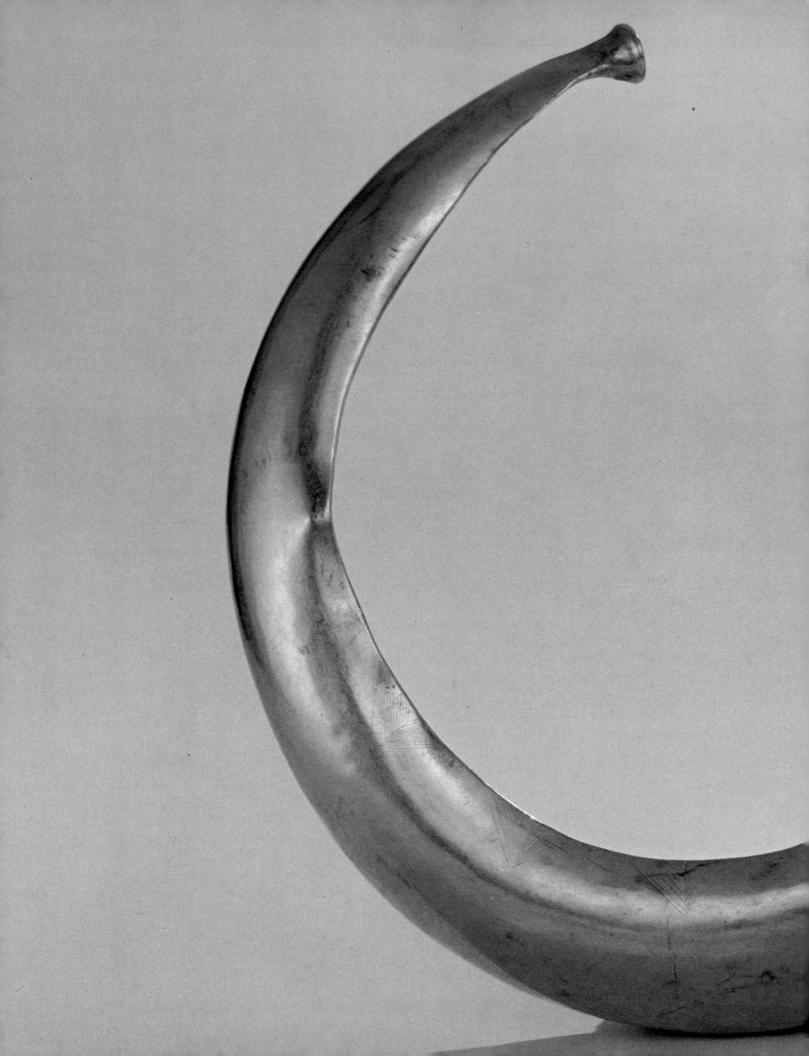

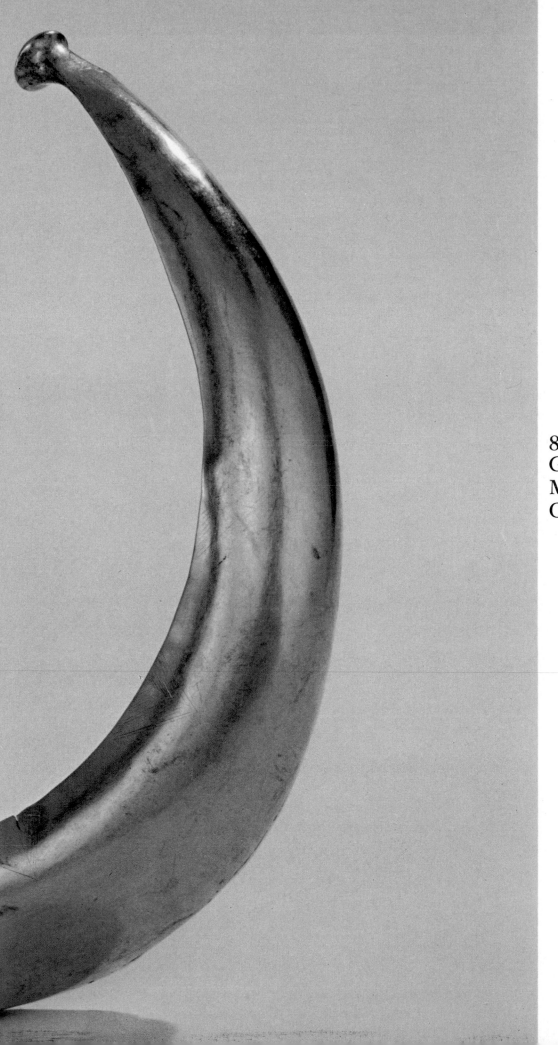

8.
Gold collar,
Mooghaun North,
County Clare

9. Bronze disc-shaped pinhead

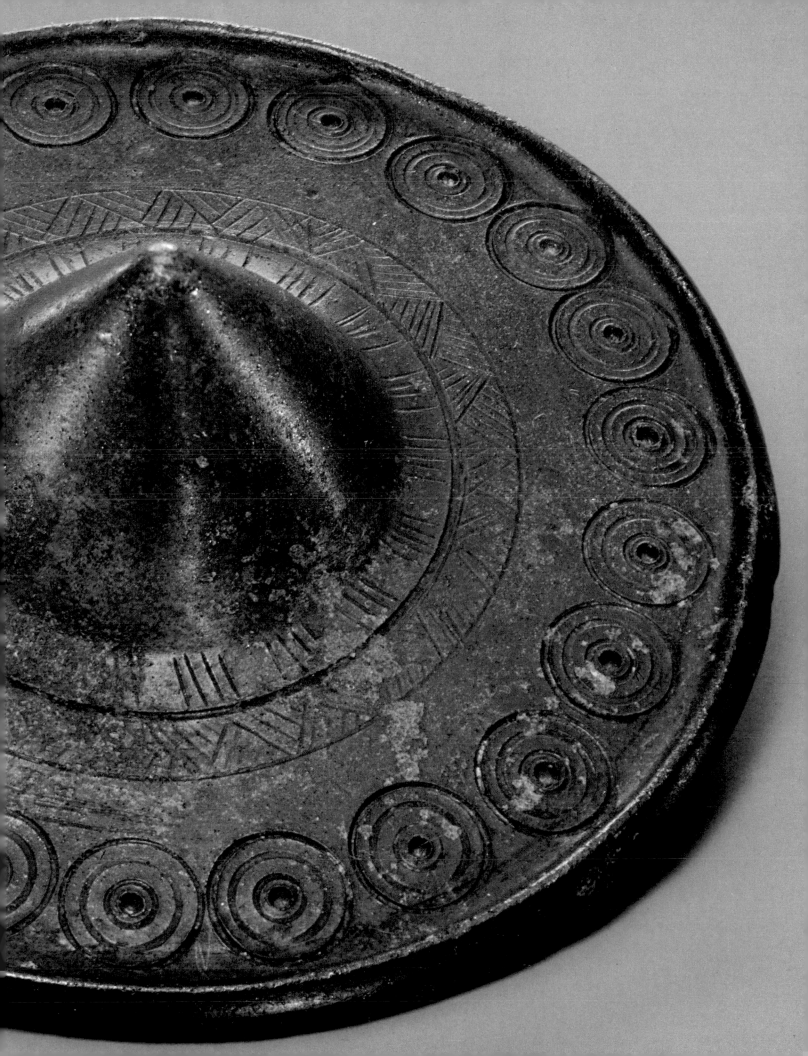

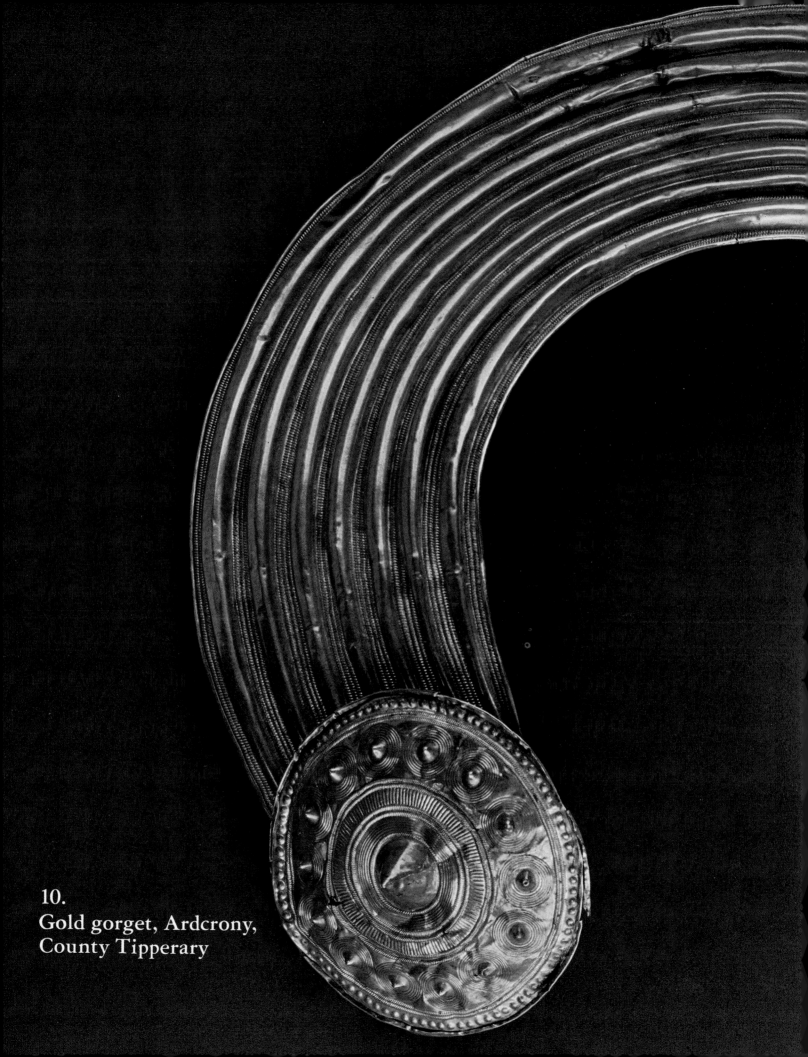

10.
Gold gorget, Ardcrony,
County Tipperary

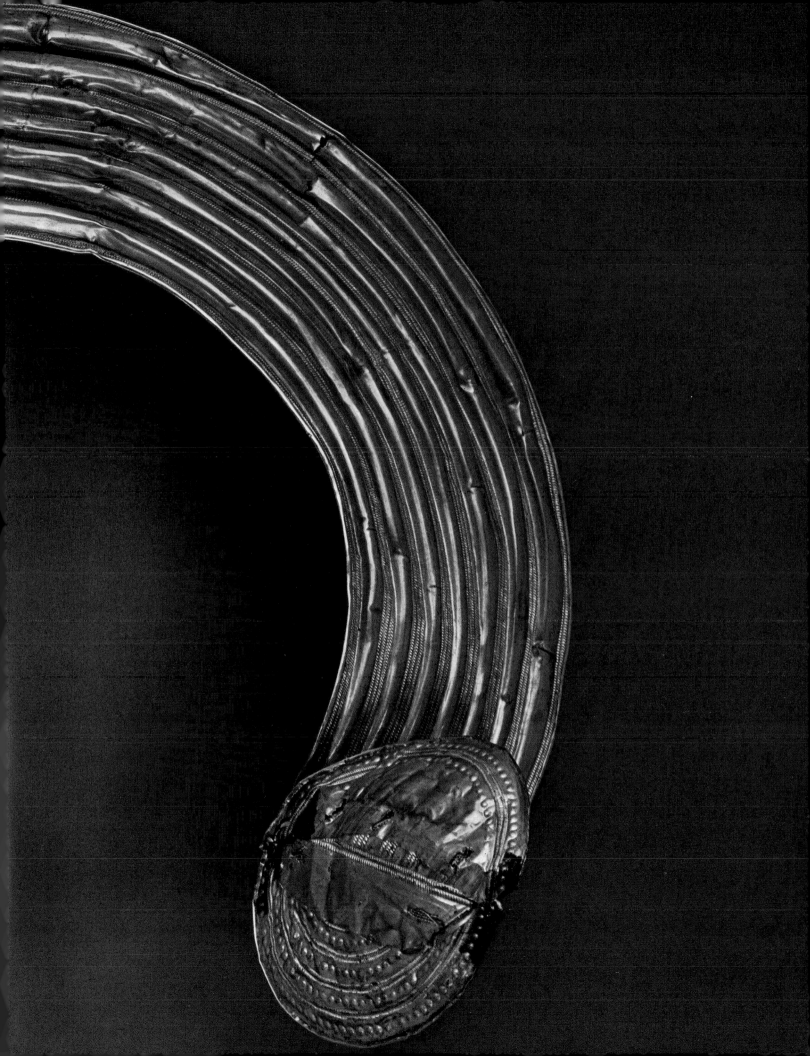

11.
Gold lock rings,
Gorteenreagh, County Clare

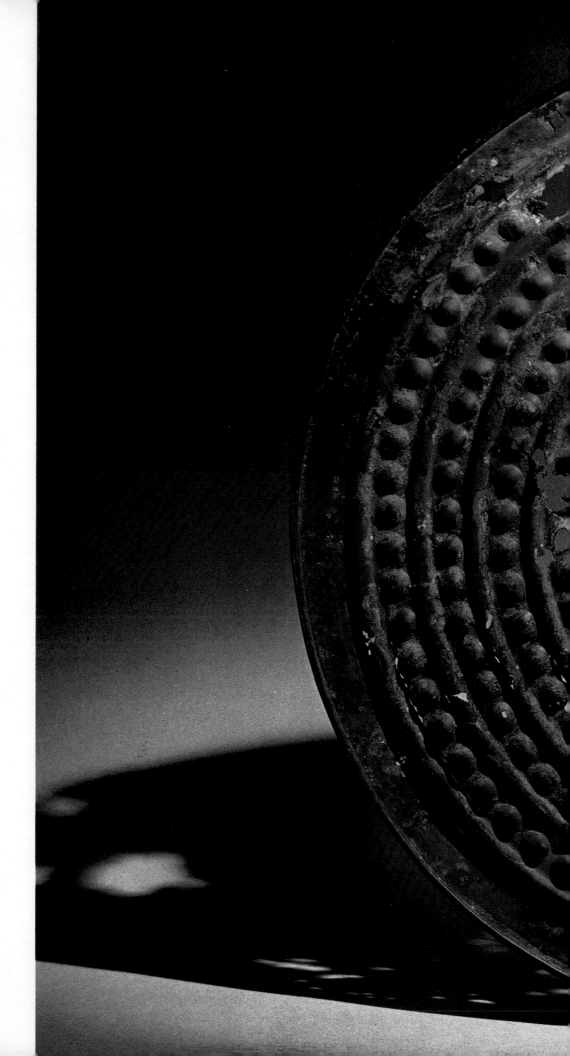

12.
Bronze shield,
Lough Gur,
County Limerick

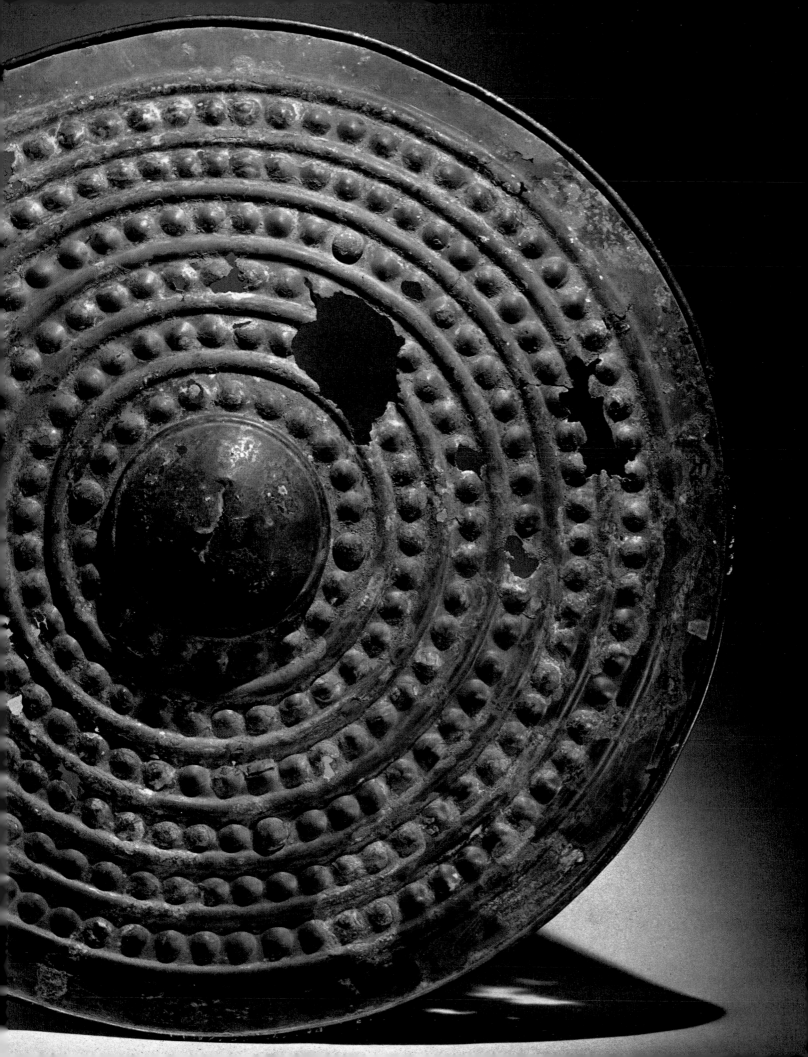

13. Bronze cauldron, Castlederg, County Tyrone

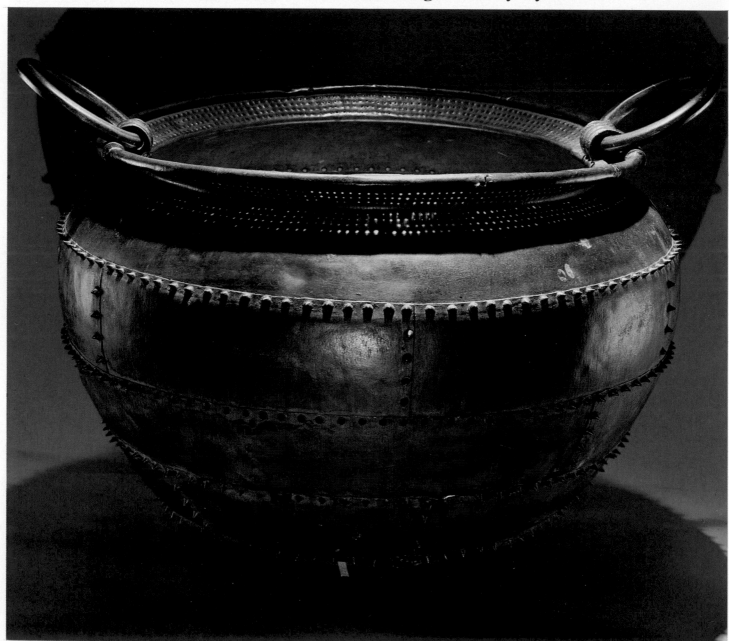

Catalogue

1. Pair of gold discs
Early Bronze Age, about 2000-1800 B.C.
D. 11.6 cm.
Tedavnet, County Monaghan
NMI, 1872:34,35

Thin gold discs such as these are usually found in pairs. A circle was cut from a thin beaten plate of gold and decorated by hammering and punching a variety of ridges, chevrons, and dots. The perforations near the center suggest that the objects were sewn to a garment.

A cross device of two parallel ridges and three lines of dots lies in the center of each disc; triple right-angled ridges with dots lie in the quadrants formed. Raised triangles decorate the ends of the cross arms and also face out from the center of the cross. About twelve such discs have been found in Ireland and about six in Britain. A few possibly related discs have been found on the Continent. In Ireland the pieces are usually found near the coasts; the inland discovery at Tedavnet is unusual.

Bibliography: IP, p. 122, figs. 51, 52; TI, pl. 1.

2. Gold lunula
Early Bronze Age, 1800-1600 B.C.
D. (at widest point) 20 cm.
Ross, County Westmeath
NMI, 1896:15

Lunulae are thought to have been neck ornaments, but they may have been worn in the hair. Possibly they were an adaptation of earlier woven or beaded ornaments.

The typical crescentic shape was cut from a thin plate of hammered gold with paddlelike extensions (usually of slightly greater thickness) at the ends. These could be rotated and thus hooked together.

All the decoration is incised, and the plate is so thin that the design can be seen in relief on the underside. The lower front is plain but is bordered by two pairs of parallel lines, each of which is decorated with triangles. The border decoration is reduced to simple lines as the ends become narrow. Each end carries four matching bands of horizontal decoration. The horizontal devices are each composed of two pairs of parallel lines with chevron strokes within each pair and groupings of vertical lines between each pair. Above and below the pairs of lines there are triangles—plain below, hatched above.

More than sixty gold lunulae have been found in Ireland—the majority in the northeast. Five or six have been found in Scotland, one in Wales, four in Cornwall, and a small number on the Continent.

Bibliography: IP, pp. 142, 144, figs. 51, 52; TI, fig. 5.

3. Flanged gold earrings
Middle Bronze Age, possibly late thirteenth century B.C.
D. 3.6 cm.
Castlerea, County Roscommon
NMI, W.63,64

These beautiful earrings are flange twisted; four flanges were created by hammering out the edges of an angled bar of gold and twisting it 180 degrees. The impressions of a small round-headed hammer can be clearly seen. These particular earrings are noted for their broad flanges and for the collar-mounting between the body and the rodlike end.

It seems certain that the goldsmith who created these ornaments had seen the finest eastern Mediterranean work.

Bibliography: IP, pp. 173-176, fig. 70; TI, pl. 8.

4. Flanged gold torc
Late Bronze Age (Bishopsland phase), 1200-900 B.C.
D. (at widest point) 38 cm.
Tara, County Meath
NMI, W. 173

In 1830 two, or possibly three, magnificent twisted flanged torcs were found at Tara. The basic element of this one is a four-flanged bar, closely twisted; the edges of the flanges are slightly flattened; there are transverse disc ends. At one end a short cylindrical bar, bent back 180 degrees, leads to an elongated cone with a hammered surface; the cone was narrow where it was attached to the disc and expanded outward to end in a flat base. The other end has similar fittings, but there a long spiraled rod of gold emerges from the flare of the cone. The spiral ends with a terminal in the form of a small round-topped cone.

The concept of this piece is from outside Ireland, but the manner of execution is native.

Bibliography: IP, p. 176, pl. 12a; TI, pl. 3.

5. Gold armlets
Late Bronze Age (Bishopsland phase), 1200-1000 B.C.
W. 7.4 cm.
Derrinboy, County Offaly
NMI, 1959: 693,694

These handsome gold armlets are made of a length of broad gold ribbon with thickened edges. Transverse ridges were worked across the ends and longitudinal ridges down the length. Alternate ridges were then worked with small hammers and punches; the transverse ridges were decorated by punch blows on both the top and underside. The thin ends of the ribbon were coiled backward and inward to create a strong edge. The ribbon was then curled to form the armlet.

Immediate prototypes for such armlets have been found in southern England and southern Scandinavia; the ultimate origins are in the middle Bronze Age cultures of central Europe.

Bibliography: IP, p. 176, fig. 76; TI, fig. 15.

6. Gold ribbon torc
Late Bronze Age (Bishopsland phase), 1200-1100 B.C.
D. 17.5 cm.
Near Belfast, County Antrim
NMI, R.2606

This elegant neck ornament was created from a strap of gold beaten to reduce its thickness progressively from the central axis to the margins. The ribbon was then twisted to the desired degree. Its surface is shallowly fluted by hammering. The narrow ends of the strap were worked into short rods ending in hemispherical knobs bent at interlocking angles. There is an ancient repair.

The twisted style was a fashionable concept outside Ireland, and the native smith, accustomed to working from sheet gold, simulated the effect.

Bibliography: IP, pp. 173-176; TI, pl. 5.

7. Gold dress fastener
Late Bronze Age (Dowris phase), about 700 B.C.
L. 21.5 cm.
Clones, County Monaghan
NMI, on deposit from TCD

This dress fastener functioned like a double button in metal, to slip through two "buttonholes" in a garment. Two conical terminals with concave bases are linked by a bow-shaped bar. The largeness and elaborate decoration of the Clones example suggest that it may have been used for ceremonial purposes only.

The connecting bow tapers from the center toward each end, and the ends join the bell-shaped terminals asymmetrically. Three small hatched triangles lie along the crest of the bow. Three bands of parallel lines, separated by bands with diagonal hatching, run around the bases of the bow. A hatched chevron design runs around the margins of this band of decoration, both above and below.

The exterior surfaces of the terminals are magnificently decorated with small pits surrounded by concentric engraved circles, scattered freehand and occasionally touching one another.

A triangular area between the end of the bow and the inner edge of the terminal has been left bare, and the decoration is similarly interrupted on the underside of the bow. The rims of the terminals carry three ridges, both within and without. A ring of hatched triangles rises from the highest inner ridge.

This type of fastener is an Irish adaptation of a northern European clothespin, in which two conjoined circular plates are furnished with a fastening pin; pins are absent in the Irish form. Many of these fasteners (all except two in gold) have been found in Ireland, where they have a wide distribution; such ornaments were also exported to Britain.

Bibliography: IP, p. 199; TI, pl. 10.

8. Gold collar

Late Bronze Age (Dowris phase), about 700 B.C.
D. 16 cm.
Mooghaun North, County Clare
NMI, W.26

This splendid collar is part of the enormous gold hoard discovered during railway construction in 1854.

The body is of sheet gold, C-shaped in section, with hammermarks on the undersurface. The crescentic body tapers from the midpoint to the ends, where it swells into solid conical terminals. The stems of the terminals are decorated with transverse and longitudinal incised lines. Where they end the outer right margin has short horizontal incised lines; the left margin has similar lines on its inside margin. At the inner margin are seven incised triangles pointing outward; incised lines parallel to their sides meet at a central vertical line in a design sometimes compared to a fir tree.

Smaller, rather similar collars, also in sheet gold, and also decorated, occur in northern Germany where they are known as "oath rings."

Bibliography: IP, p. 197, fig. 79.3; TI, p. 39, fig. 14.

9. Bronze disc-shaped pinhead

Late Bronze Age (Dowris phase), about 700 B.C.
D. 8.5 cm.
NMI, P:608

The heavy bronze disc of this pinhead was cast and then smoothed by filing before the decoration was incised. The pin, unfortunately broken off, was set into the center at the back; it was bent immediately at right angles.

The decoration is similar to that on the terminal discs of a gold gorget (10). The high central conical boss is surrounded by four concentric bands of decoration. The innermost band is composed of radial lines, usually in groups of four; the next band is decorated with indented triangles with alternating hatching; the outer margin of the outer band carries a closely set ring of concentric circles surrounding a small central depression. A heavy rim borders the disc.

Such disc-headed pins were first known in southern Scandinavia, especially Denmark.

Bibliography: IP, p. 201.

10. Gold gorget

Late Bronze Age (Dowris phase), about 700 B. C.
D. 26 cm.
Ardcrony, County Tipperary
NMI, W.16

This splendid neck ornament is beaten from sheet gold. The main body is a semicircular band with rolled edges. Seven strongly defined parallel ribs are divided by six bands, each decorated with three lines of rope molding.

The inner and outer edges and the ends are similarly decorated with two bands. The body has a crossridge at each end and beyond this a tongue of plain metal.

On such gorgets the terminals are composed of an upper and a lower convex circular plate, linked by folding the edge of the lower plate around that of the upper. The left terminal is complete; its upper plate has a central conical boss surrounded by four concentric bands of decoration defined by rope-molded ridges. The innermost band is decorated with five concentric circles; the next with radiating ridges; the next with fourteen equally spaced conical bosses, each surrounded by six raised circles; the outermost band is a ring of raised pellets.

The lower plate is seen clearly on the right terminal, which has lost the upper plate. Its lower part, which was visible when the gorget was worn, is fully decorated with five rings of bosses separated by double ridges; its upper part, which was concealed against the body, has only the two outer rings of bosses with an intervening ridge.

To secure the terminal to the band, a transverse slit was made in the lower plate; the tongue on the band was then slipped through the slit from behind and stitched to the plate with twisted gold wire. (The wire was probably made by twisting narrow strips of gold cut from the edge of a thin plate.)

Gorgets are unique to Ireland, where they are found mainly in the south.

Bibliography: CIGO, p. 57:40; pl. VIII:41.

11. Gold lock rings
Late Bronze Age (Dowris phase), 800-600 B. C.
D. 10 cm.
Gorteenreagh, County Clare
NMI, 1948

These gapped conical ornaments—thought to have been used for holding hair in place—demonstrate the highest skill of the early Irish goldsmith. They are constructed from four main pieces: a central split tube, two gapped conical faceplates, and a circular binding strip. The central tube is slit vertically and the cut edges folded back; the top and bottom curve outward around a supporting wire to grip the folded edges of the faceplates. The tubes are decorated with horizontal double rows of small punched bosses for gripping the hair. Each faceplate is built up of threadlike wires (approximately three per millimeter) soldered together. The edges of the slot carry straight-sided marginal bands also built up of wires soldered together. The work is so fine that the closely spaced circles appear to have been incised on sheet gold, but the wires can be seen on both the outer and the inner surfaces. On the outside excess solder has been cleaned away from the grooves between the wires; on the inside droplets of solder can still be seen. There are some indications that the wire itself was made by twisting a narrow strip cut from the edge of a thin plate. The surrounding binding strip is a split gold tube held in position by inserting the splayed-out edges of the plates between its rolled-in edges. One of the ornaments still retains a reinforcing wire within the tube.

These objects seem to have originated in Ireland, and they are most commonly found around the Shannon estuary. Examples found in Britain are similar; some were probably of Irish manufacture. Derived forms, sometimes incorporating bronze, are found in France.

Bibliography: IP, pp. 197-201, fig. 79.8; TI, pp. 39-40, pl. 4.

12. Bronze shield
Late Bronze Age (Dowris phase), about 700 B. C.
D. 72 cm.
Lough Gur, County Limerick
NMI, 1872:15

This splendid shield illustrates the change in the style of combat in Ireland that occurred after the introduction of the slashing sword. It is most ingenious in its craftsmanship. A simple disc of bronze thick enough to withstand a sword stroke would have been too heavy. Instead, six equally spaced concentric ridges were raised from the surface of a thin bronze plate. Between the ridges are six rings of raised hemispherical bosses. The force of a sword blow would have been greatly reduced as it struck a corrugated, instead of a flat, surface. The rim is formed of the inturned edge of the disc.

The central boss is surrounded by a basal rim. At the back a strap of bronze, curved to form a handgrip, is riveted to the shield at either side of the boss. In the ring of bosses third from the outer edge there are, at either side of one end of the handle, two loops of bronze for the ends of a carrying thong. The loops are held by rivets whose heads on the outside of the shield are the same shape as, and replace, two of the bosses.

Sheet-bronze shields were developed in central Europe during the late Bronze Age. The use of such shields spread to Britain, where finds are relatively common. In Ireland shields of leather or wood occur occasionally; those of bronze are exceedingly rare.

Bibliography: IP, pp. 195-197; TI, p. 40, fig. 17.

13. Bronze cauldron
Late Bronze Age (Dowris phase), about 600 B. C.
D. 55 cm.
Castlederg, County Tyrone
NMI, 1933:119

This cauldron is a splendid example of technical brilliance in sheet-bronze work. The base is formed from a dished circular plate; above this are three rounds of horizontally placed sheets fastened together by rivets with high conical heads; the uppermost round is formed of two pieces.

(The function of the rivets may not be purely decorative; their projecting heads would have collected heat and sped the boiling process.) The gently sloping everted rim is brazed to the body; its lip is rolled over a reinforcing ring and decorated with four rounds of small perforations.

Two heavy fittings, which combine the functions of lifting handles and suspension rings, are securely attached to the rim. On the outside a tongue curls down from the handle around the marginal ring. On the inner side of the handle is a heavy-ribbed horizontal collar, perforated for the suspending ring. This fitting runs on under the rim and becomes two short splayed-out straps riveted to the inner side of the body.

Cauldrons of this type probably originated in the eastern Mediterranean area.

Bibliography: IP, p. 204; TI, fig. 16.

2 Foreign Influences and the Beginnings of Christian Art

G. Frank Mitchell

For most purposes iron, except for its tendency to rust, is greatly superior to bronze, and those who were the first to master the techniques of smelting and forging iron easily dominated those still using the weaker metal. Like many other technical skills, ironworking began in the Middle East, in about 1300 B. C., and its practice spread slowly westward. In time iron became commonly used for weapons and tools, but most other objects continued to be made of bronze.

Salt was also a luxury in prehistoric central Europe, and the early Celts, a group of people who gained control of the salt deposits at Hallstatt in upper Austria, also gained riches and power. They reached the height of their development between the seventh and fifth centuries B. C. As the widest boundaries of their culture correspond with the widest distribution of Celtic place-names, they probably spread their language, now known as Celtic, throughout Europe. They reached England in the early part of the sixth century B. C.

A late Hallstatt sword-type has a fishtail-shaped notch in the handle; bronze swords of the same type appeared in central and northeastern Ireland about 600 B. C. However, one cannot found a close link between the two areas from this evidence alone; many varieties of sword were circulating in western Europe, whose culture was still that of the Bronze Age, and the new sword fashion may have been taken up in Ireland without any awareness of its origin.

In the fourth century B. C. the center of the European Iron Age moved west from Austria to Switzerland, where a site at La Tène on Lake Neuchâtel gives evidence of a rich and powerful culture. Luxuries were imported there from the Mediterranean, and classical motifs such as the palmette came with them, only to be transformed by the local craftsmen into the sinuous curves of the distinctive nonrepresentational style now called La Tène. The La Tène people were known as Keltoi (Celts) to the classical world—a world that watched their rapid development with increasing apprehension. By 300 B. C. the La Tène people had migrated east and west, reinforcing the Celtic language and lifestyle wherever they went. They were ignorant of the art of writing, but in the late third century B. C. they developed a system of coinage. At nearly the same time they reached Britain, and finds of pottery and wooden vessels document their settlements there. In Ireland evidence of their settlements is more elusive, but there is no doubt that they powerfully influenced native arts. In continental Europe their power ended in the first century B. C., when they were crushed between Germanic invaders from the north and the Roman Empire from the south.

Julius Caesar pursued them briefly into Britain, but the systematic Roman conquest of that area did not begin until one hundred years later and was not complete until the early second century A. D. In Scotland, in the less accessible and mountainous regions of Wales, and in Ireland the Celts took refuge, and there their influence continued uninterrupted.

As early as the third century B. C. some inquisitive Celtic adventurers—led by chieftains who wore superb gold collars (14, 15)—made a foray into Ireland. After the first century B. C., as the Romans consolidated their position in France and were making their first inroads into England, other Celts may have fled further west; a wider range of imported material and some evidence of settlements appeared in Ireland at this time. Paleobotanical evidence suggests that agriculture in Ireland was barely sustaining the dispirited population. Determined invaders armed with iron weapons—which they had learned to use well in their desperate efforts against the advancing Roman legions—would probably have had little difficulty establishing dominion over much of the land.

The first-century B. C. artifacts most frequently found in Ireland are weapons. The upper ends of the hilts of

some La Tène swords took the form of a human head and shoulders; such a hilt (**16**) was dredged up off the coast of Donegal. Swords required scabbards, and a number of those have been found in northeastern Ireland. One example (**17**) shows poor workmanship and might have been made by a native smith trying to reproduce the weapons of the invaders. However, he did use the La Tène spiral, a motif that was to echo on in Ireland for a thousand years.

Every chieftain had his totem figure, and the boar was a popular one in the Celtic world. One bronze boar (**18**) is pierced in a number of places, perhaps for attaching it to a helmet or some other parade item. The drinking cup (**20**), which may have been made in southeastern England, would have come into service during the soldiers' leisure hours.

All these were imports, or copies of imports, but the three great ornamented stones, intact at Turoe and Castlestrange, and defaced at Killycluggin, were surely carved by native craftsmen. The Turoe stone (Fig. 11) has many important features: it cannot be an import as it is made of native stone, and because of its bulk and weight it is not easily portable. It is carefully shaped and smoothed, and the low relief of its decoration suggests that the artist was copying not repoussé but rather work in which the design was made by cutting away the background. The design breaks down into quadrants (Fig. 12). The forms in the large round panels resemble the so-called "insular" designs on late La Tène British mirrors in their asymmetry of detail within a balanced whole. One lone triskele (a device of three radiating trumpet curves soon to become very popular) appears in the center of the upper triangular panel, but the Roman pelta motif, a linked pair of symmetrical spirals, is missing. The feeling of the Turoe stone is repeated in miniature on a beautiful bronze box from Cornalaragh (**19**).

In the magnificent gold torc from Broighter, County Londonderry (**21**) the development of the insular La Tène style in Ireland approaches its zenith, but the pelta is still not present. Apparent symmetry is more marked; the curving lines are narrower and the trumpet curves, their flared ends blocked by lentoids, have displaced the leaf motif of the Turoe stone. But if the Irish craftsmen were developing their distinctive style, they also continued to draw from the past. The background of the torc is roughened—not with a chisel or a rocked tracer—but with elegant compass-drawn arcs that mute the surface around the raised design.

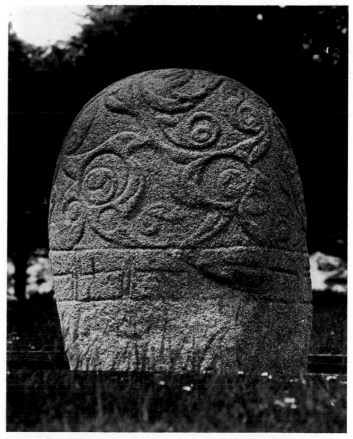

Fig. 11. Carved stone, about 50 B.C., Turoe, County Galway

In the decorated disc that surrounds the mouth of the Loughnashade trumpet (**22**) symmetry has been developed still further, and the pelta is clearly defined. If the mouth of the trumpet were filled with a boss, the design would be quite close in feeling to the central panel of the famous shield from the Thames at Battersea (Fig. 13). Only the ends of the great peltae to right and left recall the coiled terminals of the Turoe stone; soon these endings were to evolve into commalike shapes or birdheads. Thus by the first century A. D. all the components for the flowering of ultimate La Tène art were present. It is dif-

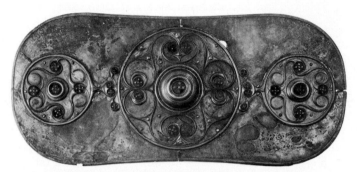

Fig. 13. Bronze ceremonial shield, about 50 B. C., near Battersea, England. The British Museum, London

ficult to date objects made in Ireland after the ultimate La Tène repertoire was complete; often it is possible only to say that they cannot have preceded the beginning of the Christian era. The design of the Monasterevin disc (**23**) is firmly based on the pelta, yet the high relief and the thickness of the curves suggest it is early, perhaps second century A. D.

The fragments of a once magnificent crown (**24**) with their spirals worked into stylized birdheads (originally with enameled eyes), represent ultimate La Tène art at its best. There is one element of surprise: a small cross in a circle appears at the base of one of the discs. Some insular La Tène and Romano-British material from Lambay Island, County Dublin, may have been brought there by refugees fleeing the Romans in the late first century A. D. The material includes a narrow gold band with crosses in circles arranged within and outside of a pair of sinuous lines. This pattern may be the inspiration for the cross in a circle on the crown. The balanced sinuous lines of the Attymon bridle bit (**26**) also recall the sinuous lines of the Lambay gold strip.

Glass was used in the Roman world in two ways: either blown or molded into vessels or colored and used to embellish metalwork. In the latter case it could be either pressed in a semimolten state into a deep recess or spread

Fig. 12. Schematic drawing of carving on Turoe stone. After M. V. Duignan

as a powder in a shallow recess and carefully heated. Both methods produced enamel. Glass vessels were not made in Ireland, but enamel came to be extensively used. The Romans also made *millefiori* glass by assembling rods of differently colored glass into bundles. Heating the bundle not only fused the rods, but the composite rod could then be drawn out, greatly reducing its diameter. A thin section of the multicolored bundle suggested a flower, and if slices were assembled side by side like the *tesserae* of a mosaic, the result looked like a flowerbed. Thus the form received its name. The Romans made great use of millefiori glass, and it continued to be made through at least the middle of the third century A. D. and in Northumbria until a century later. Like enamel, it probably came to Ireland in the second century A. D. and continued in use until the twelfth century.

The penannular brooch, used to fasten garments, also came to Ireland from the Roman world and became vastly popular. In its earliest form it was a simple ring of metal, gapped at one point, with a movable pin. The cut ends on either side of the gap were folded back and worked into animal heads with flat tops that invited decoration. When Christianity came, the cross, in reserved metal surrounded by enamel, appeared in this area. Sometimes the cross was made by arranging square slices of millefiori glass in a cruciform pattern (**28**), and in one instance the early Christian *Chi-Rho* symbol appears. What had begun as simple stylized motifs in these areas grew more elaborate until, in the eighth century, the heads were beaten down to, or cast as, thin, flat semicrescentic plates occupying as much as a quarter of the circle and lavishly decorated (**32**).

By the third century A. D. the Christian church was well established in Roman Britain, and missionaries crossing to Ireland brought a wide range of European skills and knowledge, as well as the Christian faith, with them. The old Irish language contains a substratum of pre-Patrician Latin loanwords including a vocabulary sufficient for Christian worship.

The fourth-century church appears to have existed mainly in the south of the island, and surely it is no coincidence that it was there that the first form of writing known in Ireland—the ogham script, a clumsy transcription of the Roman alphabet—first appeared.

By A. D. 400 there were so many Christians in Ireland that their spiritual supervision became a matter of concern to Rome, and in 431 Pope Celestine dispatched a mission "to the Irish believers in Christ." Patrick was the prime missionary; he is thought to have come from northwestern England, from a Christian area still under Roman influence. As a child he had been abducted to Ireland by a raiding party and had spent some years in slavery; later he escaped by ship and made his way back to England. After being urged in a vision to return as an evangelist, he received ecclesiastical training and came to Ireland as a bishop. He must have brought gospel books, psalters, and other works of devotion and scholarship with him, but no trace of these has been found.

The ship that carried the escaping young Patrick may have been en route to France; as early as the fifth century pottery from western France was being traded up and down the coast of the Irish Sea, and a hundred years later pottery from the eastern Mediterranean and North Africa was also available. It was along this same route that motifs from Coptic Egypt and Christian Africa reached Ireland.

The great rath at Garranes, County Cork, excavated some forty years ago by the late Séan Ó Ríordáin, was probably occupied at the beginning of the sixth century. No clearly defined Christian objects were found there, but two types of Mediterranean-style pottery were. The Garranes craftsmen also worked with millefiori glass, slipping the glass rods inside metal tubes to facilitate slicing into decorative discs. The most important find at Garranes

Fig. 14. Enameled bronze button, about A. D. 500, Garranes, County Cork. Museum, University College, Cork

was a small bronze button (Fig. 14) in the purest ultimate La Tène style; the metal was cut away from its surface to leave an elegant triskele of the utmost delicacy; the sunken field was originally filled with red enamel in a pattern that again recalls the top of the Turoe stone. Such a pattern might have been used to decorate an escutcheon on a Christian hanging bowl. These vessels (Fig. 15) were probably originally used as church lamps. The pagan Anglo-Saxons began to make serious inroads into England early in the fifth century and reached the Bristol Channel about A. D. 550, the northwestern coast about 615. They pillaged the Christian settlements, and looted hanging-bowl escutcheons (Fig. 20, p. 97) have been found in Saxon graves of as early as the mid-fifth century.

Continued pressure from the Anglo-Saxons forced many Christian refugees into Scotland, Wales, and Cornwall, and later on to Brittany; a few fled as far as northwestern Spain. Ireland too received contingents.

By about A. D. 500 the churches around the shores of the Irish Sea had undergone a drastic transformation as the bishops and their dioceses were replaced by abbots, ruling either over a single monastery or a chain of them. St. Enda led the way in the Aran Islands in the far west, and eventually not only did the mainland of Ireland fill with monasteries, but eremitic groups inspired by the

Aran example occupied the chain of islands along the western seaboard. Many of these islands, such as Inishmurray off Sligo, and Inishkeel near Portnoo in Donegal, still have important carved stones lying in or near their ruined buildings.

St. Columba (521–597) created a chain of monasteries in Ireland and Scotland. His house in Derry was founded in about 546; in Iona, 563. The sixth-century *Cathach,* a copy of the psalms in Latin, is traditionally attributed to St. Columba himself and is the oldest Irish manuscript. Interlace is absent from its decoration, but it contains all the other elements of early Christian art in at least rudimentary form. Some of its opening letters are built up of spirals and trumpet curves with lentoids in purest ultimate La Tène style (Fig. 16). Other initials incorporate the pelta and contain conjoined spirals (Fig. 17). Eastern Mediterranean influence also appears in the *Cathach:* another initial shows a fish or dolphin bearing a cross, a motif familiar in Coptic Egypt. On another page a worm-like animal appears with pointed jaws, the upper cocked up, the lower coiled in a spiral. This type of animal also

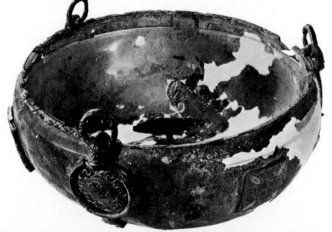

Fig. 15. Bronze hanging bowl with decorated escutcheon, about A. D. 650, buried at Sutton Hoo, East Anglia (England). The British Museum, London

Figs. 16, 17. Elaborated initials from the *Cathach,* about A. D. 550. RIA

appears in an early seventh-century Northumbrian manuscript, indicating that the *Cathach* scribe had contacts with the Saxon world.

Many more Christian missionaries left Ireland in St. Columba's footsteps. One of these, Columbanus, a man of particular energy, established a number of monastic centers on the Continent, as far afield as Bobbio, south of Milan, where he died in 615. His transplanted Irish monasteries at Luxeuil, St. Gall, and Bobbio became some of the most important cultural centers in western Europe during the early Middle Ages. Many of the manuscripts produced at these continental centers display a close relationship with Irish illumination and provide valuable evidence of active contacts between the Irish church and these centers.

The Book of Durrow, the first decisive statement of early Christian painting, is one of the oldest illuminated gospel books and begins the great series of insular manuscript illumination. Each gospel begins with a full-page evangelist symbol and a carpet page. The ornamentation of the manuscript is rooted in both Celtic and Germanic

art. One of the first carpet pages (*fol.* 3v, **27a**) displays a splendid ultimate La Tène panel covered with triskeles, trumpet curves, peltae, and birdheads. The whole composition is framed by a complicated ribbon interlace that rhythmically alternates red, green, and yellow.

Interlace emerged as the key element in the ornamental structure of insular illumination. The adoption and elaboration of this type of broad-strand interlace ornament in the Book of Durrow may have been inspired by the art of Coptic Egypt. Fifth- and sixth-century Coptic manuscripts and textiles display a system of ribbon interlace that bears a striking resemblance to the earliest type found in insular manuscripts. Whether this was transmitted directly from the eastern Mediterranean to Ireland or via Lombard Italy is not certain. In the Book of Durrow the early Christian archetype is completely transformed into a highly original work of great beauty.

Other types of interlace play an important role in creating a dynamic space on the illuminated pages of Durrow. In northern Europe Germanic artists elongated the body of an animal and then interlaced it, producing greater tension and activity. On *fol.* 192v of Durrow (**27d**) the carpet page frame comes to life with an endless procession of interlocking animals with extended biting jaws. Such a type of decoration is not confined to manuscripts but can be observed on the gold enameled clasps from the great Anglo-Saxon treasure at Sutton Hoo (Fig. 18), on which the linked procession of animals is quite similar. Based on the accepted mid-seventh-century dating of the Sutton Hoo treasure, the Book of Durrow must almost certainly be of the same age.

Interrelationships with other media are evident in the evangelist symbols. The symbolic lion of John (*fol.* 191v, **27c**)—which reflects a pre-Jerome order of the evangelists and their symbols—has been compared to quadrupeds on Pictish symbol stones. Likewise the highly abstract and cubic figure of the man, the symbol of Matthew (*fol.* 21v,

27b), is composed mostly of a type of millefiori inlay ornament transposed from metalwork (**28**).

The *Domnach Airgid* (**66**) has been altered through the centuries but was originally encased in bronze plates decorated with interlace and fretwork. The impression is remarkably similar to the Book of Durrow, and the two works must be contemporary.

At Fahan Mura in Donegal, less than ten miles northwest of St. Columba's original monastery at Derry, stands a splendid slab (Fig. 19) incised with a cross filled with broad-ribbon interlace on both faces; the pattern is different on each side, just as the pattern varies from page to page in the Book of Durrow. The slab bears a seventh-century inscription in Greek uncials on one edge.

The Book of Durrow is the first clear glimpse of the metamorphosis of pagan artistic forms for Christian purpose. The vital impact of these two opposing tendencies laid the foundation for the Golden Age of Irish art.

Although the Book of Durrow contains only one page of animal interlace, the motif rapidly gained favor with the early Christian craftsmen; it is seen to superb effect in the Book of Lindisfarne (Fig. 26, p. 101), which stands on the threshold of the eighth century, at the opening of the Golden Age.

Though it is conventionally dated to the eighth century, it is not impossible that the crucifixion plaque from near Athlone (**29**) was made in the last half of the seventh century, between the time of Durrow and Lindisfarne. Although ultimate La Tène motifs abound, animal ornament is absent; if animal ornament had been known to the artist, surely he would have employed it.

The ecclesiastical figure from Aghaboe (**30**) may be considered with the Athlone piece. Wear has removed much of the decoration, but ultimate La Tène details can be seen around the head, and the body is framed in interlace; again there is no sign of animal ornament. This piece may also precede the opening of the eighth century.

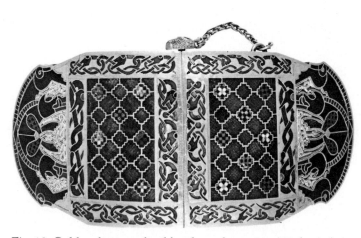

Fig. 18. Gold and garnet shoulder clasp, about A. D. 650, buried at Sutton Hoo, East Anglia (England). The British Museum, London

Fig. 19. West face of Fahan Mura slab, about A. D. 650, County Donegal

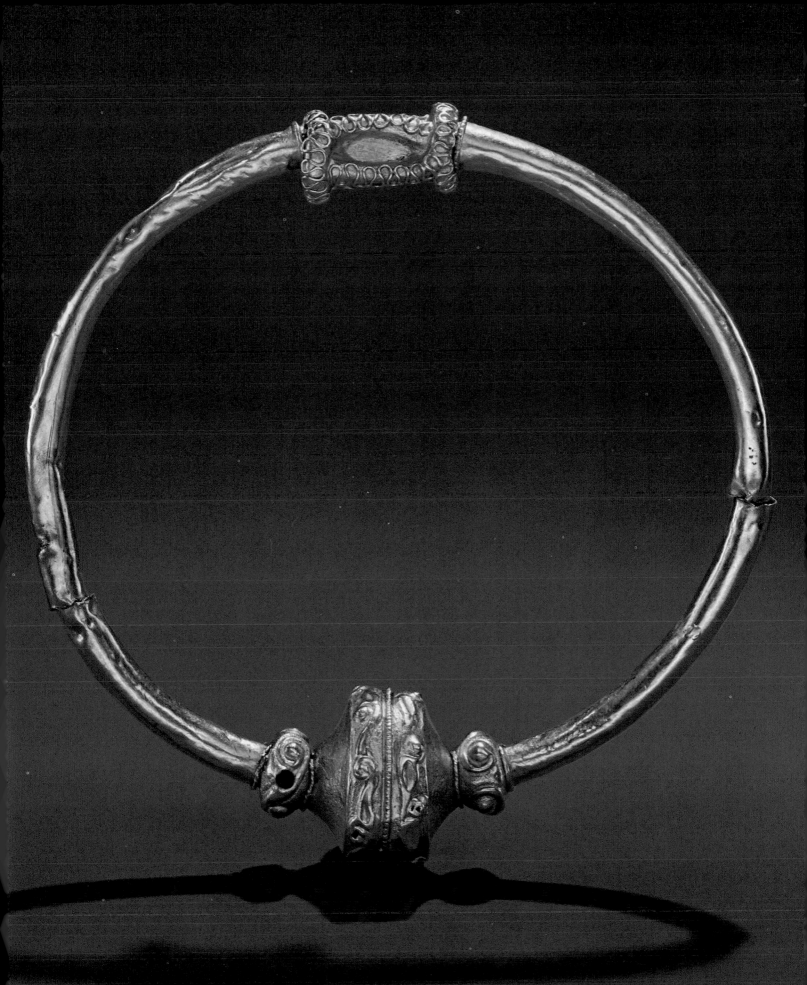

14. Gold torc, Clonmacnoise, County Offaly

15.
Twisted gold torc,
Clonmacnoise,
County Offaly

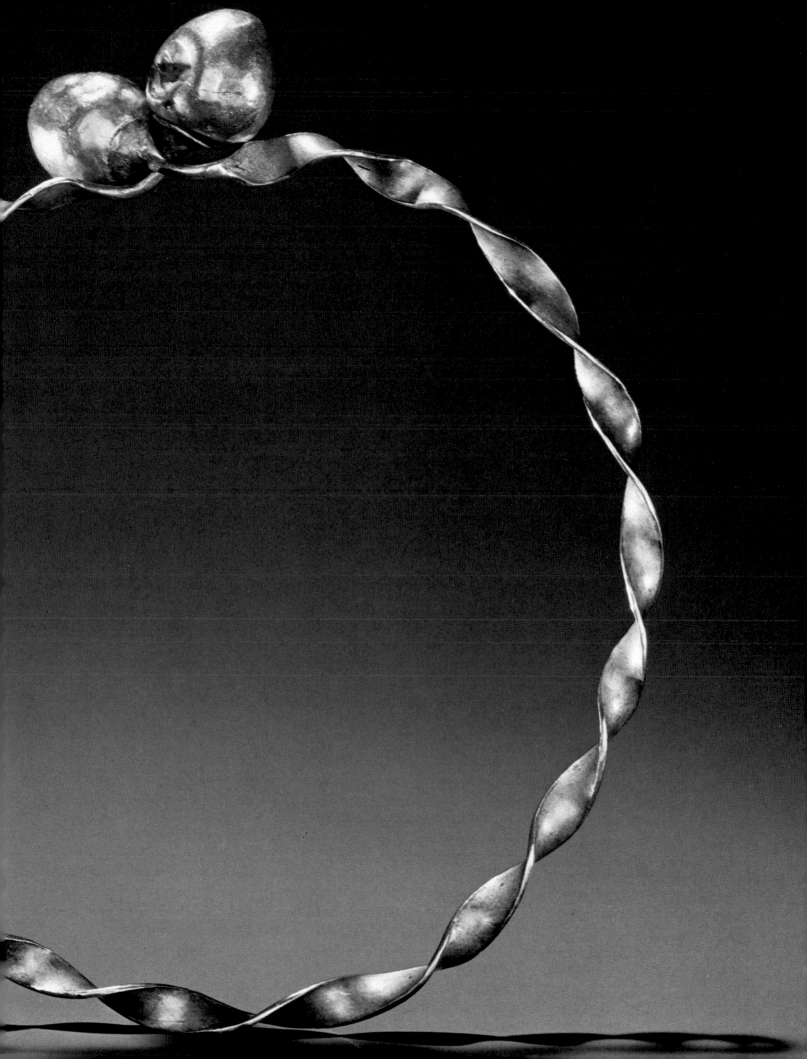

17.
Bronze scabbard plate,
Coleraine,
County Londonderry

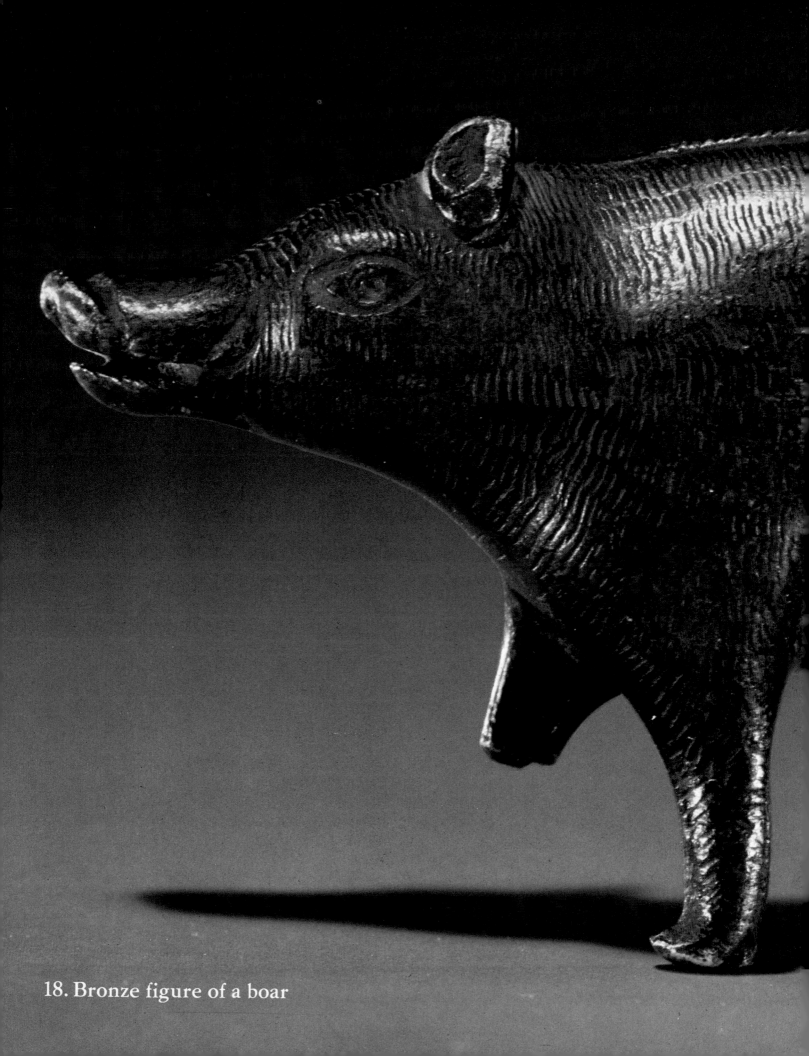

18. Bronze figure of a boar

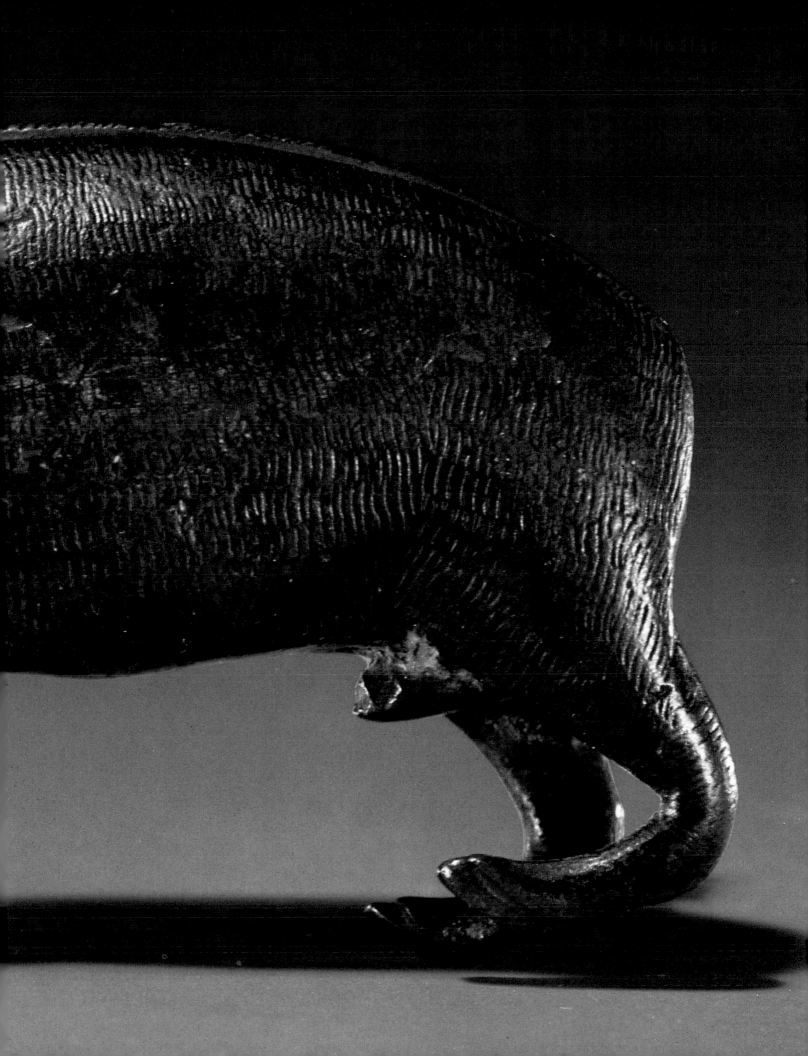

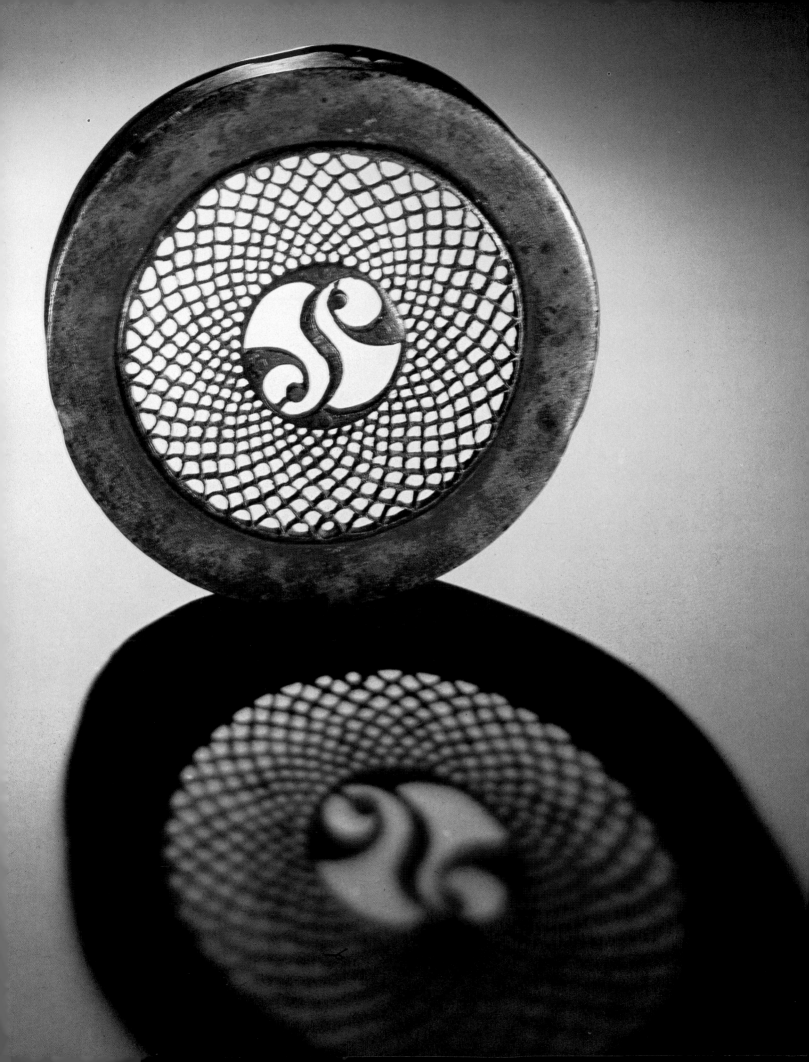

19. Bronze openwork boxlid, Cornalaragh, County Monaghan
20. Bronze cup, Shannon River near Keshcarrigan, County Leitrim

21.
Gold torc,
Broighter,
County Londonderry

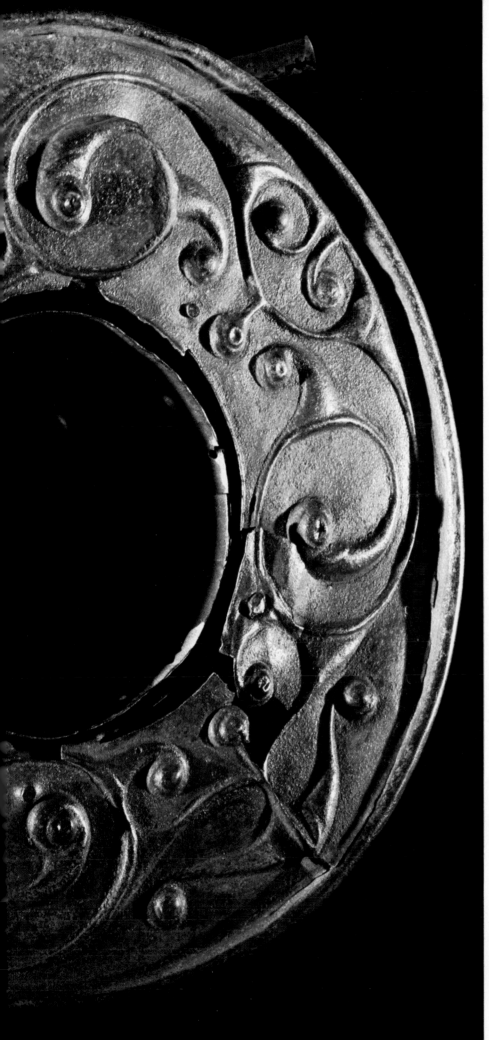

22.
Bronze trumpet,
Loughnashade,
County Armagh

23. Bronze disc, Monasterevin, County Kildare

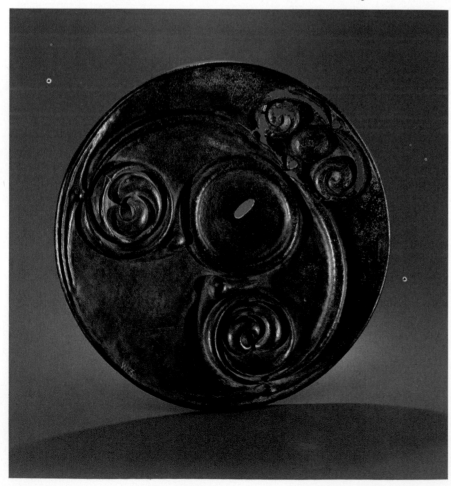

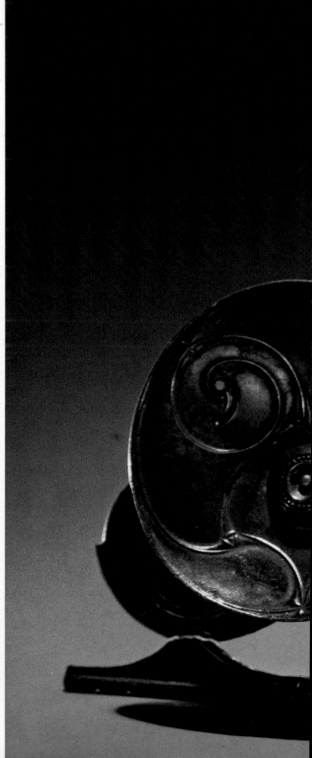

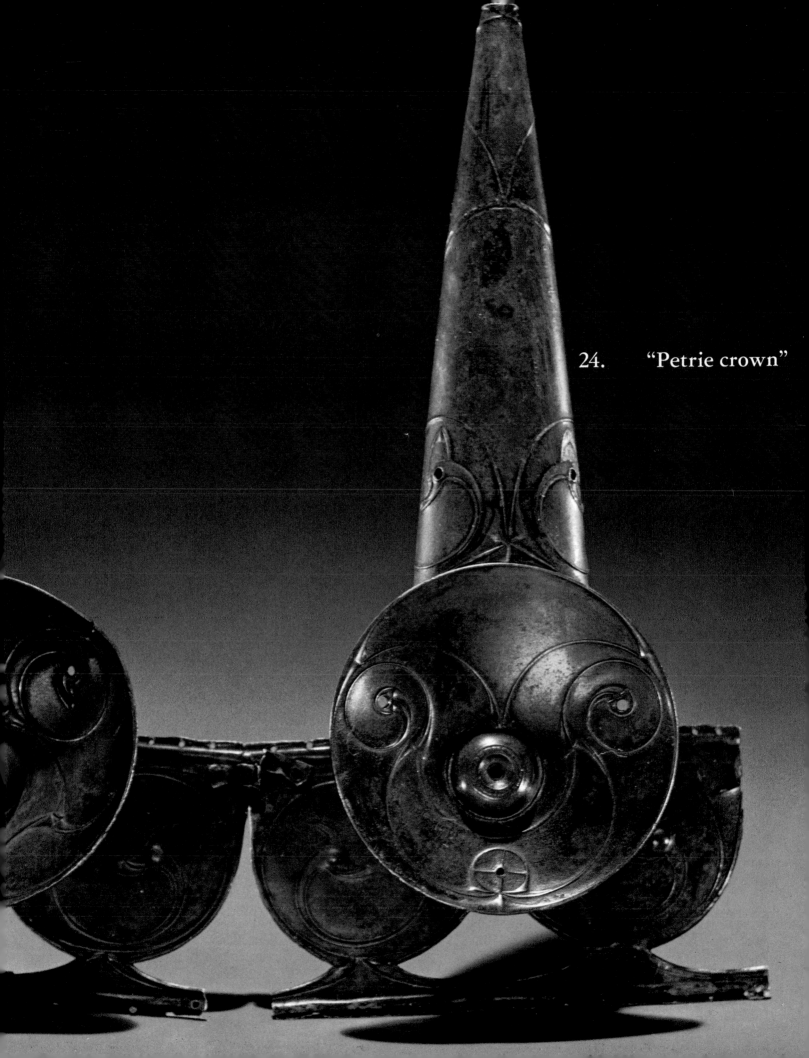

24. "Petrie crown"

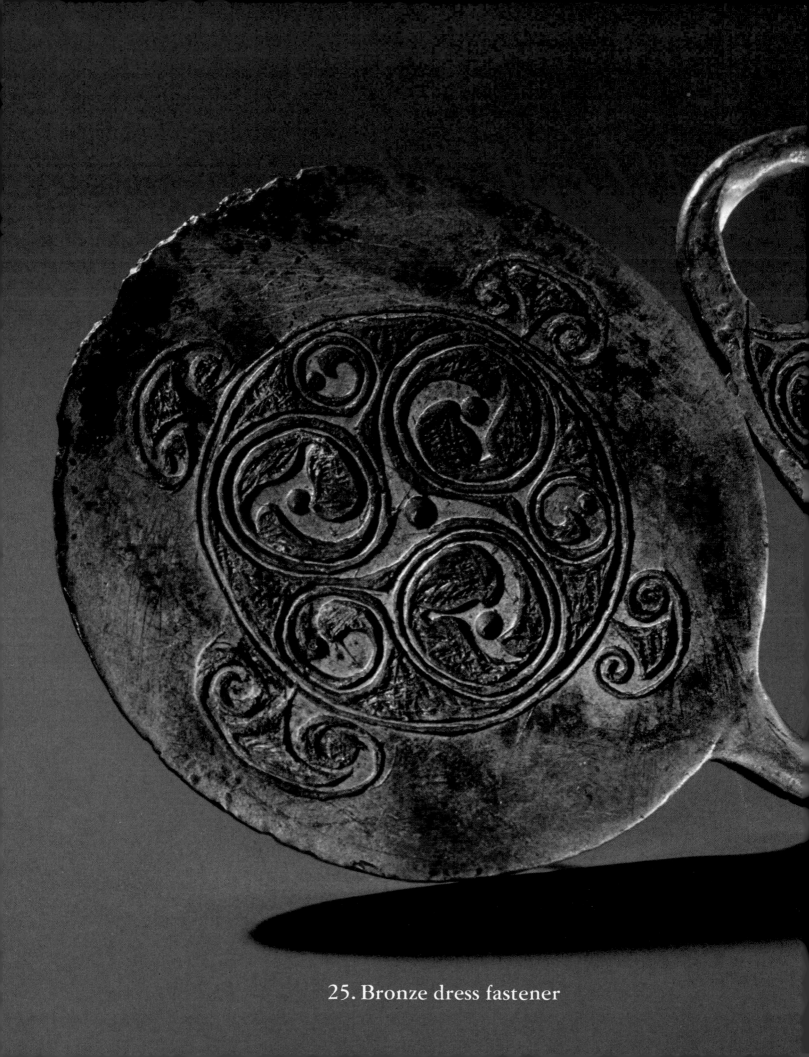

25. Bronze dress fastener

26.
Bronze snaffle bit,
Attymon,
County Galway

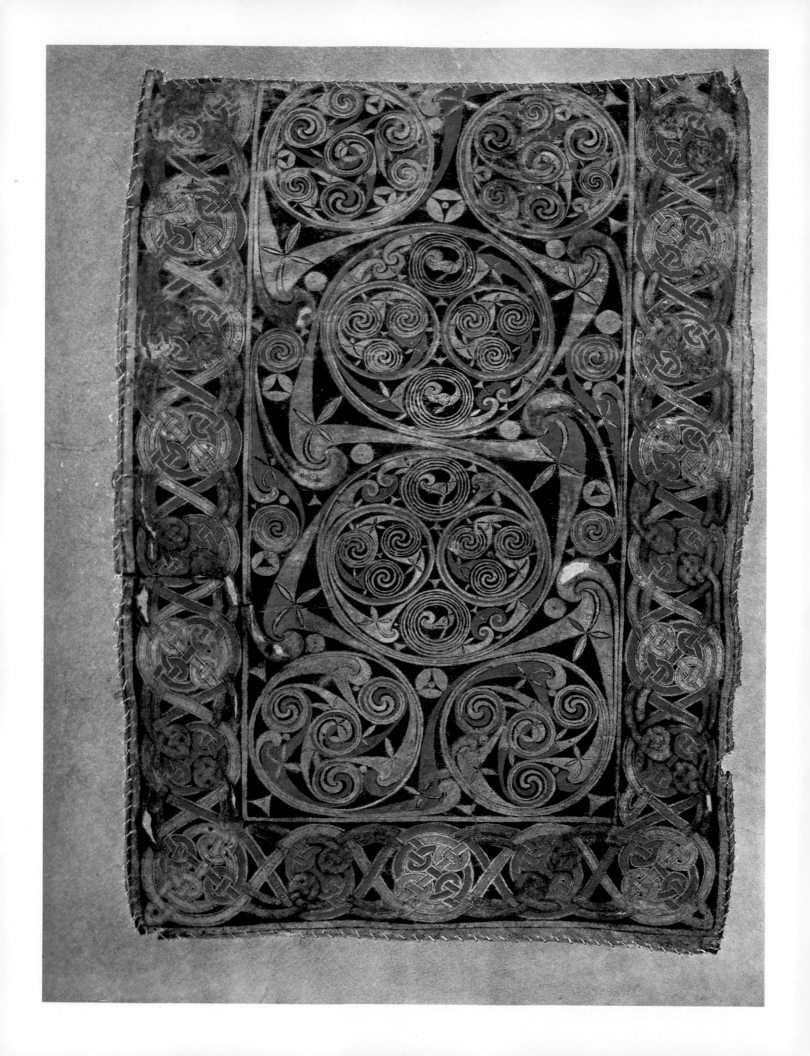

27a.
The Book
of Durrow,
fol. 3v:
carpet page

27b.
The Book
of Durrow,
fol. 21v:
the man,
symbol of
St. Matthew

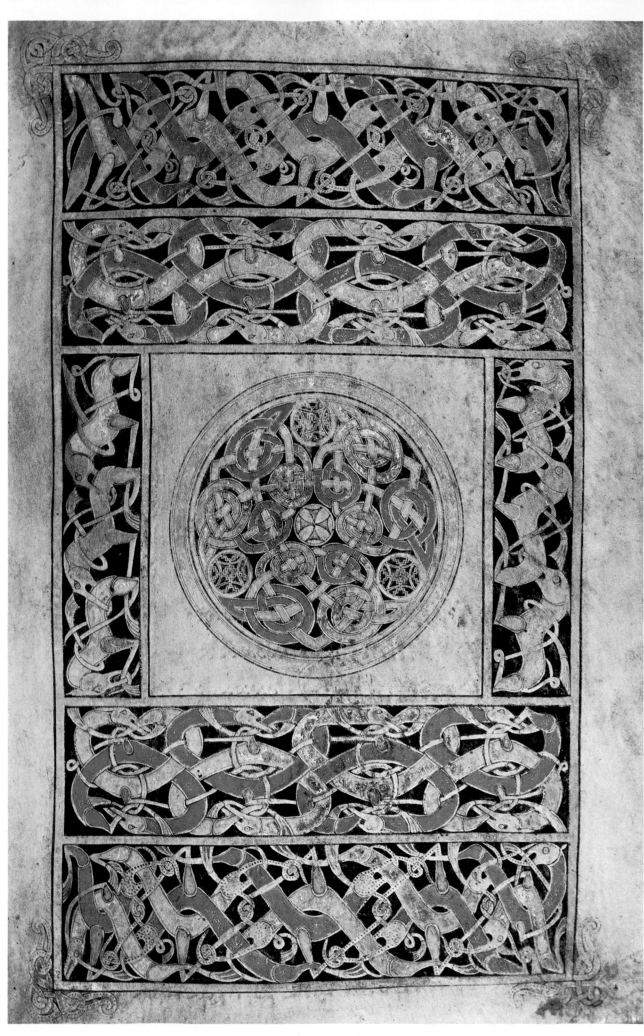

27c.
The Book
of Durrow,
fol. 191v:
the lion,
symbol of
St. Mark

27d.
The Book
of Durrow,
fol. 192v:
carpet page

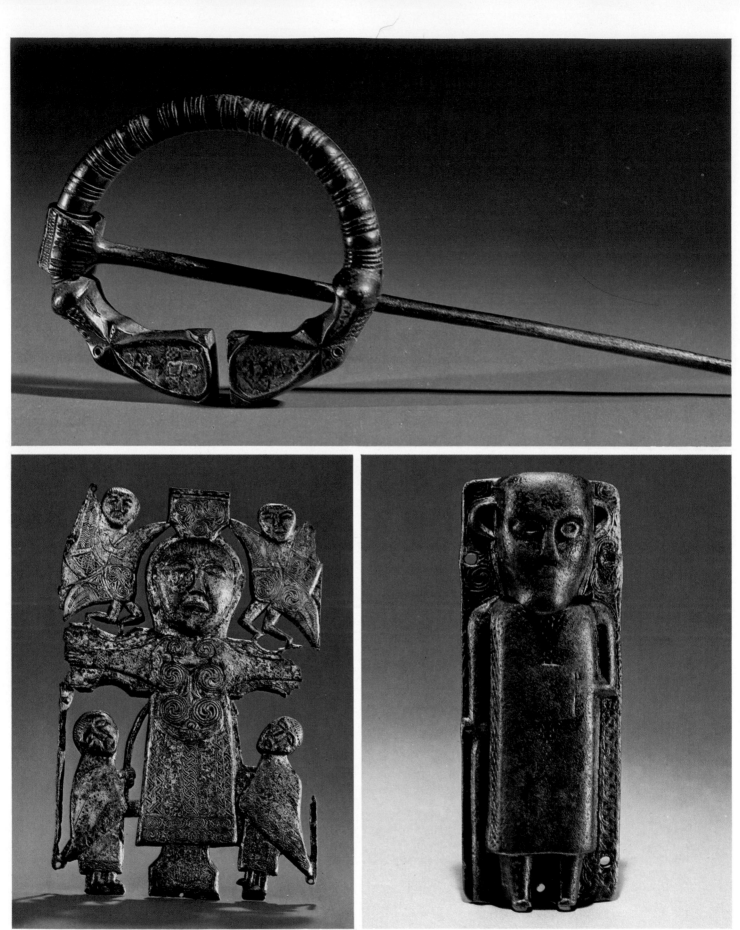

28. Penannular brooch
29. Bronze crucifixion plaque, near Athlone, County Westmeath
30. Bronze figure of an ecclesiastic, Aghaboe, County Leix

Catalogue

14. Gold torc
La Tène period, third century B. C.
D. 14.5 cm.
Clonmacnoise, County Offaly
NMI, W. 290

This beautiful ornament is essentially two half-hoops of hollow gold tubing linked at the back by a boxlike feature and at the front by a device that suggests a pair of opposed buffers on a railway train. The torc can be opened by passing the right-hand end of the hoop inside the front feature; a pin secured the joint when in the closed position.

The front feature has a cylindrical center, conical sides, and inflated terminal collars. The cylinder is divided by a central beaded ridge and has on either side a sinuous ridge ornamented with spiral knobs; the rest of the surface is stippled. The cones too are stippled; they are separated from the collars by a ring of soldered spiral wires. The collars are decorated with a series of short sinuous ridges that rise into prominent spiral knobs; stippling surrounds the decoration.

At the back the hoops have a terminal flange and then a constriction where they join the boxlike decoration. The box has circular ends and four concave sides; the edges are outlined in continuous twisted tubing and decorated in an elegant repoussé meander design, emphasized by a stippled background.

The gold contains platinum, and the collar is certainly an import, probably from northwestern Europe.
Bibliography: AEIA, p. 114, no. 174.

15. Twisted gold torc
La Tène period, third century B. C.
D. 14.5 cm.
Clonmacnoise, County Offaly
NMI, W. 291, R. 1550

This torc is very simply made: a narrow ribbon of gold with unthinned edges was twisted, and its ends were then worked into round rods which terminated in cones with recessed ends; hollow, olive-shaped knobs were fitted into the recesses.

Neck ornaments made by twisting a ribbon of gold were certainly known in Bronze Age Ireland (6), and this collar has usually been assigned to the middle Bronze Age. However, its rounded terminals, which are hollow, are quite different from those of Bronze Age specimens. Twisted gold ribbon torcs were also known in La Tène Europe, and a smaller specimen has been found in Ireland in a La Tène context.

According to Wilde this collar was found with **14**, which is certainly a La Tène import. This piece too is most surely of La Tène, and not of Bronze Age, date.

Bibliography: W. R. Wilde, *Catalogue of the Antiquities of Gold in the Museum of the Royal Irish Academy,* Dublin, 1862, pp. 47, 73-74, fig. 603.

16. Bronze sword hilt
La Tène period, first century B. C.
L. 13 cm.
Ballyshannon Bay, County Donegal
NMI, S.A. 1926: 47

This anthropoid bronze hilt, from a short triangular iron sword, is of a type well known from Britain and France, as well as farther afield. The strong reel-shaped grip moldings, the triangular chest panel, and the vestigial U-form limbs are typically French, though it has been claimed the hairstyle is barbaric rather than classical. A horizontal band, representing either fabric or coiled hair, runs across the forehead; lateral projections, meant as ears or decorative knobs, have been largely cut away. A circular hole has been drilled into the top of the hollow head.

It must remain a question whether this is an import or of native manufacture.

Bibliography: AEIA, p. 141, no. 229.

17. Bronze scabbard plate
La Tène period, second century B. C.
L. 45 cm.
Coleraine, County Londonderry
NMI, 1937: 3634

This long, narrow scabbard plate is made of thin bronze. For most of its length it is almost straightsided; the last quarter tapers to a narrow tongue. The present mouth is bow shaped and contains three rivets; the chape is missing, but there are two terminal rivet holes. The design is of repeated spiral units, pointing alternately right and left. A double (or treble) incised line begins in one margin; and a small hatched spiral appears above it. As the line nears the opposite margin, it rises vertically and expands into a crescentic hatched area; a small hatched spiral hangs down from the outer side of the crescent. The line narrows again, recrosses the plate, and curls down to end in two successive hatched lobes. The designs above and below are mirror images. The craftsman worked freehand with a rocked tracer, and the execution is uneven.

Other decoration is created by a chevron arrangement of parallel rows of faint hyphens, perhaps produced by light strokes from a round-ended punch.

After some use, the scabbard was remade, with the decorated face of the plate turned inside. The reversal of its curve was effected by punching round depressions along the margins. Well-marked longitudinal abrasions were produced by repeated removal and replacement of a sword. The scabbard was also shortened, as the present top interrupts the design.

About ten scabbards engraved in La Tène style are known from northeastern Ireland. This example is crudely executed, which suggests it is a native copy.

Bibliography: AEIA, p. 148, no. 249.

18. Bronze figure of a boar
La Tène period, probably first century B. C.
L. 8 cm.
NMI, W. 11

This is a beautifully modeled hollow figurine of a wild boar with a ridged back. Neat hatching indicates the body bristles; those on the snout are stippled; the tusks and the genitalia are emphasized. There are two grooved holes, one above the other on the rump. The figure has been brutally treated at some stage of its history; the right foreleg and the left forefoot are missing; the back legs have been bent forward and upward. The boar may have been mounted on a standard or a helmet.

Bibliography: TI, p. 45, fig. 27.

19. Bronze openwork boxlid
La Tène period, first century B. C.
D. 7.5 cm.
Cornalaragh, County Monaghan
NMI

This circular boxlid was cast with a wide, slightly raised circular disc of thickened metal at the center. Within this is a similar, smaller disc. The lid has a short cylindrical flange with a thickened rim at top and bottom.

An elegant openwork La Tène design was cut into the inner disc. Two low triangles with concave sides arise at opposite sides of its rim. From their apices a sinuous strap, which narrows at each end, spans the central space. Above and below the strap a spiral arm rises from the rim and curls around to parallel the strap; each arm ends in a small knob linked to the rim by a reinforcing bar.

The outer disc was pierced with neatly graded apertures, which decrease inward; they have rounded tops and converging concave undersides.

Four rivets on the central disc and four equally spaced holes around the outer circumference of the pierced design show that a circular plate, probably of gold, once lay below the openwork. The box is probably an import.

Bibliography: TI, p. 51, fig. 33.

20. Bronze cup

Insular La Tène period, first century A. D.
D. (at widest point) 15.5 cm.
Shannon River near Keshcarrigan, County Leitrim
NMI, W. 37

This beautiful vessel was probably shaped by first beating a sheet of metal to the approximate form required; the work was completed by spinning the metal—Roman style—against a mold. A groove runs around the top; it is defined by an incised line below and a decorated rim above. The rim has been elaborately worked: on the inside it is defined by a groove; the outside contains a gutterlike groove with a ridge of metal rising from its floor; the ridge has been crimped into a zigzag by blows on alternate sides from a circular or round-headed punch.

The seminaturalistic animal head that forms the handle also suggests Roman influence. It is a superb piece of casting; the eyes and mouth are open; the expanded lower lip connects the handle to the bowl.

Such bowls were well known in the Belgic area in southeastern England in the first century A. D., and this bowl is almost certainly an import.

Bibliography: AEIA, pp. 160-161, no. 273; E. M. Jope, "The Keshcarrigan Bowl and a Bronze Mirror-handle from Ballymoney, Co. Antrim," *Ulster Journal of Archaeology* 17 (1974), pp. 92-96.

21. Gold torc

Insular La Tène period, first century B. C.
D. 19.5 cm.
Broighter, County Londonderry
NMI, 1903: 232

This splendid torc, of two conjoined half-hoops with a decorative fastener, is most elaborately made. The design, based on two interlocked sinuous curves, was worked by repoussé technique down the center of the two flat sheets of gold, leaving broad, plain margins. The design proper ends in a pair of balanced leaf motifs; the intervening curves form trumpets with lentoid mouths and foliage. In the spaces between the opposed curves are separately clipped on bosses of relatively flat, well-defined spirals. At each end of the sheet was a line of raised pellets. The remaining surfaces were covered in fine concentric lines made by a compass set from a number of different centers. The decorated plates were rolled around a form and their edges soldered together in a tube. The tubes were then filled with resin or pitch and bent into hoops.

A bufferlike terminal was attached to the front end of each hoop. The first impression given by each terminal is that of a cylindrical drum with a broad flat depression running around it. The depression on the left drum is decorated by a freestanding band of gold covered with transverse ridges composed of three pellets side by side; the depression on the right drum is now empty. A rectangular area with folded edges interrupts this depression at the back.

The end of each drum bears a circular depression. On the left drum this area is decorated with radiating ridges; a low cylinder projects from the center, and this carries a flat T-shaped tenon.

A waisted cylinder, in three parts, rises from the inner margin of the groove in the right drum. The right-hand part is joined to the wall of the groove; the central part is

a concave ring; the left-hand part terminates in an everted collar. It is free to rotate against the central ring, and the gold plate that caps it carries a circular depression with a slit in its floor into which the tenon in the left-hand drum could be inserted; if the end of the cylinder were then rotated, the catch was secured.

Possibly a second decorative feature linked the two hoops at the back, or there may have been a simple joining tube inserted in the hoop ends.

Bibliography: AEIA, p. 167, no. 289; TI, p. 52, pl. 6.

22. Bronze trumpet
Ultimate La Tène period, first century A. D.
L. 127 cm.
Loughnashade, County Armagh
NMI, W. S.

The tube of this curved trumpet was made by rolling the edges of a sheet of bronze and riveting them to an interior strip. A ridged ring is placed about halfway down the tube, and below this the tube is cylindrical, ending in a simple rolled mouthpiece. Above the ring the tube expands slightly to an elongated conical form.

The mouth is decorated by a rimmed circular bronze disc. The central perforation is reinforced by a short length of bronze tubing slipped inside the mouth of the trumpet. The design, executed in repoussé, is rigorously controlled; the decorated quadrants are virtually mirror images of one another. The wiry curves are based on peltae of various sizes and flexures, and the tendrils end in spiral bosses in high relief. The larger spirals terminate in subtriangular, curvilinear forms (Duignan, 1976, fig. 3) reminiscent of the Turoe stone (Fig. 12). Trumpet curves make only a modest appearance. A date early in the Christian era would seem appropriate.

Bibliography: AEIA, p. 147, no. 246; TI, p. 52, figs. 35, 37; M. Duignan, "The Turoe Stone; its Place in Insular La Tène Art," in *Celtic Art in Ancient Europe; Five Protohistoric Centuries,* London, 1976.

23. Bronze disc
Ultimate La Tène period, second century A. D.
D. 30.5 cm.
Monasterevin, County Kildare
NMI, W. 3

This cast bronze disc was decorated by hammering. It is slightly concave and has a rolled-back rim. Over most of the surface the hammermarks have been smoothed down by filing. An eccentric circular depression (pierced by an off-center elongated hole) bears unsmoothed hammermarks. The depression is bordered by a circular rounded ridge from the top of which raised curved ridges sweep outward and downward; they end near the edge of the disc at the junction of two opposed trumpet curves. The curves are united by a circular boss, not by the usual lentoid feature. At each side a tight spiral ridge ending in a comma in high relief swings in from the junction; the remaining space inside the spiral is filled by a crescentic device in high relief. Opposed trumpet curves with intervening spherical bosses link the spirals to the central ridge. A smaller design, very similar in feeling, lies above the depression; here the inturned spirals are separated by a raised circular boss.

The design shows a certain stiffness due to the conflict between the free-flowing curves of the older La Tène style and the formality of the Roman pelta, a motif which, once introduced, recurred again and again in ultimate La Tène art. A date in the second century A. D. is suggested.

Bibliography: ECI, p. 247, pl. 1.

24. "Petrie crown"

Ultimate La Tène period, first century A. D.
Bronze with enamel
H. 15 cm.
NMI, P. 869, 870

These intriguing fragments of what could have been a crown, may perhaps continue to be described as the "Petrie crown," in honor of George Petrie, the great antiquary in whose collection they first appeared. In such a crown circular discs would have been mounted on a hoop or band of metal, with conical horns rising from behind the discs. Small perforations along the edges of the hoop suggest that fabric may have been stitched to it. All the pieces are decorated in curvilinear low relief. The design was produced by cutting away metal and not by casting or hammering.

Along the hoop is a row of spiral designs, in contact along the upper margin but curving away from one another below. These are composed of trumpet curves closed by lentoids. Within the design gradually diverging spiral curves terminate in stylized birdheads with sharply reflexed combs. Similar trumpet curves tangential to the lower margin support the design, and the area between the curves and the design has been cut away.

The disc attached to the horn is concave and carries a central boss with a concave setting for a bead. Around the setting a circle of pellets is contained within rims. The circumference of the disc is divided into three roughly equal parts, each occupied by a bordering double-ended trumpet curve. At bottom center a small cross-in-circle lies between crescentically arranged trumpet curves. From the apices of the crescent trumpet spirals spring outward to create a pelta that terminates in expanded mouths with lentoids joined by a semicircular rim. A perforation for a setting lies inside the rim. Trumpet curves

sweep back tangentially from the rim of the disc above the spirals to touch the top of the central boss, itself surrounded by a circular trumpet-ended ridge.

A similar design occupies the second disc, but here the circumference is not equally divided, and the ends of the lateral spirals do not close around the holes for the settings; but further short trumpet curves radiate from the setting, possibly to suggest a birdhead. The central boss contains a stud of red enamel.

A short concave cylinder, one centimeter in diameter, joins the disc to the band. The base is crudely riveted to the band, and the top is brazed to the disc.

The horn was created by folding a sheet of bronze to the required shape and securing the edges by riveting them to an underlying strip of copper. Very sophisticated metalworking was required to create the complex double curvature at the base of the horn. The design was cut on the horn after it was in position, as the cutting is carried through the rivet head. From the point where the horn is seen above and behind the disc, trumpet curves diverge. An oval curve runs upward and outward to meet a second junction of trumpet curves on the flank of the horn, and from this junction another curve runs downward and inward before rising to end in a beautiful birdhead in an oval frame. In front of the eye the beak is built up of two trumpet curves, and two more frame the prominent comb, which is vertically ridged. From the lateral junction of trumpet curves, further curves sweep around the back and rise to the top of the horn, which ends in a circular beaded border; the tip is missing. The base of the horn is fitted over a segment of a hollow sphere, and this is pinned to a strap crudely brazed to the back of the disc.

The symmetrical peltae of the disc suggest a late date.

Bibliography: AEIA, p. 159, no. 270; IA I pp. 67, 71, 207, pl. 11; M. J. O'Kelly, "The Cork Horns, the Petrie Crown and the Bann Disc," *Journal of the Cork Historical and Archaeological Society* 61 (1961), pp. 1-12.

25. Bronze dress fastener
Ultimate La Tène period, sixth century A. D.
L. 13 cm.
NMI, W. 492

This piece consists of a poorly cast flat disc with an S-shaped projection, alternately flat and round in cross section. It is decorated on only one side and was presumably used as a dress fastener; the curved stem was meant to slip through slits in a garment.

The design was produced by cutting metal away; the depressions created were filled with enamel. On the disc a circular groove and ridge define a central area; four regularly spaced peltae lie outside the groove; one is markedly larger than the others. Within the circle the arms of a triskele are spirally coiled and end in birdheads with narrow beaks and reflexed combs. Smaller spirals ending in comma-shaped thickenings spring from the triskele. In the center of the commas, in the triskele, and at the eye of each birdhead are small depressions for enamel.

The projection is oval in section where it leaves the disc; it was flattened and recurved and then expanded into a subrectangular broad area. This area carries within an asymmetrically pointed oval frame two tightly coiled spirals that end in heavily developed commas pointing toward one another. Beyond the rectangle the projection becomes circular once more, curved again, and then forms a narrow flattened strap. The metal was cut away from the strap surface to leave irregularly arranged small triangles once surrounded by enamel.

This piece is almost certainly of local manufacture and is almost impossible to date. It was probably made in the sixth century A. D.

Bibliography: IA I, p. 68, pl. 13.

90

26. Bronze snaffle bit
Ultimate La Tène period, possibly sixth century A. D.
L. 32 cm.
Attymon, County Galway
NMI, 1891:9

Irish snaffle bits are composed of five conjoined pieces: two side rings, two side links, and a center link. A find at Attymon produced two snaffle bits and two Y-shaped decorative pieces, the harnesses of a pair of horses.

The center link is a figure-eight toggle. In some bits the side links are simple bars, but in this example, which represents the Irish bit at its highest development, the inner hole lies at the center of a flat disc, which is set off from the rest of the bar by a decorative collar. The side link is curved and faintly keeled, and instead of stopping just outside the horse's lips, it protruded beyond the sides of the mouth. It is decorated with an elongated oval raised lobe, which lies on both sides of the keel, and is elaborated below into a pair of outwardly facing conjoined peltae with a terminal lobe below them.

The symmetry of the design and its peltae suggest the bit was made late in the ultimate La Tène period.

Bibliography: IA I, p. 11, pl. 4; R. Haworth, "The Horse Harness of the Irish Early Iron Age," *Ulster Journal of Archaeology* 34 (1971), pp. 26-49.

27a-d. The Book of Durrow
Early Christian period (first phase), mid-seventh century
Vellum
H. 26 cm.
Library, TCD, 57

The Book of Durrow is too large to be conveniently portable and was probably intended for use at an altar or on a lectern. It shows the first incontrovertible blending of Irish and Germanic (or Saxon) influences—the style often

known as Hiberno-Saxon.

The book is traditionally associated with Durrow, County Offaly, where an important Columban monastery was founded in A.D. 553, and was probably produced in a scriptorium there. However, strong Saxon influence is evident in the style of the animal interlace on *fol.* 192 v (**27d**), which closely resembles that on some of the jewelry (Fig. 18) discovered at the seventh-century Saxon burial site of Sutton Hoo in England. This striking similarity has led to the suggestion that the book was made in Northumbria.

It contains the four gospels, the canons of concordance, and some other material. The script is Irish majuscule; the decorated pages are painted in red, yellow, green, and deep brown against a black background or the reserved vellum page.

Some pages open with expanded initial letters, often surrounded by red dots; others are pages of pure decoration (carpet pages), and at the opening of each gospel appears the symbol of the evangelist in a style that shows influence from Pictish Scotland. On many pages designs of ultimate La Tène spirals and panels of Mediterranean broad-ribbon interlace are subtly and dramatically organized. Germanic animals appear only on one page.

Bibliography: IA I, pp. 166-175, pls. 31, 55, 57, 60, 61, E; A. A. Luce, G. O. Simms, P. Meyer, and L. Bieler, *The Book of Durrow* 2 vols., Olten, Lausanne, and Freiburg, 1960.

28. Penannular brooch

Early Christian period (first phase), sixth century
Bronze, with added enamel and millefiori glass
L. 18 cm.
Library, TCD

This is an early penannular brooch with only slightly expanded terminals. The head of the pin was formed by beating the top out to a flat ribbon, decorating it, and then rolling it around the ring; the front is decorated with a V-shaped device; there is a strap across the top; the back bears incised parallel lines. The pin is plain and tapers to a point.

The ring is round in section; a circumferential groove separates a decorated front from a plain back. On the front radial grooves in groups of three are separated by plain spaces the same width as the group. The terminals have been cast in the form of flat-topped stylized animal heads, which turn back to devour the ring. The sides of the muzzles carry V-shaped decorations. The straight edges that define the gap between the terminals also form the back of each triangular animal head. At the top of the head is an oval area, filled with red enamel, on which slices of millefiori glass are arranged in the shape of a cross. The slices were cut from three different millefiori rods.

Bibliography: E. C. R. Armstrong, "Four Brooches Preserved in the Library of Trinity College, Dublin," *Proceedings of the Royal Irish Academy* 32, C (1914–1916), pp. 243-248.

29. Crucifixion plaque

Early Christian period (first phase), late seventh century
Bronze, formerly gilded
H. 21 cm.
Rinnagan, St. John's, County Roscommon, near Athlone,
 County Westmeath
NMI, R.554

This magnificent gilt-bronze crucifixion plaque was found at Rinnagan, a promontory at Lough Ree on the Shannon River near Athlone—a site occupied since antiquity. The plaque has numerous small marginal holes, which suggests it was originally pinned to wood and served as a book cover.

The central figure of Christ dominates the design. The nailed feet point downward. The body is clothed in a long-sleeved garment with interlace at the wrists; the garment has a broad basal hem, decorated with an ultimate Le Tène design; the sides carry a band of fretwork, and a band of two-stranded interlace runs down the center. A heavy design, composed of three ultimate La Tène belt buckles in a cluster, adorns the chest. The cross, seen behind the figure, is plain, except where it projects above the head; there it is ornamented in ultimate La Tène style.

The spongebearer and lancebearer appear on either side of Christ; the clothing of the latter is decorated in ultimate La Tène style.

The attendant angels are primitively rendered with arms, legs, two pairs of wings, and spiral designs at the point at which the wings are attached. But the wings appear to spring from the underside of the bodies, and only one arm, clutching a short sword, can be seen. The wings are hatched in a conventional way; the rest of the ornament is in ultimate La Tène style.

The great gospel books probably once contained a representation of the crucifixion, and it seems very likely that the creator of this plaque had a manuscript illustration before him as he worked. The absence of animal ornament suggests an early date, perhaps the late seventh century.

Bibliography: CAAI, pl. 28; IA I, p. 114, pls. 46, 48; TI, pl. 32.

The figure, in high relief but heavily worn, is set in a decorated rectangular frame pierced by four irregularly placed holes. It is said to have formed part of a shrine of St. Canice of Kilkenny and could conceivably have been the endplate of a narrow house shrine.

The head is large and strongly molded, with enormous ears; a decorated band runs around the forehead; the top of the head also bears decoration. The tubular garment was covered, except at the shoulders, by incised interlace, of which traces remain under the chin and on the sides; fingers can be seen on the hand that holds the staff; the booted feet point outward.

The head and shoulders are set against a background of ultimate La Tène design. A scalloped design borders the upper arms. Interlace and fretwork are seen below the arm that holds the book. A herringbone design appears between the legs; the rest of the border carries double-strand interlace.

The figure cannot be later than the eighth century; the absence of animal ornament suggests it may even have been made in the late seventh century.

Bibliography: CAAI, p. 145, pl. 18; IA I, p. 114, pl. 47; TI, fig. 45.

30. Figure of an ecclesiastic
Early Christian period (first phase), late seventh century
Bronze, formerly gilded
H. 13 cm.
Aghaboe, County Leix
NMI, R. 2945

3 The Christian Triumph: The Golden Age
Liam de Paor

He saw a woman at the edge of a well, and she had a silver comb with gold ornament. She was washing in a silver basin in which were four birds of gold, and bright little gems of purple carbuncle in the chasing of the basin. She wore a purple cloak of good fleece, held with silver brooches chased with gold, and a smock of green silk with gold embroidery. There were wonderful ornaments of animal design in gold and silver on her breast and shoulders. The sun shone upon her, so that men saw the gold gleaming in the sunshine against the green silk. There were two golden tresses on her head, plaited in four, with a ball at the end of every lock.

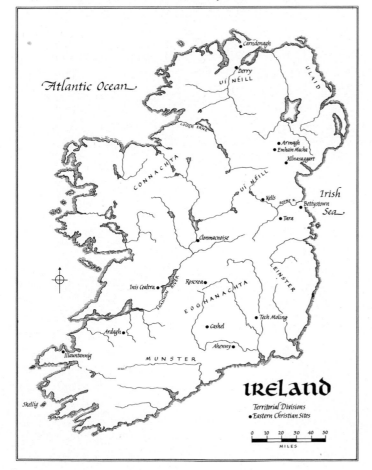

IRELAND

Territorial Divisions
• Eastern Christian Sites

0 10 20 30 40 50
MILES

The storyteller's imagination, in this description of Etain from the saga "The Destruction of Da Derga's Hostel," serves to introduce the styles of the Golden Age of the eighth century. About A. D. 700 our written records begin to give for the first time a fairly full picture of Irish society and a glimpse of Irish imagination and its visual sense. It was a society nurtured on stories of a heroic past but itself reflecting changes that had been rapid and profound over a period of a hundred years and more.

At the beginning of the eighth century Ireland had about one hundred fifty petty kingdoms. Each of these had its own ruler, but they were not fully independent; they were subordinate to overkings. They paid tribute to these and rendered them some military service. In return the overkings made formalized gifts. Within each little kingdom, or *tuath* (a word originally meaning "people"), society was graded from the king down through various degrees of freemen to the serfs and slaves. The whole population of such a tribal political unit would, on the average, have numbered only two or three thousand.

The noblemen were farmowners, whose wealth was mainly reckoned, however, in numbers of cattle—the chief scale of value and medium of exchange. They had clients, to whom they lent stock and land and from whom in return they received support; the way to power lay in the support obtained from large numbers of clients.

The ancient laws had been written down by A. D. 700. They played an important part in legal and property transactions. For the purpose of such dealings, the king was just one land- and propertyholder among others. Property was privately owned, but its absolute disposal was vested not in the individual but in his extended family. There is some evidence to suggest, however, that the system worked in such a way as to concentrate wealth and power in fewer and fewer hands.

A man or woman had no practical, or enforceable,

rights except within the context of his or her own tuath. A significant exception was made of the special class of persons who had certain defined intellectual or artistic skills. This class included poets, judges, historians, and people who worked in precious and semiprecious materials and in due course was extended to include the Christian clergy. Such people were free to travel from tuath to tuath and were assured of protection. Thus in spite of the very large number of petty political units, early Ireland was unified in law and culture. A common written form of Irish, in use from Munster in the south to the Irish colonies in Scotland in the far north, ignored dialect differences in the vernacular speech and provided a means of transmitting ideas and tradition.

One of the functions of the ruler was to patronize poets and musicians. The king, originally a holy man, represented and personified his tuath in external relations—in war, in diplomacy, and (in pagan times at least) in dealings with the otherworld. Artificers worked for him, and, in a rigidly graded society, he, like the nobles of less degree, showed his status in his personal display.

The influence of Rome on the development of early historic Ireland was both wide and profound. In about A. D. 300 the styles of personal ornament worn in the military provinces had begun to be copied and adapted in Ireland. By the full historic period, the costume of the upper classes was one derived not from Celtic central or western Europe but from the Mediterranean. It consisted essentially of the two garments mentioned in the description of Etain: a dyed woolen cloak, often embroidered or otherwise embellished at hem and angles, worn over a linen (not usually silk) tunic gathered in at the waist. A buckle (like the costume style itself, a non-Celtic item) to fasten the girdle and a pin or brooch to secure the cloak provided focal points of display. Men and women, lay people and clerics appear to have worn essentially the same costume, but variations of color, embroidery, and jeweled ornaments indicated status. There is some evidence to suggest that the lower orders may have continued to use a form of dress derived from the trousers and jacket or blouse of prehistoric central Europe, but little is really known about the lower orders.

External influences may have stimulated the political upheaval that began about the fifth century, at which time Ireland was, apparently, under the dominance of several great tribal alliances, or "nations." All of the north was under the sway of a people called the Ulaid (hence the later "Ulster"); they were of La Tène background with an aristocracy of warrior-charioteers whose chief center was at Emhain Macha. Their downfall echoes through early Irish saga, especially the great heroic tale known as "Táin Bó Cuailnge." South of the rivers Boyne and Erne other groups dominated—the Laigin (hence "Leinster") across the midlands to the Shannon River, and further south other groups such as the Domnainn. All this was changed in the sixth and seventh centuries. New conquering dynasties and overkingdoms broke up the old pattern forever and gave a new political shape to the country which was to last for hundreds of years. Possibly these new dynasties derived from Irish mercenaries in Roman service returning to Ireland when Rome lost its administrative grip on the western provinces of the Empire. Their revered ancestral figures, however, are associated with freebooting warfare and raiding on these same provinces.

Two dynasties, the Uí Néill in the northern half of Ireland, and the Eoghanachta in the southern half, divided most of Ireland between them. Possession of the sacred hill of Tara was the symbol of royal rule in the north; in the south the equivalent site was the rock of Cashel. In the eighth century one of the Cashel kings made a first attempt to dominate the whole island by taking and holding for a while the rival center of Tara.

The most important continuing Roman influence was

of course Christianity, which had come to Ireland from the Gaulish and British provinces. The big change that had occurred, mainly during the seventh century, was the accommodation of Christianity to Irish society. The fifth-century missionaries had brought with them a church organization molded on the pattern of the Roman Empire. There, the overseer of the regional Christian community—the bishop—had as his area of jurisdiction a *civitas*. In Ireland the missionaries found a somewhat forced equivalent in the tuath. They formed islands of Latinity, copying in manuscript the necessary gospel books and psalters, attempting to be Roman in dress, hairstyle, and demeanor. But when the barbarians invaded the western Roman Empire, these missionary communities became isolated from the mother churches in Gaul and Britain.

Then the new Christian enthusiasm for renunciation of the world, which stemmed from Egypt and Syria in the form of what we call monasticism, swept into Ireland. Not bishops, but presbyters, began founding communities to follow stern and ascetic rules of life. At the same time, the aristocratic world of Celtic Ireland, with its roots in the prehistoric, non-Roman Iron Age past, adopted Christianity. It did so largely on its own terms and with many of its own ancient values and traditions intact. The upper orders, for example, continued to practice polygamy until Gaelic Ireland came to an end in the late Middle Ages.

The church was transformed. By the eighth century, the episcopal system of organization established by the fifth-century missions had been submerged. Federations of monasteries dominated the ecclesiastical scene. Many of the monastic churches soon came under the wing of powerful kingroups and dynasties. Alienation of land and property from an extended kingroup through gifts to the church was circumvented by the device of appointing a member of the kin as head of the monastery. Then, the steady accumulation of land and property under monastic control tended to reinforce both the identity and the power of the extended kingroup. Laymen, "heirs" of the holy founders, ruled many ecclesiastical settlements and monastic alliances by hereditary right, with large lay communities of farm families and artificers as their clients. Sanctuary within the ecclesiastical *terminus,* protected by wonder-working relics and by the power of holy founders, whose miracles were retailed by the hagiographers, provided refuge and immunity for fugitives or outlaws and safekeeping for valuables. These were the basic requirements for the growth of towns and the cultivation of complex arts and crafts.

Of one of these centers, Kildare, the seventh-century writer Cogitosus says: "It is a great metropolitan city. Within its outskirts, whose limits were laid out by St. Brigid, no man need fear any mortal adversary or any gathering of enemies; it is the safest refuge among all the enclosed towns of the Irish. The wealth and treasures of kings are in safe-keeping there, and the city is known to have reached the highest peak of good order."

This was the economic basis for the production of such splendid works as the gospel book of Kildare, now lost, which was described by Giraldus Cambrensis at the end of the twelfth century in terms that might appropriately be applied to the Book of Kells (**37/38**): "Fine craftsmanship is all about you, but you might not notice it. Look more keenly at it and you will penetrate to the very shrine of art. You will make out intricacies, so delicate and subtle, so exact and compact, so full of knots and links, with colors so fresh and vivid, that you might say that all this was the work of an angel, and not of a man."

The churches must, in the sphere of art too, have been centers of renewed Romanization, reinforcing influences already manifest in personal adornment, through the importation of ecclesiastical trappings. Bishop Tirechan in the seventh century wrote that the fifth-century bishop

Patrick had with him a bronzesmith, one Assicus, who made rectangular casings for books, of which the author himself had seen three, on the altars of the churches of Elphin, Armagh, and Saul.

The core of the monastery was the small religious community of celibates, including bishops, who had high status and (often) piety but lacked authority or jurisdiction. But many of the larger establishments were thoroughly secular in their general character by the eighth century; they were centers of wealth and patronage in an increasingly sophisticated and self-confident society.

Apart from the ecclesiastical centers there is evidence (from excavation as well as from written sources) of the practice of metal- and glassworking, enameling, and other crafts on secular sites. The lords of the land built raths for themselves; these were well-protected enclosures of earth and stone, sometimes with timber stockades, within which they erected their farmhouses or penned their cattle. The craftsmen who made jewels or implements in the shelter of such enclosures may well have been more often itinerant than permanent residents—skilled artisans who traveled from patron to patron.

Some Roman tombs were house shaped; the reduction of the tomb to a house-shaped shrine is a common medieval development. The further reduction to a very small size, as in early Irish (and Scottish) examples had the advantage of making the deceased saint portable, as it were; he could be borne on circuit for the veneration of the faithful and the collection of monastic dues. Such reliquaries were probably to be found in all the early churches. They were small yew-wood caskets with hinged lids, the whole being in the form of a miniature building with a hipped roof.

In tracing the development of this type from extant fragments and examples one is again, as with somewhat earlier work, drawn to the area of activity of the Columban monks, who made close contacts with the Picts of Scotland and the Angles of Northumbria. The small reliquaries may derive from house-shaped shrines of stone which appear to have existed in the primitive churches throughout the Atlantic province of Irish Christianity. The shrines may be primary, perhaps often providing the first stimulus to monastic development. They are related to the cult of martyrs on the Continent; martyrs in the strict sense not being available in the west, holy men who bore peaceful witness replaced them. The stone shrines were mostly very simple structures, occasionally provided with an aperture through which the bones inside could be seen or touched by pilgrims. Examples survive in Kerry and Clare and other parts of Ireland and Scotland.

To the numerous class of miniature reliquaries belong a number of well-preserved examples. The Emly shrine (31) illustrates the main features. The wooden casket, with its hinged "roof," or lid, is ornamented with bronze sheeting sometimes in openwork, as in this example, fixed to the wood surface. Further embellishment was provided by tinning or silvering the bronze and by the addition of squared or round ornamental panels, while the escutcheons supporting the hinges for the carrying strap and the metal strap end were also treated as focal points for ornament. Most of the surviving examples of this type appear to be of seventh- or eighth-century date, the Emly shrine itself probably being a work of the eighth century. They show a number of distinctive features of the metalworker's styles in the period approaching A. D. 700. In particular, there is a development in the enameler's art: yellow enamel is now used as well as red, with occasional small touches of other colors. The "red-and-yellow style" of the enamelwork on the reliquaries depends largely on simple rectilinear panels derived from the late-Roman world—interlocking *L*, *T*, and cross shapes predominating. These are also commonly found on the escutcheons and mountings of the large bronze hanging bowls excavated from ninth-century west Norwegian graves—for example, in

the anthropomorphic escutcheons of the Miklebostad bowl (Fig. 20). Early experiments with animal ornament, kerbschnitt bronze reliefs, and lightly engraved motifs against a stippled or punched background on a silvered surface are also found on the small reliquaries. The full development of the techniques and style may be seen in such works as the Moylough belt shrine (Fig. 21), on which buckle and counterplate especially have been

Fig. 21. Bronze clasp plates on belt shrine, about A. D. 700, Moylough, County Sligo. NMI

treated as fields for ornament, and the Ardagh chalice (33).

The metalwork of the closing decades of the seventh century shows a range of experimentation and the absorption of numerous and complex external influences. A fairly stable style, essentially derived in its techniques and its basic ornament from late Roman work, seems to have been established in enameling. The design repertoire of earlier days, based on whirling triskeles, trumpet

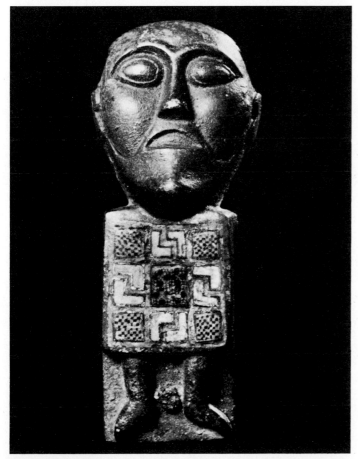

Fig. 20. Bronze hanging-bowl escutcheon with enamel and millefiori glass, about A. D. 675, from Miklebostad, Norway. Historisk Museum, Bergen

97

curves, and other curvilinear forms of ultimate La Tène origin, seems at times to have been laid aside by the late-seventh-century craftsmen; but the attraction of these forms was clearly very strong, and after some tentative experiments, they were to be developed into a new and unprecedented elaboration in which they were combined and integrated, with occasional success, into designs that also incorporated more recently obtained motifs.

The most securely established new technique was the kind of relief casting known as *kerbschnitt*, or "chip carving." Its faceted and angular surface derived ultimately from work in wood or bone but was developed as a bronzeworker's style in the North Sea area in Roman times and was brought to England and Scotland with the Anglo-Saxon migration. Kerbschnitt was soon to enable the Irish craftsmen to adapt their favorite trumpet spirals to the borrowed patterns and technique, as we see superbly illustrated on the stem ring of the Ardagh chalice (**33**).

In this late-seventh-century period, the metalworkers were still experimenting somewhat uncertainly with animal motifs encountered overseas in the world of the wandering monks, among the Picts, the Anglo-Saxons, or the Franks. In the Book of Durrow animal ornament, like ribbon interlace, is borrowed without being absorbed in the Pictish-looking creatures who serve as symbols of the evangelists (**27c**) and in the very Germanic ribbon-animals of one strange painted page (**27d**). The metalworkers too seemed for a time to be uncertain quite how best to bring the animals into their designs and adapt them to their purposes.

Work in stone appears to have been mainly on a small scale in the seventh and early eighth centuries. The expanding monasteries undoubtedly provided patronage for a growing number of masons, if only for the manufacture of hand mills, mortars, and other such equipment. Where these survive they show that the workers of the time were proficient in cutting and shaping hard-grained stone, which they finished by hammer dressing. At a later date, they could produce works of considerable elegance and precision by similar techniques in the construction of mortared stone churches, but none of these can be placed with confidence as early as the eighth century. It is probable that simple oratories of unmortared stone, of the type looking rather like an upturned boat (Fig. 22) may date back to the seventh century or even earlier, but these are virtually unornamented and belong to a simple but effective building tradition with its roots deep in the prehistoric past.

In the development of the more formal stone artifacts connected with the early churches and monasteries, however, we are offered some interesting insights into the esthetic sense of the masons. Grave markers were used in Irish as in British and continental Christian burial grounds. At first these were simple: small flat stones cut with a suitable symbol of Christian faith and laid on the grave. Work on the stone was confined to a minimum—careful selection of the position for the placing of the symbol; a little dressing back of the surface; then the chiseling out of the symbol itself, with an eye to its bal-

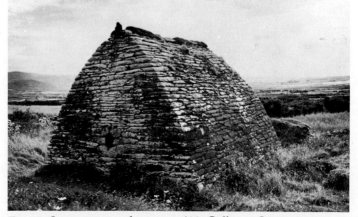

Fig. 22. Stone oratory, about A. D. 600, Gallarus, County Kerry

Fig. 23. Cross with *Chi-Rho* monogram, from carved stone grave slab, about A. D. 650, Inis Cealtra, County Clare. Drawing after L. de Paor

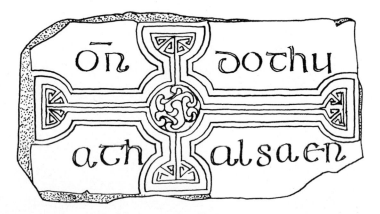

Fig. 24. Carved stone grave slab with half-uncial inscription, about A. D. 700, Clonmacnoise, County Offaly

ance within the natural shape of the slab. This is an art in the tradition of masons who worked without mortar and who employed a great part of their skill in selecting rather than shaping their stones. It shows the maximum respect for the natural material itself and, like a good potter, the mason achieved elegance and precision in design by the sureness of his eye as much as by the skill of his hands. A little grave marker found at Inis Cealtra (Fig. 23) exemplifies this. It bears a *Chi-Rho* cross, which combines both the Greek and the Latin interpretations of that form, and the loop of the *Rho* has been transformed into an ultimate La Tène curve. This is a seventh-century work; its effect is achieved simply by placing the cross-monogram in exactly the right position within the irregular outline of the small slab.

Later grave slabs show similar elegance, with a new development: the recording of the name of the dead man. A beautiful example at Clonmacnoise commemorates one Tuathal, a wright (Fig. 24). The lettering is derived from the beautiful and clear manuscript hand evolved in the sixth century in Ireland, but it is well adapted for its minor monumental purpose. While the great majority of inscribed grave slabs must be dated somewhat later than the eighth century, and some of them are fairly elaborately ornamented with designs derived from manuscript painting, it is in this seventh/eighth-century period that the canon for their design was established.

There were other important developments in stone-carving, showing, as in metalworking, a phase of experiment, diversity, and uncertainty at the end of the seventh century followed by the emergence of a mature and assured style. Christian symbols were applied not only to grave markers but also to pillar stones and standing stones. The upright slab, or stele, like that at Fahan Mura (Fig. 19, p. 60) was another medium for carving and for the display of Christian symbols. By about the end of the seventh century there was a tendency not merely to

display the Christian cross (often composed of or decorated with ribbon interlace) on the slab as the chief symbol, but to make the slab itself cruciform. At Carndonagh, in the far north of Donegal, several of the new tendencies combine to form a new monumental art. A high cruciform slab (Fig. 25) is decorated all over with incised motifs to create a false relief. The motifs include broad-ribbon interlace with a double contour line as on the Book of Durrow (27), but there are also figural representations and other details that suggest that the cross is considerably later than Durrow. The tall slab is flanked by two low-standing pillar stones with figures and decorations in the same style.

While the metalworkers and stonemasons were experimenting with borrowed motifs and techniques, gradually working out the mature early Christian style that was to dominate the eighth century in Ireland and northern and western Britain, the specifically Christian elements of

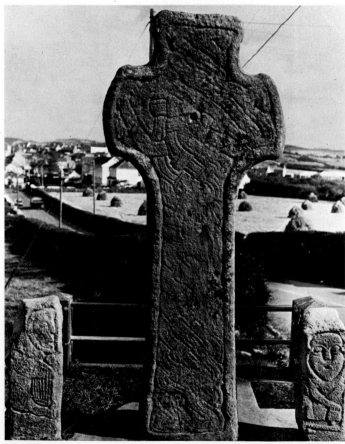

Fig. 25. Carved stone cross, about A. D. 675, Carndonagh, County Donegal

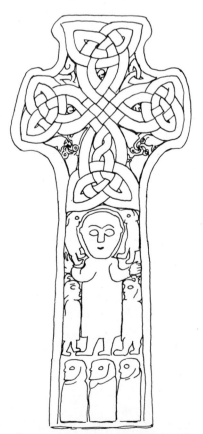

this style were being elaborated by the manuscript painters. It was a period when, presumably, the basic texts needed for Christian worship had been copied in sufficient

quantity to meet the requirements of the by now numerous churches. Some of these had become wealthy centers of population and activity. There was a demand for sumptuous books; time and skill were lavished on the presentation of the word of God, and jeweled shrines and glittering embroidered textiles were made in honor of the saintly founders of great monasteries. In this as in other matters, the eighth century was a time when emphasis shifted from function to display.

To produce the art of the illuminated manuscripts, the scribes and miniature painters drew on varied sources. Having on their native ground no tradition of representational art and no background of iconology, they depended for the illustrational side of their work on Byzantine or other Mediterranean book paintings or on ivory or wood reliefs. These had been brought west in some numbers in the course of the seventh century, ever since Gregory the Great began the task of Romanizing the churches established by Gaulish, British, and Irish missionaries during the twilight of the Roman world. An iconography was soon established: the Mediterranean models show very clearly in the illustrations in the sumptuous late-seventh-century Anglo-Saxon work, the Lindisfarne Gospels (Fig. 26).

For the decorative side of the work the artists turned to the polychrome enameled and inlaid goldwork and bronzework (whether in Christian shrines and church vessels or in personal jewelry) of the world around them, both Irish and Anglo-Saxon. An obvious, and amusing, example is the man or angel who symbolizes St. Matthew in the Book of Durrow (**27b**) with his millefiori-decorated cloak, or surtout. But the borrowing can be seen clearly in many other places—in the copying of step-patterned studs, or in the rendering in an enamellike paint of the patterns and colors of the metalworker's red-and-yellow style.

The text and lettering themselves provided a signif-

icant medium for the development of a decorative style. The manuscript makers prepared their vellum, working with rule and compasses, composing each page carefully before they began copying the sacred text. They borrowed from architectural forms for their layout or designed heavy frames with something of the character of carved wooden structures to give weight and emphasis to important sections of the text. The beautiful half-uncial script was itself a considerable Irish contribution to civilization,

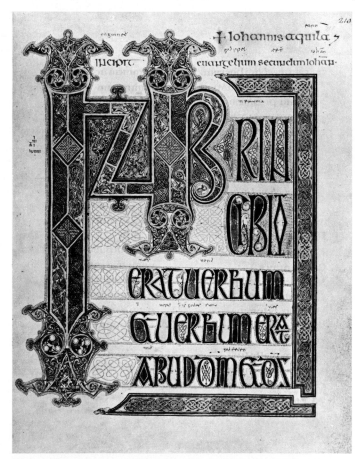

Fig. 26. The Lindisfarne Gospels, *fol.* 210R, late seventh century. The British Library, London

for it was a major element of the Carolingian book hands which in turn, through the Renaissance printers, formed the basis for most of the Roman typefaces used today.

The half-uncial evolved in a period that is dark to us, since no manuscript older than the *Cathach* (Figs. 16, 17, p. 59) survives. In the eighth century it was fully developed, but it was still necessary to borrow from the Mediterranean world when capital or monumental letters were required for display rather than legibility, and there was some tendency to draw upon the Greek alphabet for this. The device, seen in the *Cathach,* of giving extra emphasis to the initial of a new passage by arranging a kind of diminuendo into the text, was taken up as a main decorative feature. The initial of Christ in particular (the Greek *Chi* and *Rho*) became the focus for the principal ornament in the rich gospel books. In the Book of Durrow, the letter *Chi* occupies almost half the page length; in the Book of Kells it extends the full page length (**37/38d**) and is treated as a dominant decorative motif in an extraordinary dazzlement of minute and complex ornamental detail.

The development after the Book of Durrow can be traced only patchily, because so many books have been lost and because of the difficulties of identifying scriptoria (painted manuscripts were always highly mobile). The Book of Durrow itself may very well have been written and painted at Lindisfarne, from which most of the Irish monks were driven out by the Romanizing party after A. D. 663.

The Lindisfarne Gospels provide the first reasonably complete and sumptuous gospel book in this tradition. It is a work of the late seventh century, done at Lindisfarne when Irish influence was waning there, although the monastery had been founded by the Irish from Iona. There were also simpler and less lavish painted gospel books, which must have been produced in considerable numbers in the eighth century. The gospel book of St.

Gall in Switzerland (an Irish monastery) is a good example. Each gospel is introduced by a decorative page, using enlarged initials as ornaments, faced by a page with a portrait of the evangelist; the monogram of Christ is also given a full page. The book was probably written and painted in Ireland, and the Book of Dimma (**35**), probably from Roscrea, follows in the same tradition.

The most sumptuous of all the gospel books dates from more than a century later than Durrow. Exactly where the Book of Kells (**37/38**) was made is not certain, but it was probably at the island monastery of Iona. The monastery of Kells was founded from there at the beginning of the ninth century after the first disastrous Viking raids, and the relics and valuables of Iona were brought to Ireland. This large and luxurious gospel text displays in the greatest elaboration of all the tendencies and styles that have been discussed. It has also numbers of additional features such as interlinear drawings (in a comparatively naturalistic style) of everyday animals and scenes. A comparatively small number of motifs and manuscript painter's pigments have been combined and endlessly recombined in minute and dazzlingly elaborate webs of ornament, geometry, whimsy, and near-madness in this astonishing work, so that it merits the words of Giraldus Cambrensis on the lost book of Kildare. The Book of Armagh (**43**), written a little later, contains other matter besides the text of the gospels, but it is much simpler in its ornamental scheme than Kells. The script, although decorative and lively, the work of one Ferdomnach, is not the very formal book hand of the more elaborate manuscripts, and, apart from scribal flourishes, ornament is virtually confined to a few initials and the symbols of the evangelists.

The extraordinary elaboration of the Book of Kells was achieved about the end of the eighth century. An equivalent development was reached by the metalworkers around the beginning of the century. We have glimpses

of their working processes in the so-called "trial pieces," a number of which have come down to us from the period. These are pieces of bone or stone on which, sometimes, the metalworker has made preliminary sketches of his design; sometimes he has done a more elaborate and finished work, perhaps as the first stage of making a mold. The example from Lagore (**39**) is of this more elaborate type.

We do not know with any certainty by just what means the craftsmen began to acquire further new techniques about this time, including in particular the making of gold filigree. A few objects, such as a tiny filigreed bird found in a rath at Garryduff, County Cork, indicate that this craft was established in the country, probably, although not certainly, through Anglo-Saxon influence.

At any rate filigree is the medium through which richness and glitter were imparted to metalwork that was already colorfully elaborate. The so-called "Tara brooch" (**32**) has the full development of the vernacular style as it was achieved about the beginning of the eighth century. It is comparatively small, but the minuteness and skill of the work on it is such that, as in the Book of Kells, an astonishing amount of detailed ornament is fitted into a very small space. Kerbschnitt reliefs are used with great confidence, and the animals, rendered in glittering filigreed gold wire, are in the new style which was to dominate the animal ornament of the coming century.

The techniques and motifs found on the brooch are used in even greater variety and elaboration on the large silver chalice found at Ardagh, County Limerick (**33**), along with other objects deposited or hidden probably early in the tenth century. This is virtually a compendium of the art of the Irish metalworker, drawing on all sources available at the end of the seventh century. It has the somewhat unusual feature of a decorative inscription (in the technique used on the house-shaped reliquaries—showing the motifs as a reserve against a stippled back-

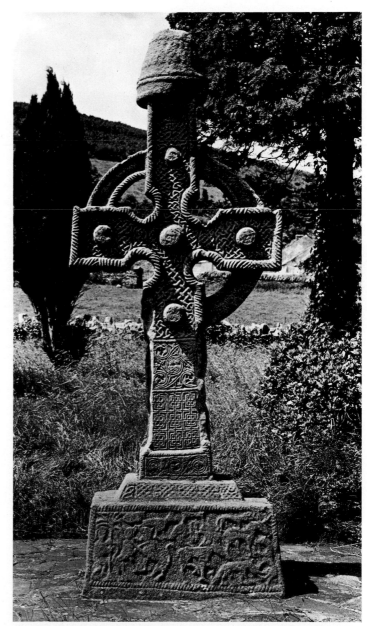

Fig. 27. East face of Ahenny north stone cross, about A. D. 750, County Tipperary

ground) with the majestic lettering found in the nearly contemporary Lindisfarne Gospels (Fig. 26).

These objects represent a climax. After them, the passion for minute work and great elaboration diminished. The general trend toward display, however, did not. In a series of comparatively large brooches (or rather pins) the ring itself is actually closed, although the earlier penannular form continues to be reflected in the arrangement of the ornament. These are therefore sometimes referred to as "pseudopenannular" brooches. The brooch series shows a divergence in the eighth century of Irish and Scottish metalworking traditions, although both are very much in the same idiom; in Scotland the brooches, with one notable exception, remain penannular.

This greatly enriched metalworker's style is reflected in the later development of stone sculpture in the eighth century. It was a custom among the Irish to set up a cross, presumably made of wood, as a symbol of Christianity—in the central enclosure of a monastery, at the cardinal points, at entrances, and perhaps at graves. We know from texts that these were sometimes set in millstones. Representations suggest that large processional crosses were also carried on occasion. These too were presumably made of wood, and we may imagine them sheeted in metal. In the eighth century we find these translated into stone: great ringed crosses that faithfully reproduce the forms of cover molds and rivet bosses, even in one instance the brambling of a gold boss. The Irish examples of this stage are concentrated along the lower Suir valley, at Ahenny (Fig. 27) and other places; there is a corresponding group in Scotland, on Islay and Iona and at the far end of the Great Glen.

By the end of the century the eighth-century style was established in its full maturity in all available media. At this point, however, the arrival of the first Vikings ushered in a new era.

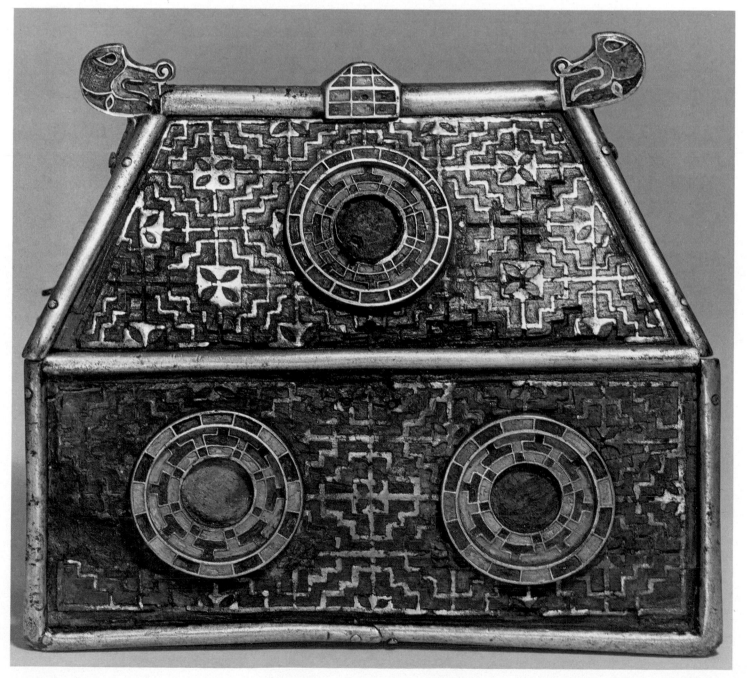

31. Emly shrine, County Limerick

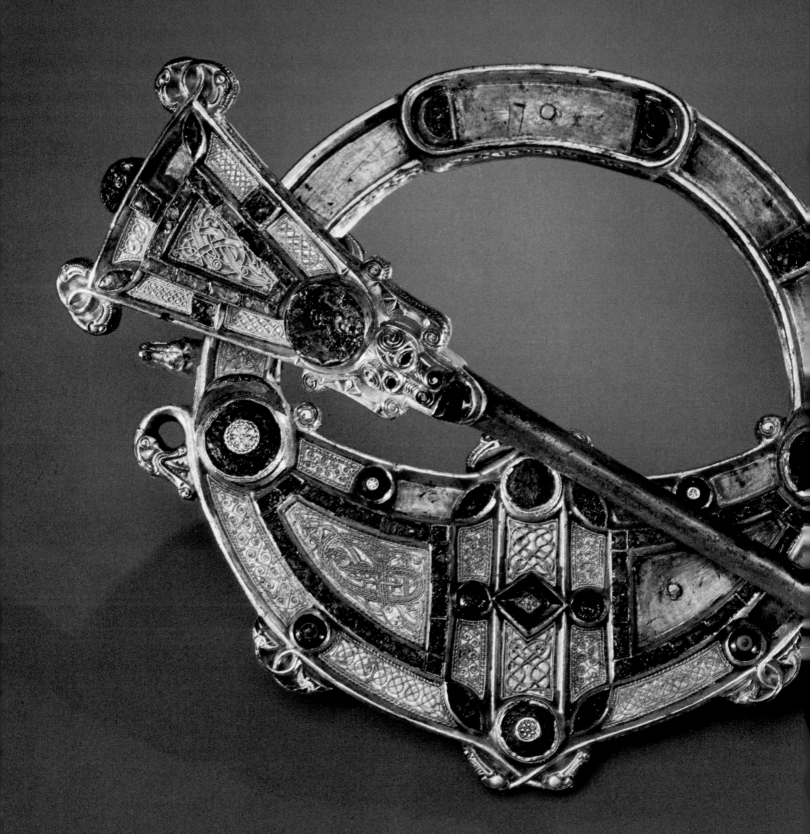

32.
"Tara" pseudopenannular
brooch, Bettystown,
County Meath

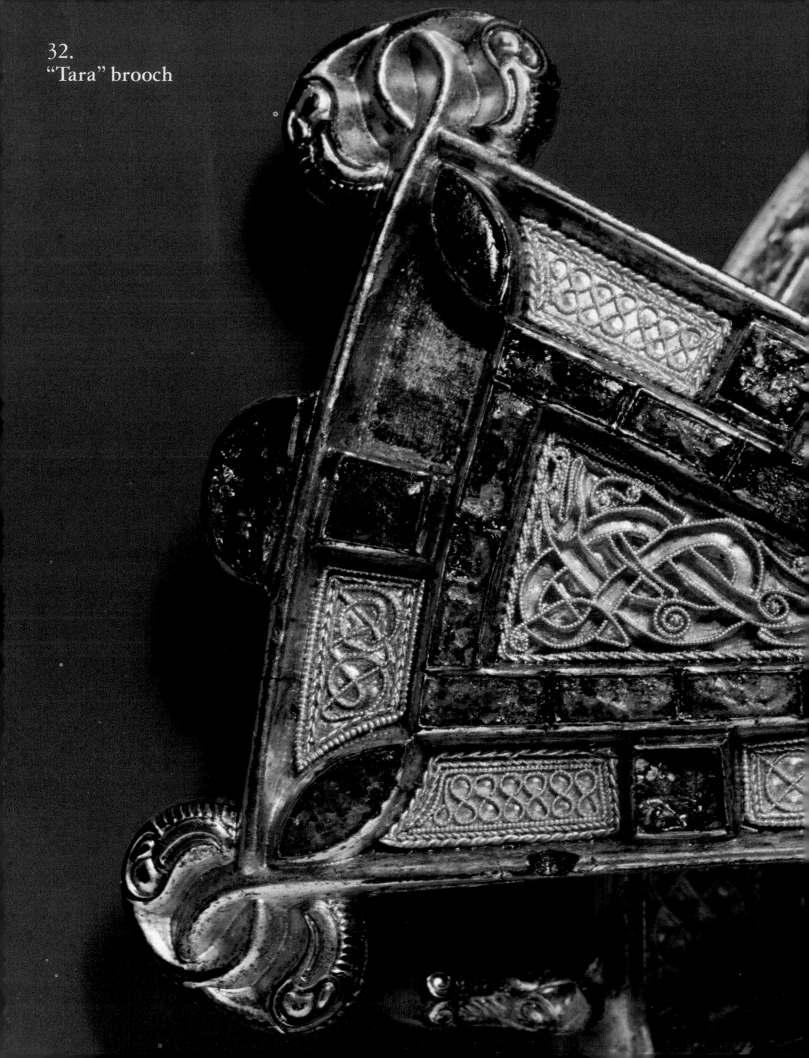

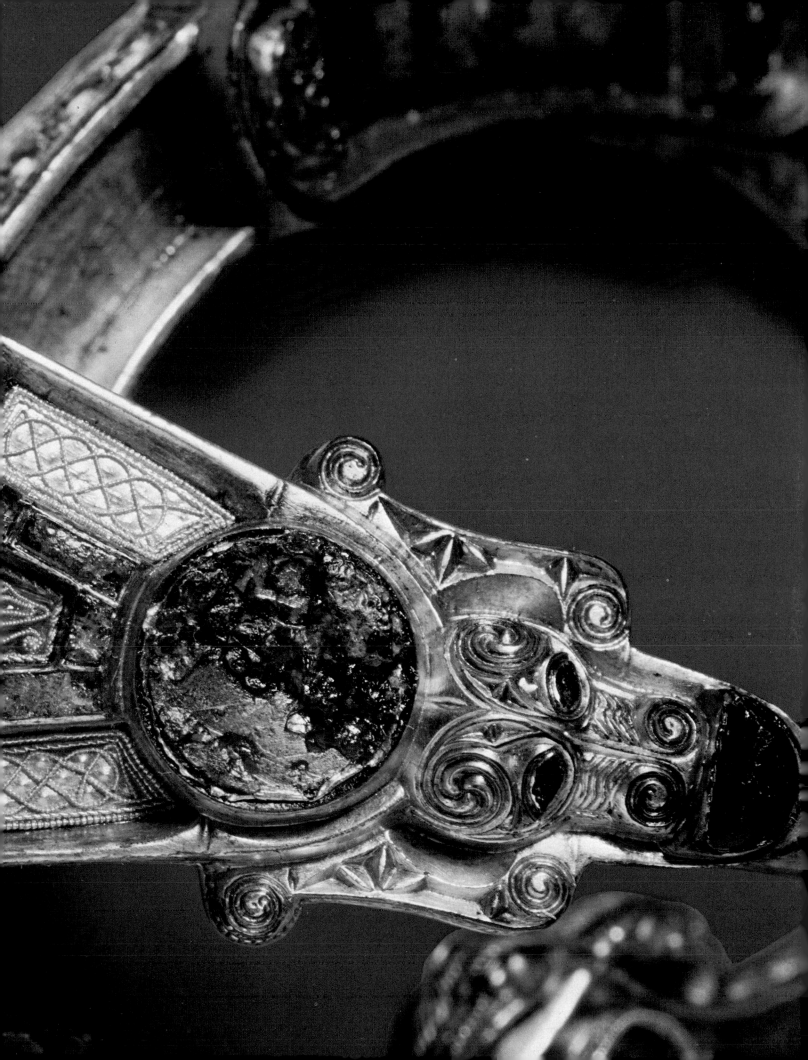

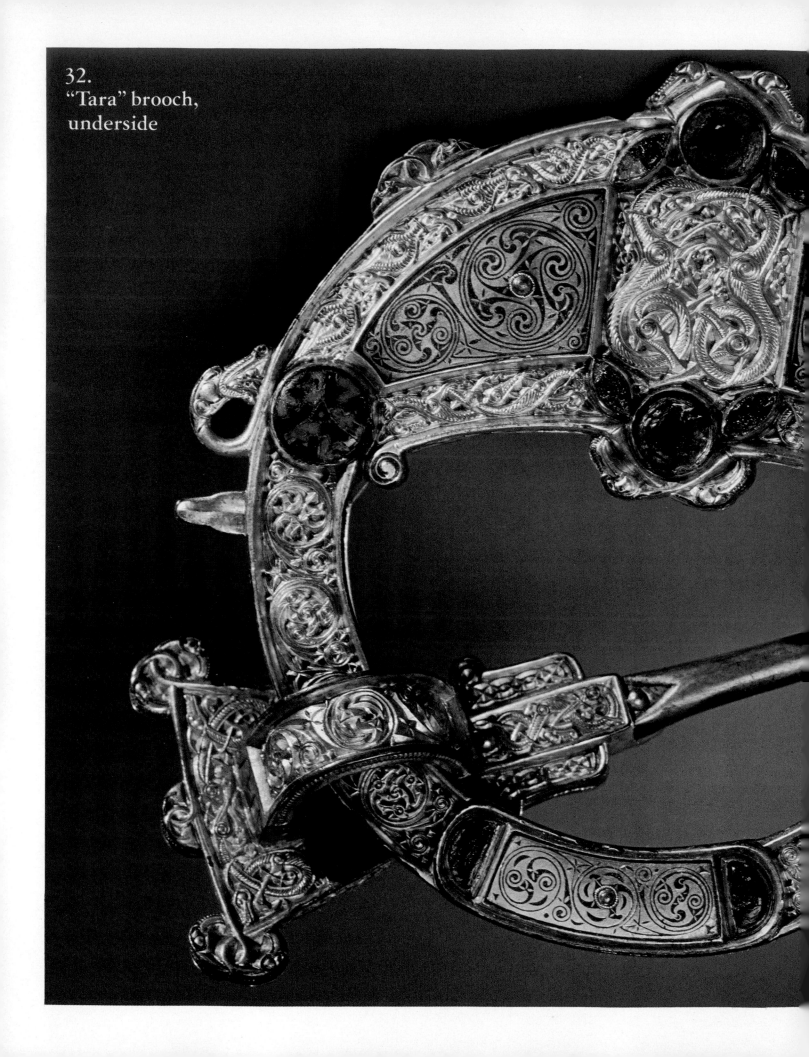

32.
"Tara" brooch,
underside

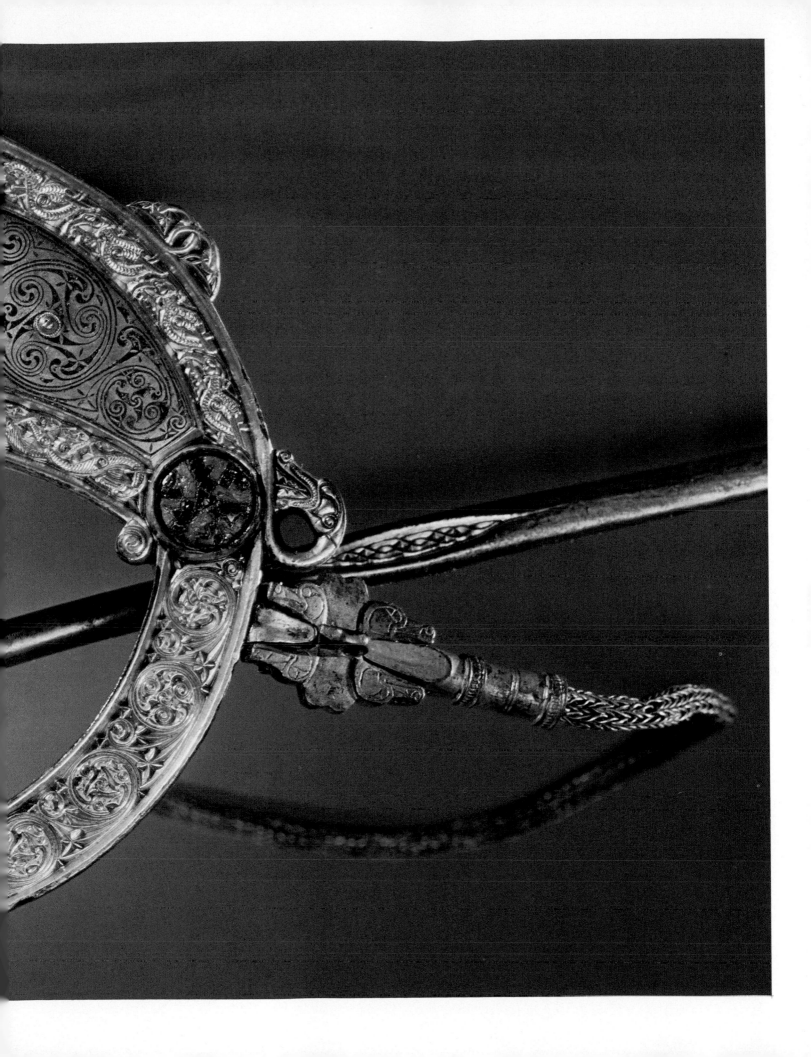

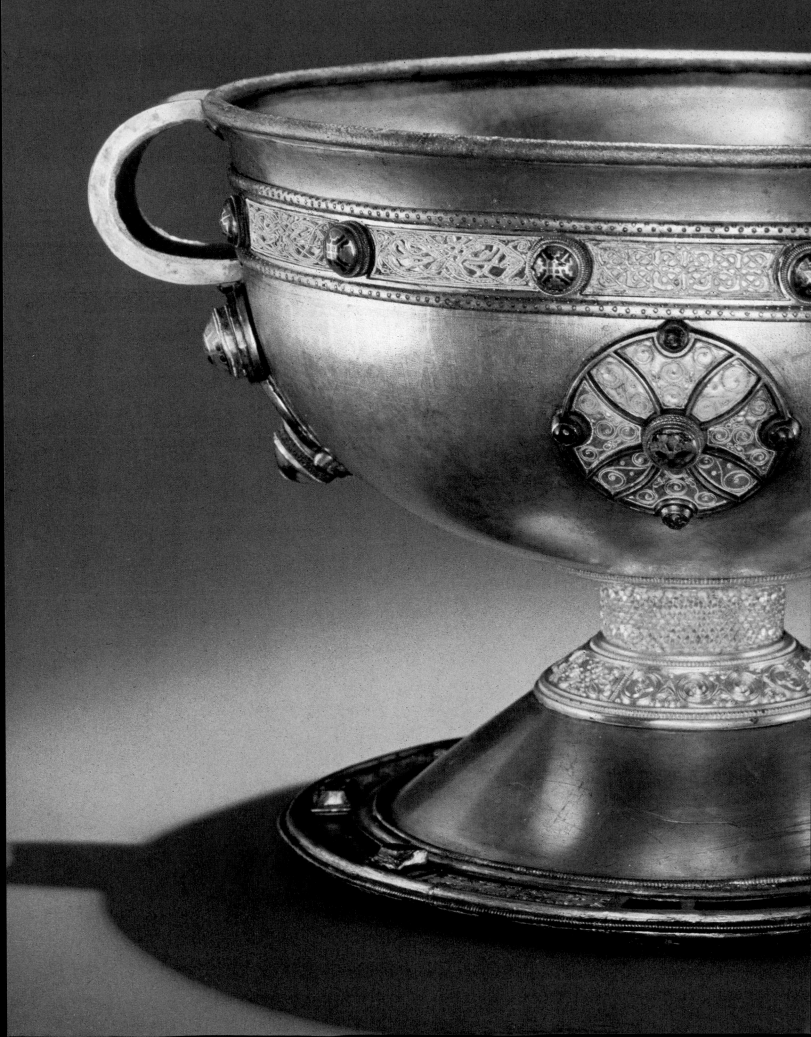

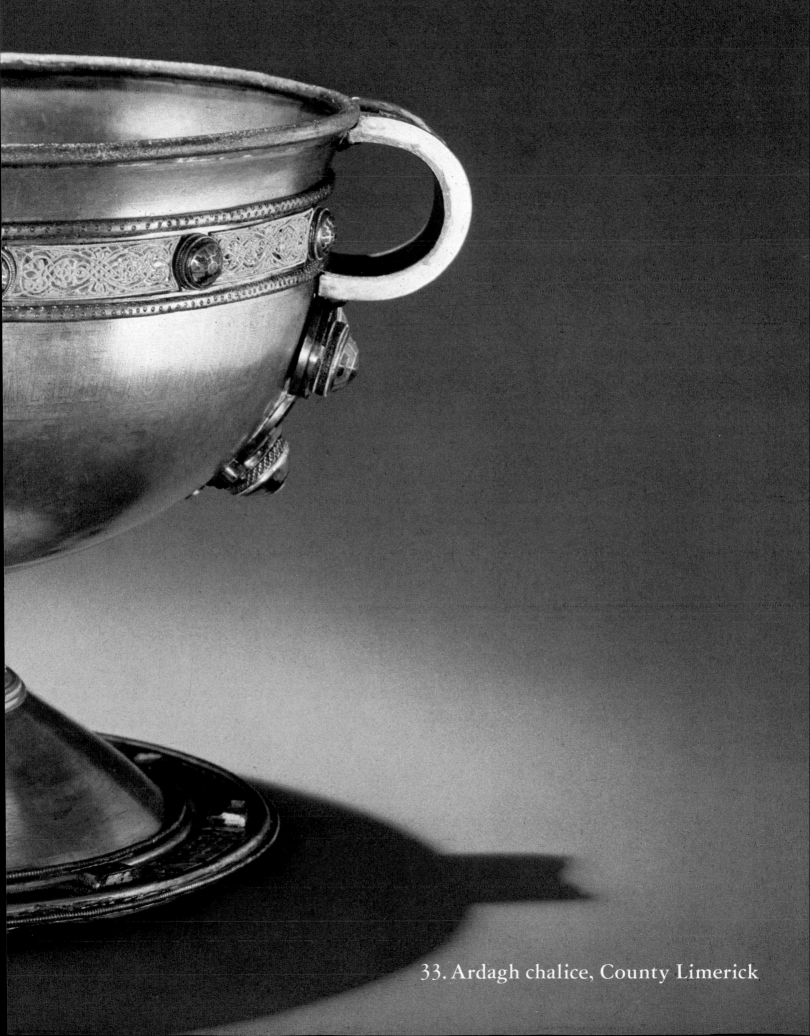

33. Ardagh chalice, County Limerick

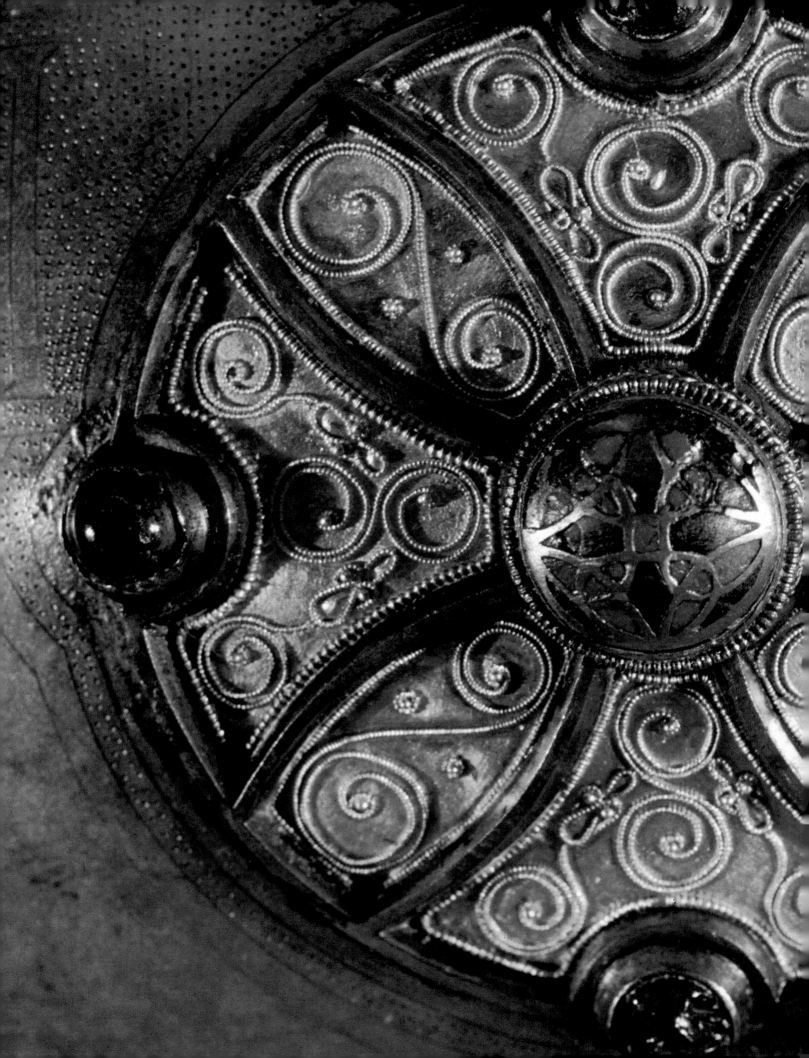

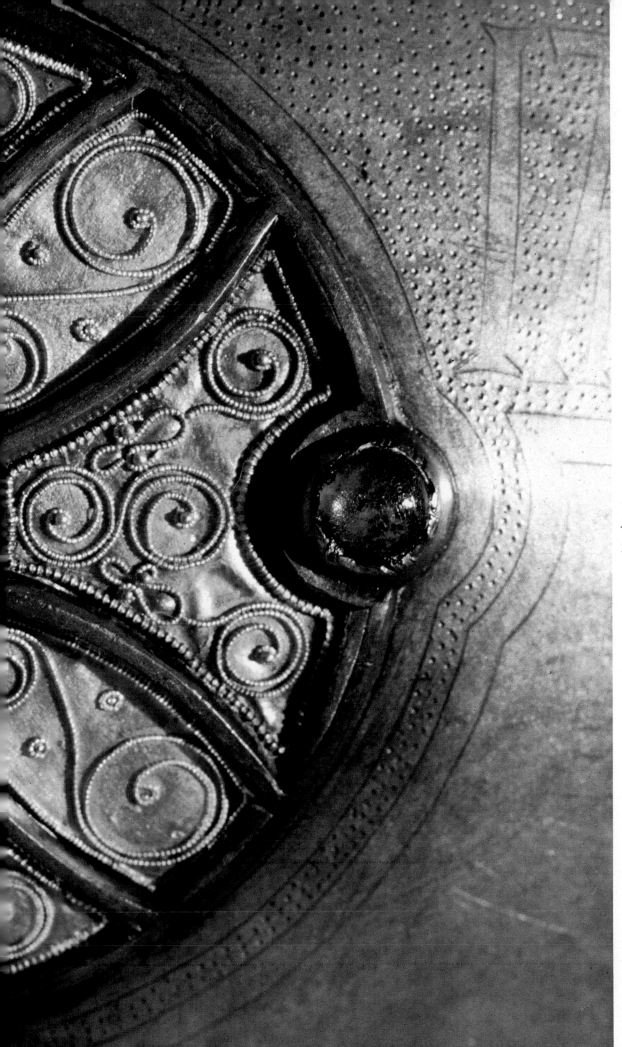

33.
Ardagh chalice:
roundel

33. Ardagh chalice

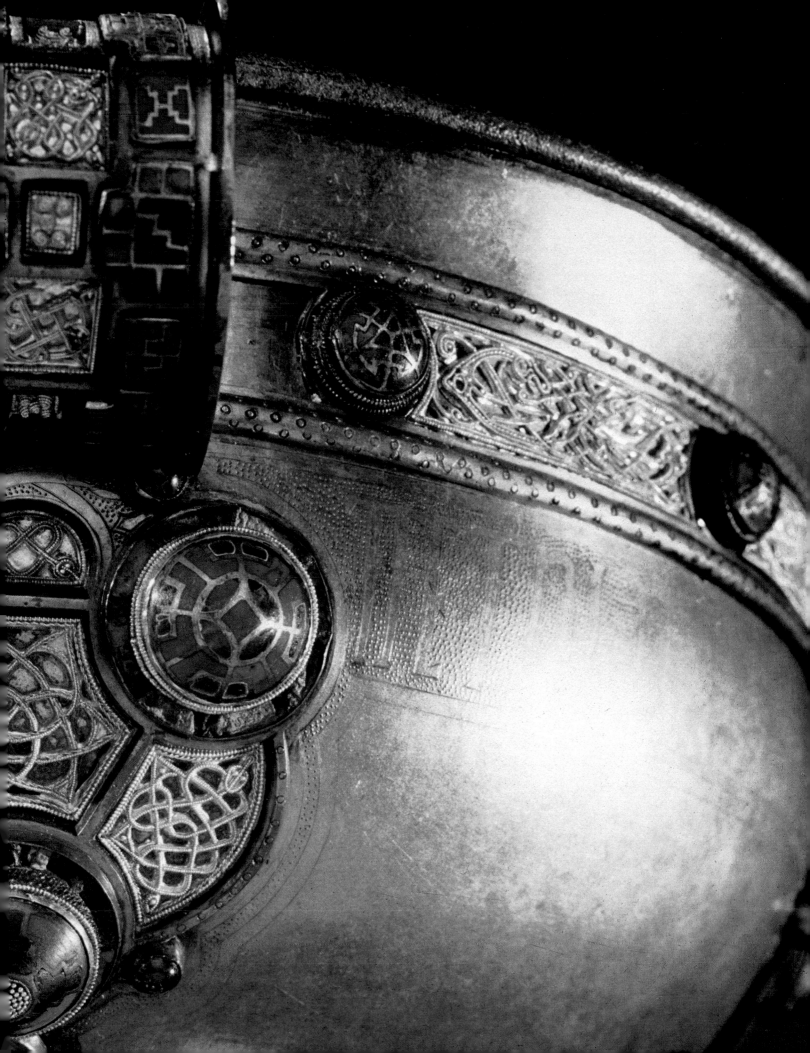

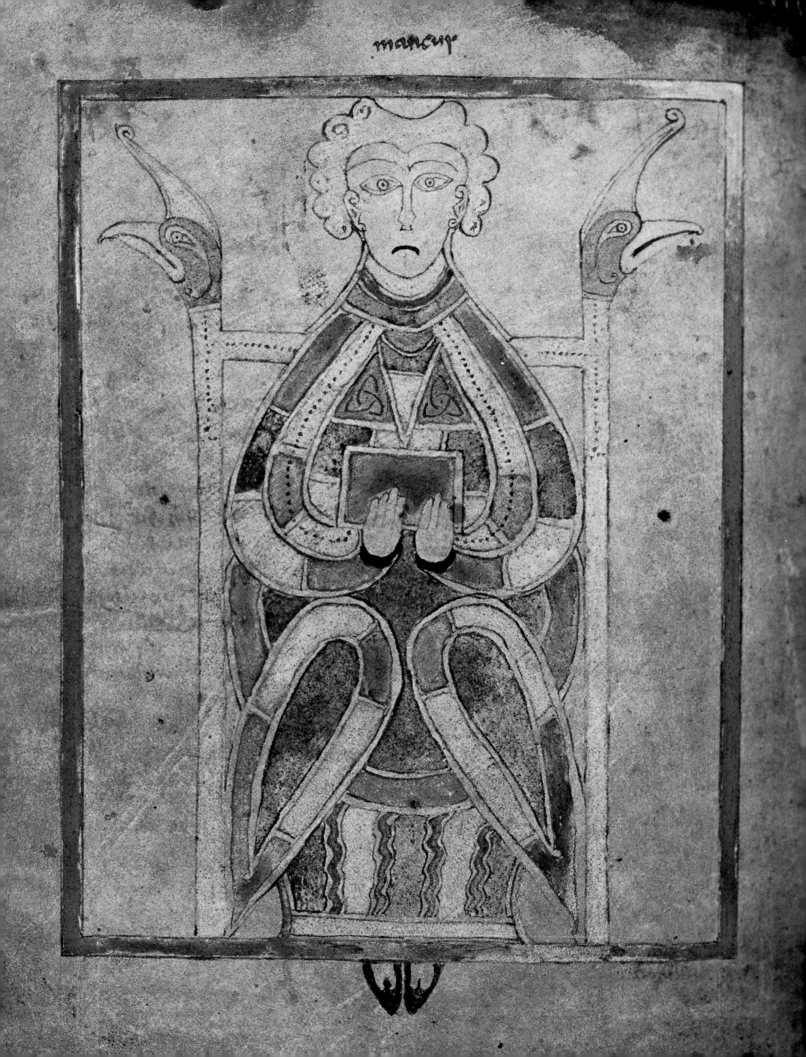

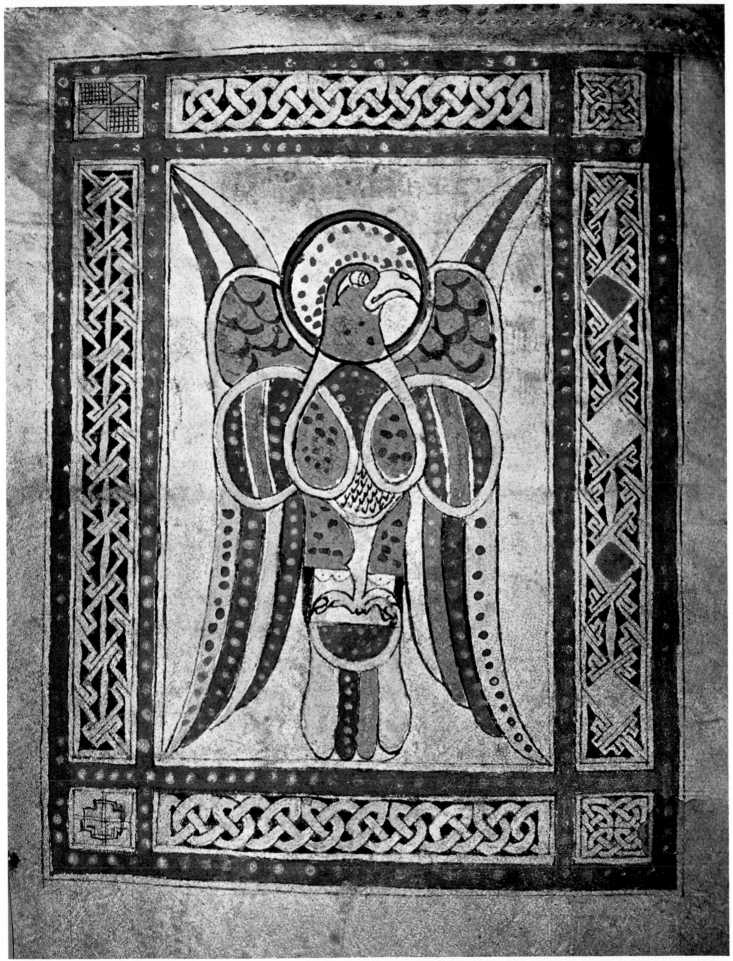

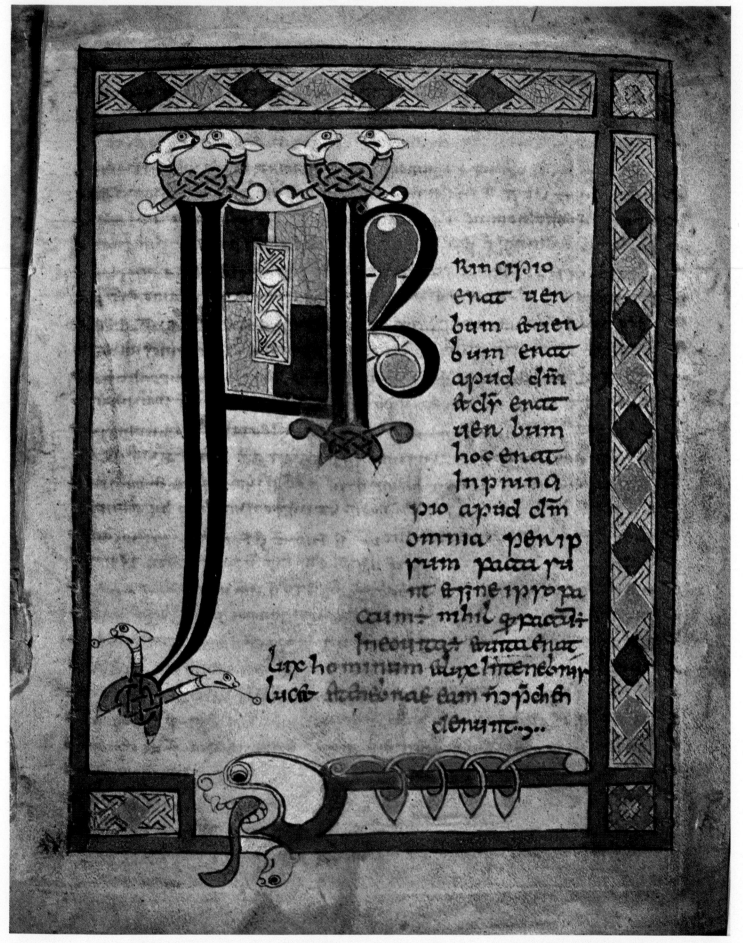

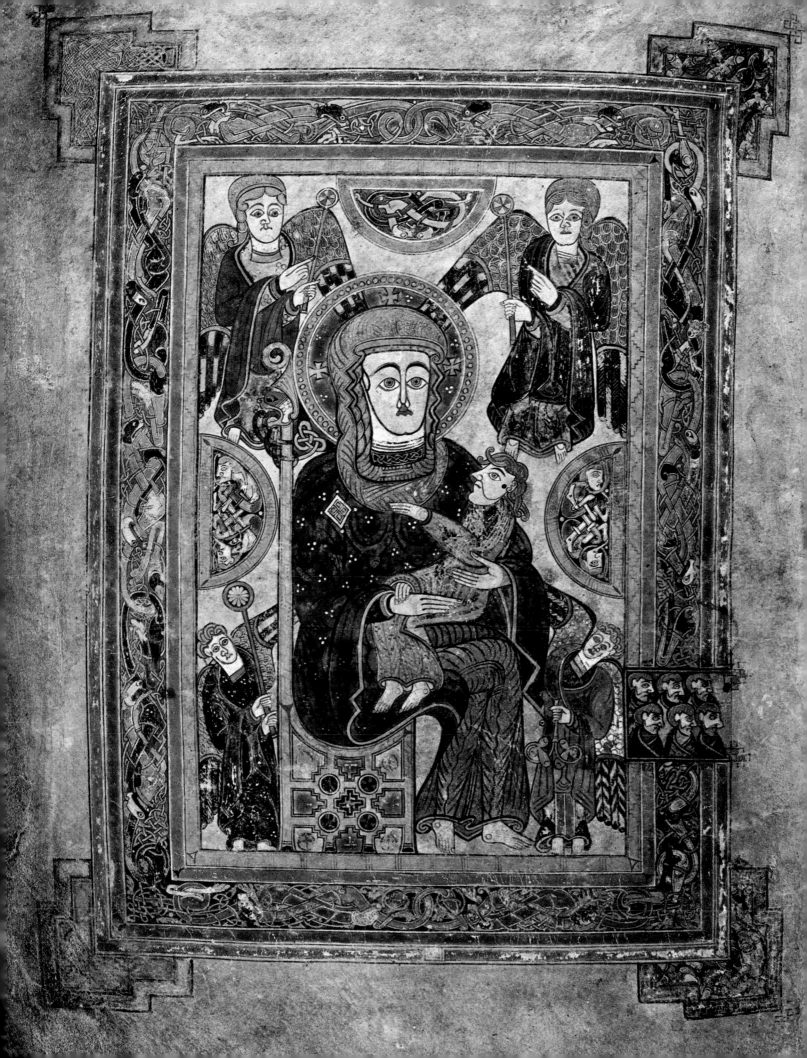

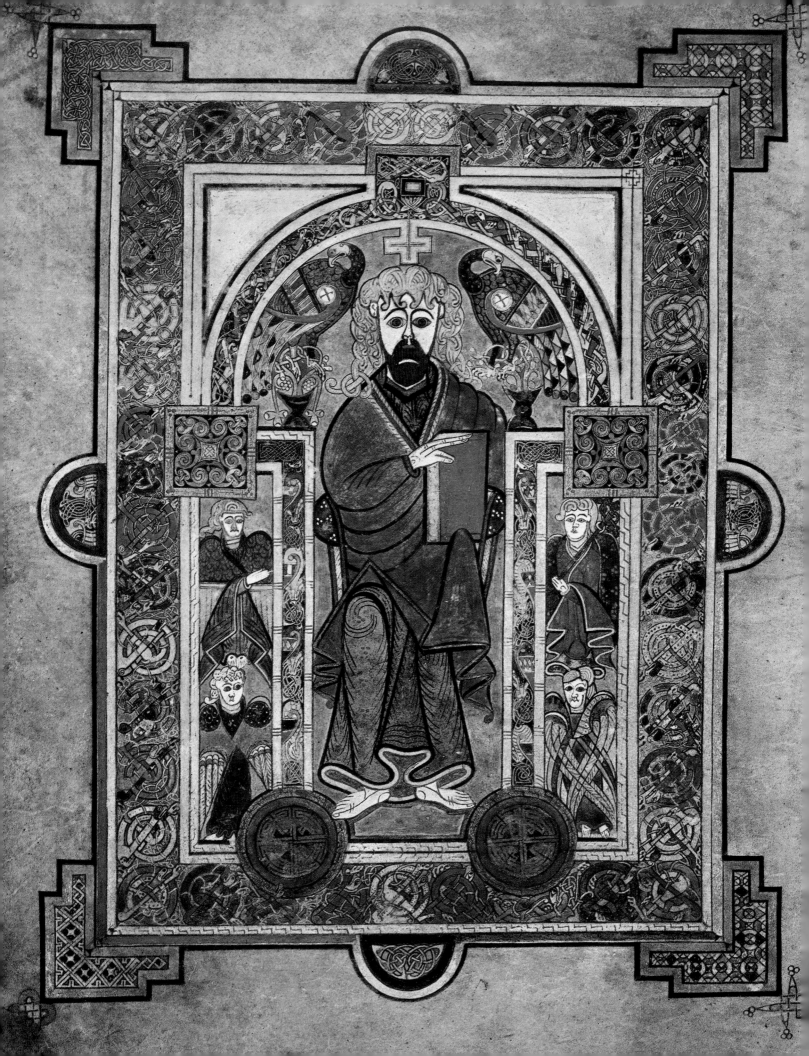

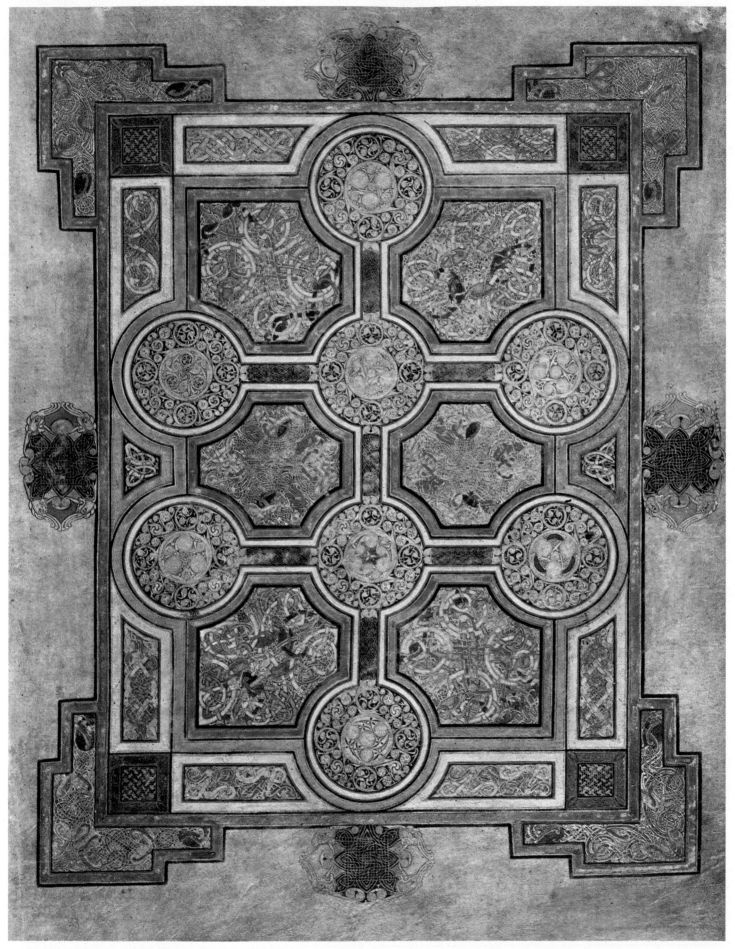

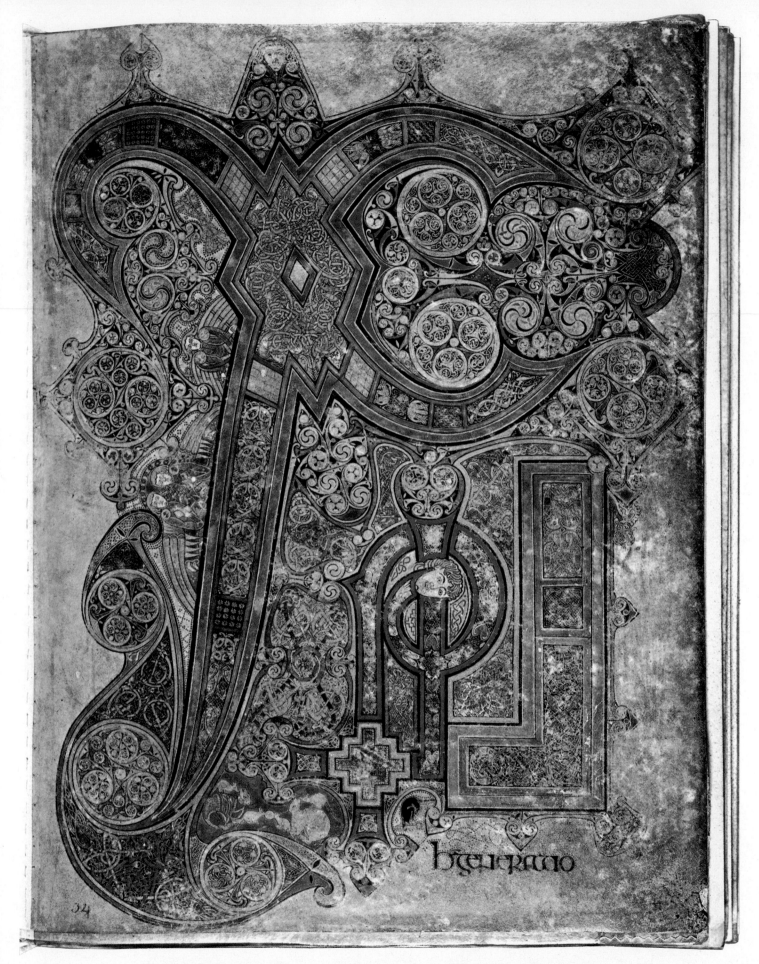

37/38d. The Book of Kells, *fol.* 34R: Chi-Rho page
37/38e. The Book of Kells, *fol.* 114R: the arrest of Christ

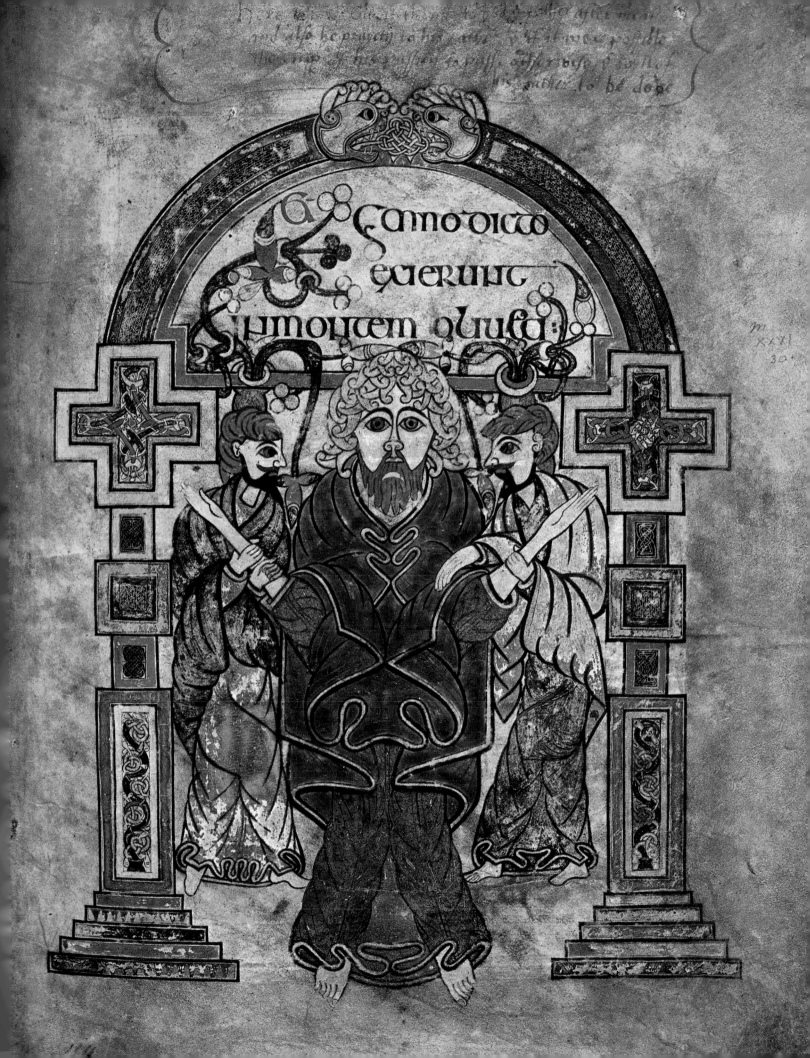

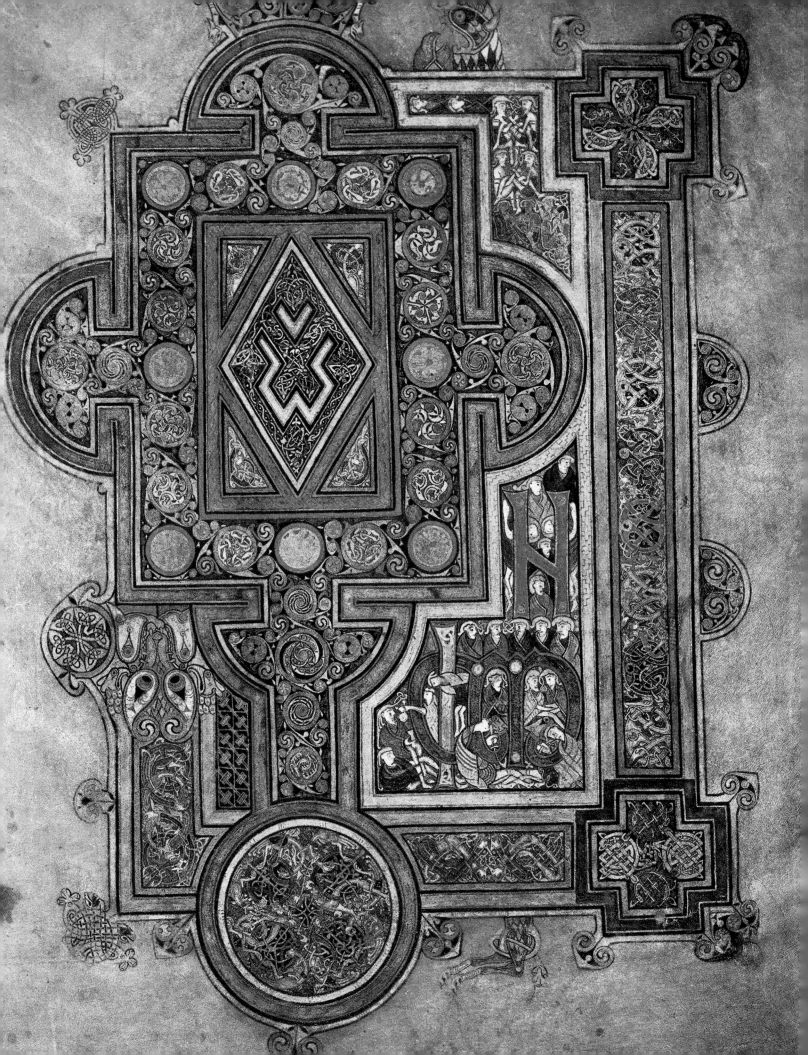

37/38f. The Book of Kells, *fol.* 188R : opening page of St. Luke's gospel
39. Bone trial piece, Lagore Crannog, County Meath

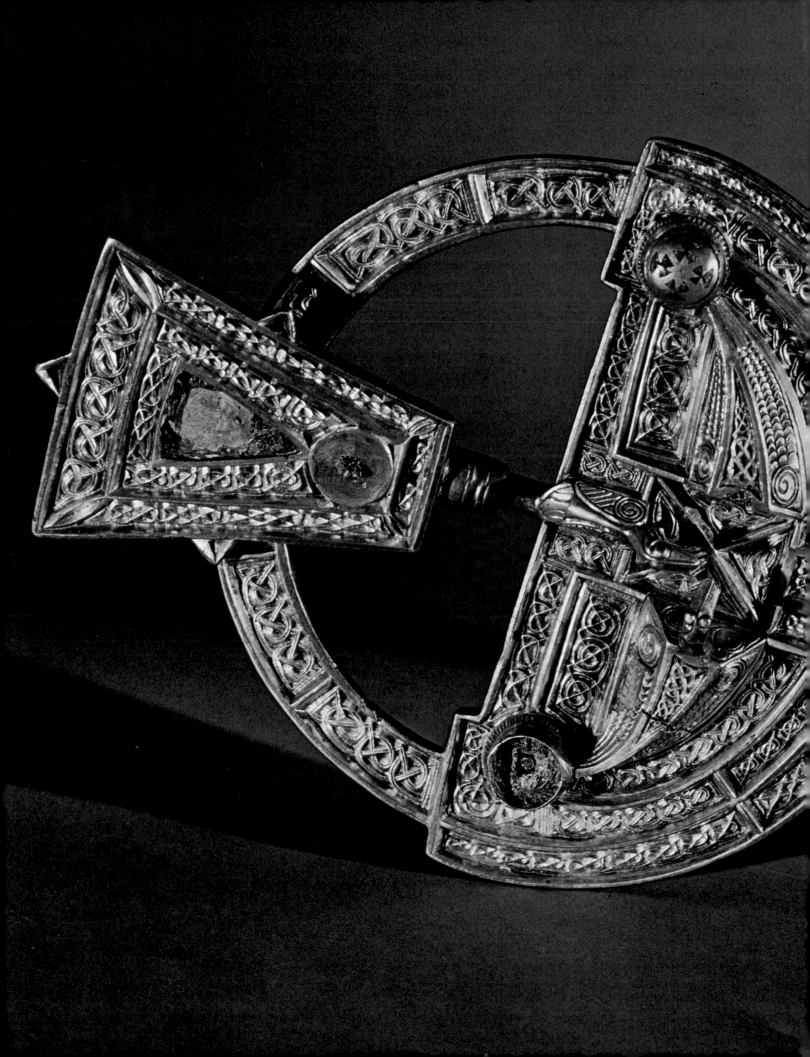

40 Large Ardagh brooch, County Limerick

41.
Silver-gilt
pseudopenannular brooch,
County Cavan (?)

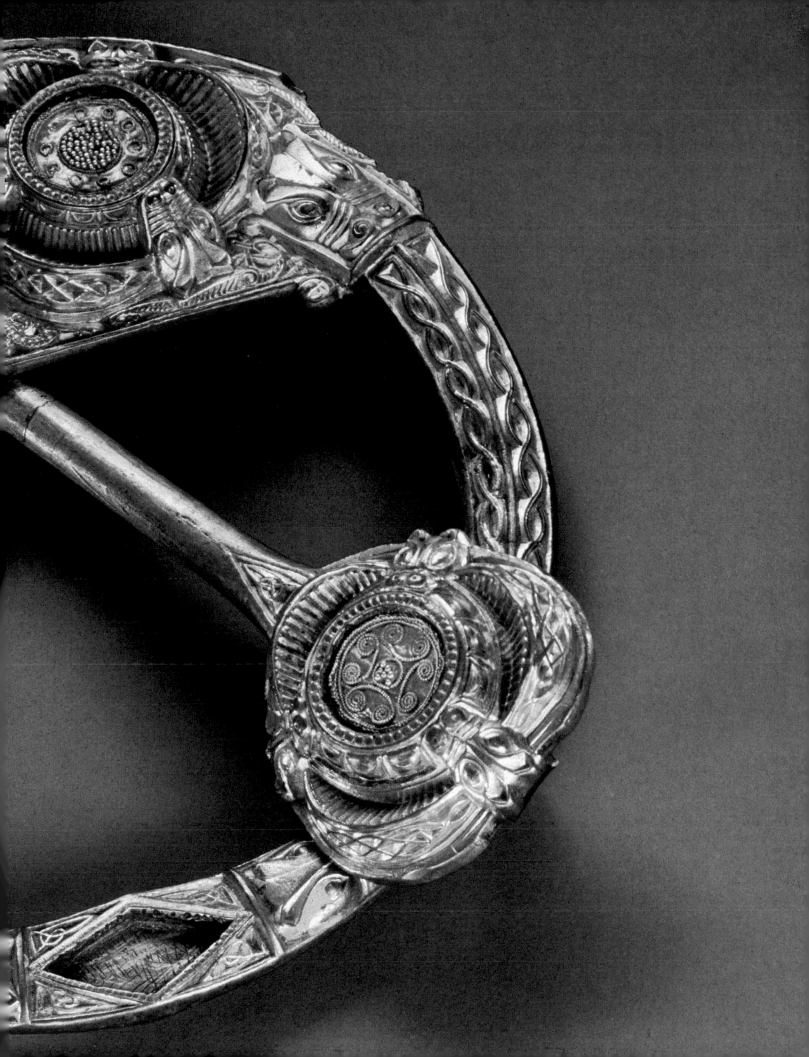

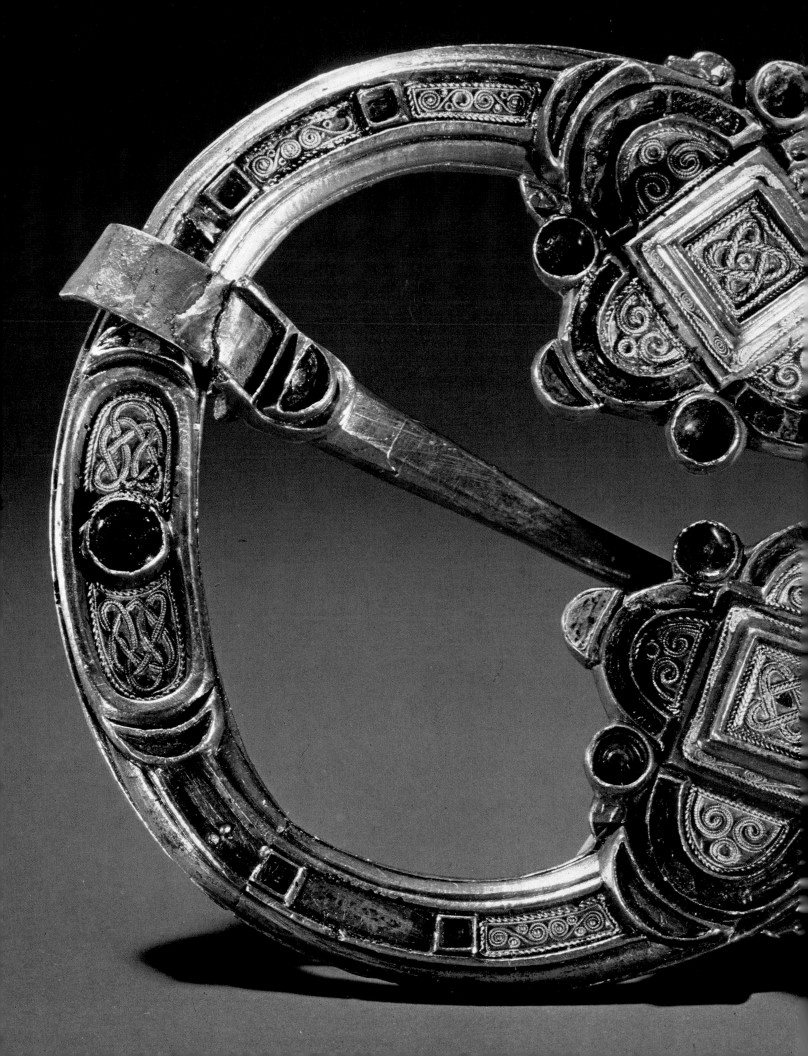

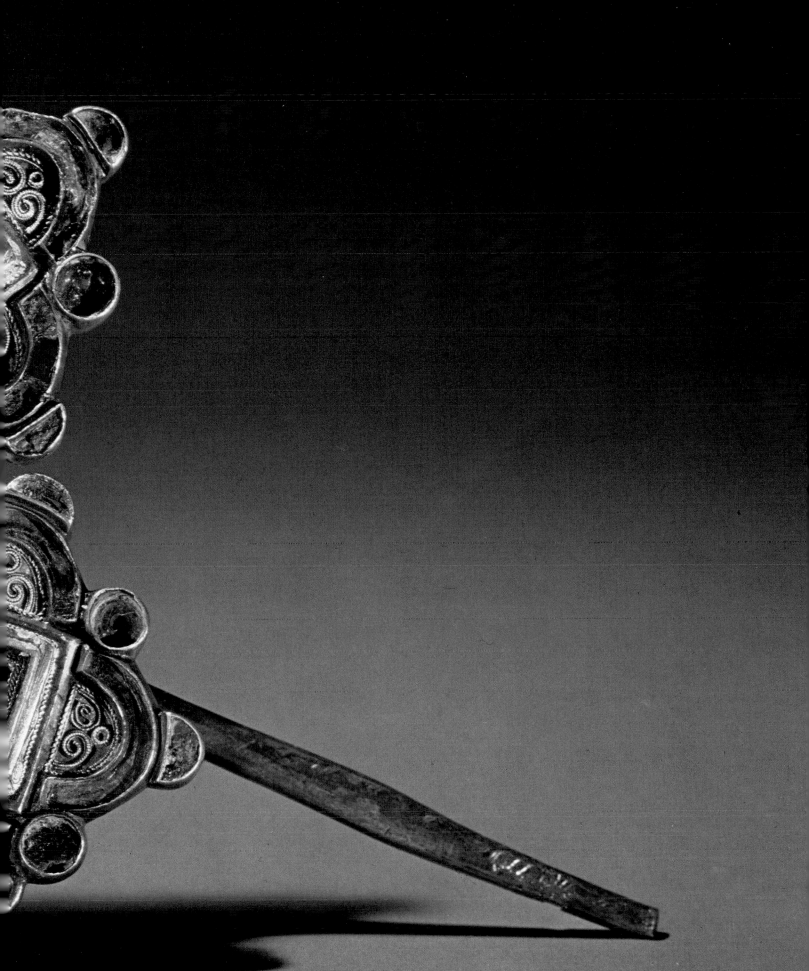

42. Penannular brooch, Kilmainham, County Dublin

43. The Book of Armagh, *fol.* 32v: the evangelist symbols

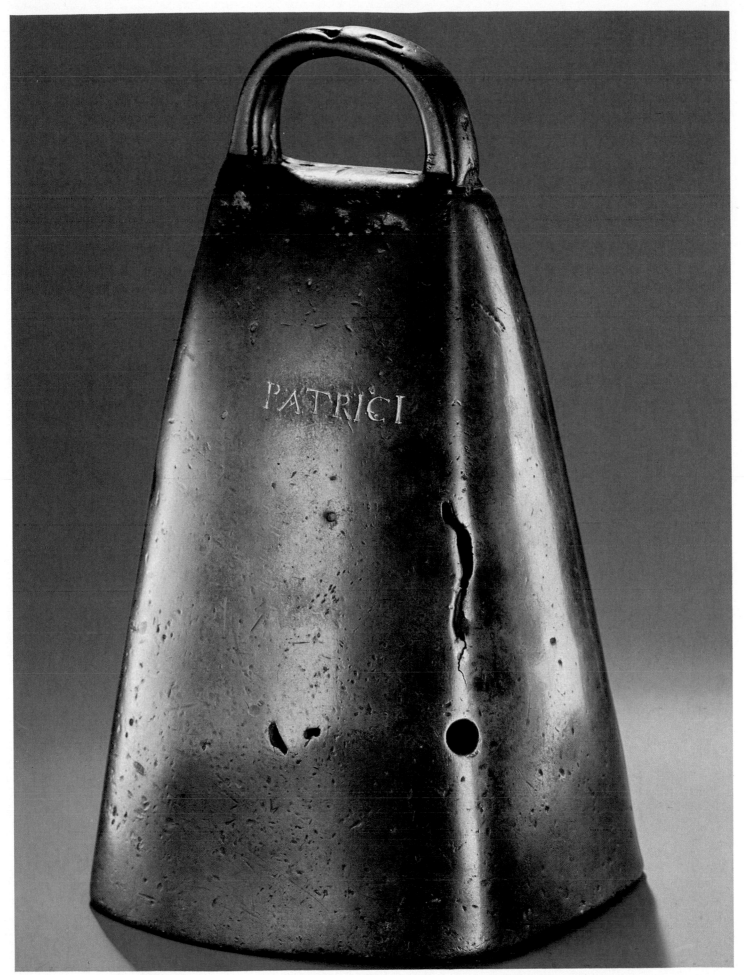

44. Bronze bell of Clogher, Donaghmore, County Tyrone

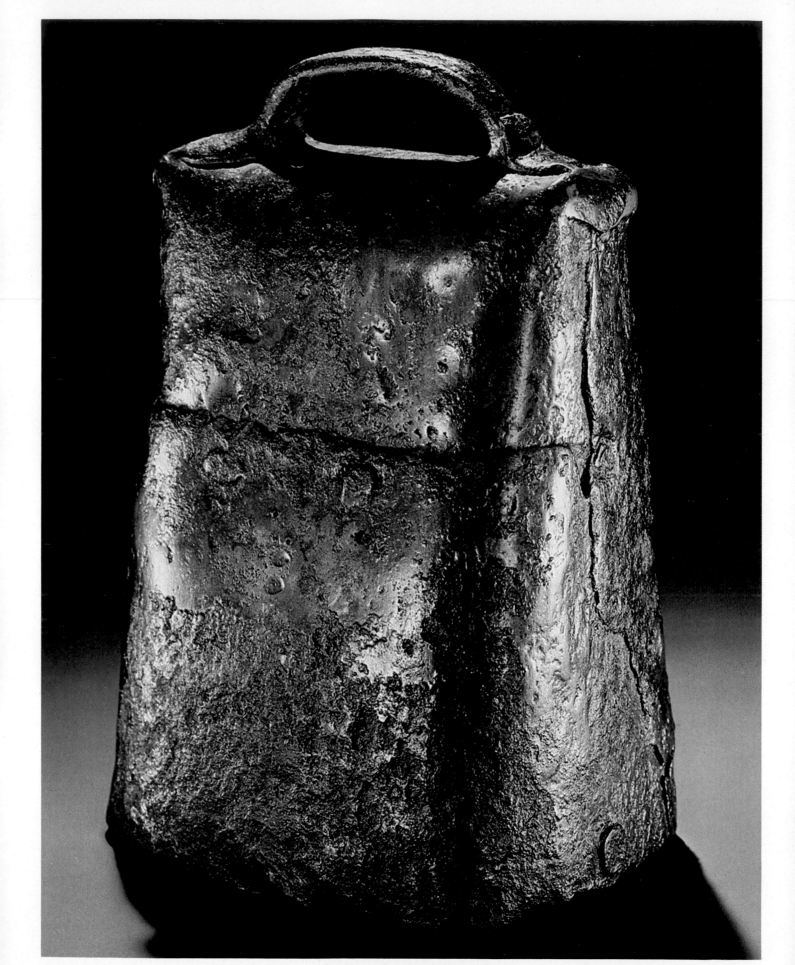

45. St. Patrick's bell

Catalogue

31. Emly shrine

Early Christian period (second phase), late eighth century
Yew wood with applied silver, gold cloisonné, enamel,
 and gilt-bronze
H. 9.5 cm.
Museum of Fine Arts, Boston, 52.1396

House- or purse-shaped portable reliquaries probably
originated with the enormous increase in missionary ac-
tivity during the seventh century. They originally had
straps fastened to hinges on the ends so they could be
carried about. The Emly shrine—so called because it was
for centuries in the possession of Lord Emly, County
Limerick—is more a microsarcophagus and certainly con-
tained sacred relics.

The shrine is constructed of yew wood, and its surface
has a network of open geometric steplike patterns inlaid
directly on it in silver. The unusual repeating geometric
pattern carpets the surface except for the medallions with
deep green, yellow, and dark green-brown cloisonné
enamels. A ridge pole that terminates in two fantastic
biting animal heads surmounts the roof. In the center of
the ridge is a miniature knop repeating the shape of the
shrine itself.

Although the form and decoration of the Emly shrine
are much like those of other metalwork in Ireland and
Scotland, it is related to work even farther afield. A con-
temporary shrine in an abbey church at Amiata in Tuscany
is directly comparable. The appearance of a similar shrine
in Italy is probably due to the wide-ranging activity of the
Irish Columban monks.

Bibliography: Fabrizio Mancinelli, "Reliquie e Reliquiari
ae Abbadia S. Salvatore," *Estratto dai Rendiconti della
Pontificia Accademia Romana di Archeologia* XLVI
(1973–1974); Georg Swarzenski, "An Early Anglo-Irish
Portable Shrine," *Bulletin of the Museum of Fine Arts,
Boston* LII (October 1954), pp. 50-62.

32. "Tara" pseudopenannular brooch

Early Christian period (second phase), eighth century
Bronze, gilded, with added amber, gold, glass, silver, and
 copper
L. 22.5 cm.
Bettystown, County Meath
NMI, R. 4015

This famous brooch was not found at Tara; the name was
given to it by a jeweler through whose hands it passed.
The actual discovery was made on the seashore at Bettys-
town, County Meath, near where a block of cliff had
collapsed after erosion by the waves.

The brooch is to the Ardagh chalice what the Book of
Kells is to the Book of Durrow; the relatively large Ar-
dagh chalice has areas of unadorned silver, but the small
Tara brooch (it seems too late now to shake off the
eponym) is crowded with detailed decoration front and
back. As with the chalice, design, technique, and mate-
rials are of the highest quality.

The broken plaited wire still attached to one side may
be no more than a safety chain or may indicate that this
surviving brooch is one of a former pair. A stylized animal
head at the brooch end of the chain is hinged to an ovoid
plate with paired segments of animal heads at each end;
two human faces, one upright, the other inverted, lie in
the center of the plate. The chain is fastened to the plate
between the two outer animal heads; the two inner heads
grip a similar animal head connected to the ring of the
brooch. When the brooch was recently restored in the
research laboratories of the British Museum in London,
the human faces were shown to be of molded purple glass
and not of amethyst as had been supposed; other molded
glass studs are present elsewhere on the brooch.

On the back are two trapezoidal plates; these bear a
dark ultimate La Tène design against a silver background.
The plates were thought to be of silver, with the dark

color produced by niello, but the recent laboratory work shows that they are of silvered copper and that the design is created by intaglio cutting, which when first worked would have been rich copper red against a silver background.

In the eighteenth century cabinetmakers' apprentices had to make model furniture with all its ornament fully developed. The small Tara brooch can almost be regarded as a model, constructed to demonstrate every skill the eighth-century jeweler knew.

Bibliography: CAAI, p. 126, pls. 13-15; IA I, pp. 108-110, pls. 28, 38, 40, 41, II; Naomh Whitfield, "The Finding of the Tara Brooch," *Journal of the Royal Society of Antiquaries of Ireland* 104 (1976), pp. 120-143.

33. Ardagh chalice
Early Christian period (second phase), early eighth
 century
Silver, bronze, and gold, with added glass and rock crystal
H. 15 cm.
Near Ardagh, County Limerick
NMI, 1874: 99

Over one hundred years ago a boy digging potatoes in Reerasta Rath near Ardagh made the richest discovery of early Christian objects in Ireland: one silver chalice, one bronze chalice, and four brooches. The most recent brooch cannot be older than the tenth century; the silver chalice must be at least two hundred years older. This treasure must have been among the possessions of a rich and stable monastery.

The silver chalice is the finest piece of eighth-century metalwork that has ever come to light. Here masterful design, technical proficiency of the highest order, and a wide range of materials have been combined to create a work of perfection.

The silver bowl, provided with handles for lifting, is linked by a gilded collar to a conical silver foot, made more stable by a broad horizontal flange. The designer did not hesitate to reserve large areas from decoration just as the artists of the Book of Durrow set their design off against plain vellum. But on the chalice, where decoration is used it is sumptuous. Ultimate La Tène scrolls, plain interlace, animal interlace, plaits, and frets abound. The techniques employed are engraving, casting, filigree, cloisonné, and enameling.

Below the horizontal band of gold filigree on the bowl the names of the apostles in shining metal stand out amid a sea of stippling. The lettering is very similar to that of the Lindisfarne Gospels of about A. D. 700 (Fig. 26).

The decorated flange around the foot of the bowl has square blocks of blue glass—which overlie reflecting sheets—separated by panels of interlace and geometric ornament. The arrangement of these motifs is strikingly similar to the decorated strap of the great *Chi-Rho* page of the Book of Kells (*fol.* 34R,**37/38d**).

Obviously the chalice shows strong influence from the Saxon world; it must have been made soon after the Book of Lindisfarne and just before the Book of Kells.

Bibliography: CAAI, pp. 142-143, pls. 51-53; ECI, pp. 249-250, pls. 22, 23, 25-27; IA I, pp. 107 ff., pls. 33, 39, C, D; TI, pp. 97-105, pls. 62-64; R. M. Organ, "Examination of the Ardagh Chalice—A Case History," *Application of Science to Examination of Works of Art, Museum of Fine Arts Seminar,* Boston, 1970.

34. Bronze chalice
Early Christian period (second phase), eighth century
H. (after restoration) 10 cm.
Near Ardagh, County Limerick
NMI, 1874: 100
Not illustrated

This small plain bronze chalice was found within the

larger one (33) at Reerasta Rath. It was damaged by the digger's spade and has been restored; only the bowl and the foot are original.

Its basic shape, that of the larger chalice, was produced by spinning the raw metal against a former. It has a thickened rim, with a pronounced groove below it. The cone of the foot has concave, not straight, sides; the rim of the foot is similar to that of the bowl.

The two chalices are probably contemporary.

Bibliography: CAAI, p. 142, pl. 53.

35. The Book of Dimma

Early Christian period (second phase), mid-eighth
 century
Vellum
H. 19 cm.
Library, TCD, 59

This is a small book for private devotion, probably originally associated with St. Cronan's monastery at Roscrea, County Tipperary.

It is a gospel book, with some liturgical additions, written in a cursive script in two columns. The colors are red, green, and yellow, and some pages have colored borders. In the very formalized portraits of Matthew, Mark, and Luke, the evangelists are depicted outlined against the frames of chairs rather than seated on them. The sides of the chair on which St. Mark (35a) is placed rise into terminal birdheads; on the heads are high combs, which recall the combs on the birdheads on the "Petrie crown" (24). The faces of the evangelists are a series of curves (especially remarkable in the treatment of the ears), and their garments are an assemblage of enameled panels. St. John is represented by his symbol, the eagle (35b); the text of his gospel, which opens with a large initial, is in a different hand.

Bibliography: IA I, p. 201, pls. G, L.

36. The Stowe Missal

Early Christian period (second phase), end of eighth
 century
Vellum
H. 15 cm.
Library, RIA

St. Mael Ruain of Tallaght, County Dublin, is commemorated in the mass from which this small book derives its name. The book was at Lorrha, County Tipperary, in the early eleventh century and reappeared in the Duke of Buckingham's library at Stowe in England; hence the modern name.

The book, in Latin with some Irish, written mainly in compressed Irish majuscule, contains two different documents: an excerpt from the Gospel of St. John and the Missal. Pink and yellow are the principal colors. There are some large, ornamented initials, some pages with broken frames, and a portrait of St. John.

The vertical panel of the frame on one page bears interlaced birds much in the manner of the Book of Lindisfarne of about A. D. 700 (Fig. 26); the initial on the same page has opposed spirals in the center of the letter and a drawing of a stud or boss in the tail. St. John, dressed in the style of the St. Gall Gospels of the mid-eighth century, stands against a decorated curtain; his symbolic eagle rises above it. He is flanked by panels of fret pattern and knotted interlace.

Bibliography: IA I, p. 201, pl. 112.

37/38. The Book of Kells, vols. II and IV,
 the Gospels of St. Mark and St. John

Early Christian period (second phase), mid-eighth
 century
Vellum
H. (trimmed) 33 cm.
Library, TCD, 58

This famous manuscript contains the four gospels (in a mixed Old Latin and Vulgate text), in Irish majuscule script, brilliantly illustrated. The ornament varies from pages fully covered by the most detailed designs in strong colors to quick animal portraits sketched between the lines of an otherwise plain page. As Françoise Henry has shown, several artists were employed for the principal pages: one for the formal portraits of the evangelists, one for the dramatic scenes such as the Temptation of Christ, and a third for the great ornamental pages. Here (37/38d) detail is piled upon detail, and one is left to marvel at how the unaided eye and the unsupported hand could trace the intricate designs. Areas of blank vellum are few on these pages.

The chief difference between the Book of Durrow and the Book of Kells is the complexity of Kells' design. Those who decorated Durrow were not afraid to leave large areas of blank vellum to complement the beauty of their designs. In Kells the motifs that Durrow handled relatively simply—ultimate La Tène spirals, Mediterranean interlace, and Germanic animals—are repeated and developed both in pattern and detail.

In addition to the gospels, prefaces, summaries, and tables of concordance, the book contains some legal documents of the eleventh century that concern the abbey of Kells. The *Annals of Ulster* record that both the book and its now vanished shrine were stolen from Kells in 1006. Since the connection with Kells goes back to the beginning of the eleventh century, it may be speculated that the book was written there some centuries earlier.

Some say the Columban monastery at Kells was first founded in A. D. 806 to receive the community from Iona when Viking raids made their continued stay on that exposed island impossible. If this is the case, and if the Book of Kells was in fact written at Kells, then the book cannot be older than the ninth century.

But to judge the book on purely stylistic grounds with no thought for geographic associations, it belongs with the Ardagh chalice (33) and the Tara brooch (32), both of which were made in the first half of the eighth century. Many of Kells' pigments are applied in a complicated manner like those in the Book of Lichfield, made no later than the eighth, or perhaps even in the late seventh century.

Old records show that the Kells church was rebuilt after a fire in A. D. 804, and the site may have been the scene of ecclesiastical activity in the eighth century or even earlier. However, if this early monastery was rich enough to afford such a treasure as the Book of Kells, it is curious that the early annals are silent about it. The early Christian style of ornament strongly indicates that the book originated in a wealthy Columban foundation either in Ireland or in Northumbria. Wherever it was written, it quickly found its home at Kells.

Bibliography: E. H. Alton and P. Meyer, *The Book of Kells,* 3 vols., Bern, 1950; Françoise Henry, *The Book of Kells,* London, 1974.

39. Bone trial piece
Early Christian period (second phase), eighth century
L. 22 cm.
Lagore Crannog, County Meath
NMI, W. 29

Metalworkers' designs were developed, and apprentices were trained, on bone rather than on precious metal. The grain in wood could cause technical difficulties, but the outer wall of the bone of a large animal was free from grain and was firm, but not too hard—ideal for cutting "trial pieces." Various designs—interlace, triquetras—are lightly scratched over most of the surface of the present example. The upper surface was polished, and designs were cut into the bone, but none were completed. There are small panels of interlace, both with and without a

decorative frame. The interlaced straplike animals, with hatched bodies, spirals where the limbs are attached, and heads with rolled-back snout and pointed oval eye, are very like a pattern on the back of the eighth-century Tara brooch (32).

Bibliography: IA I, p. 93, pl. 37; TI, p. 86, fig. 56.

40. Large Ardagh brooch

Early Christian period (second phase), eighth century
Silver, gilded, with added glass
L. 33.5 cm.
Near Ardagh, County Limerick
NMI, 1874: 10

This is a large silver-gilt pseudopenannular brooch of the Tara class, with a semicircular plate that occupies more than half of the circumscribed area. The ring is rectangular in cross section. The plate protrudes slightly beyond the ring, and the latter runs simply into the plate without a connecting collar. Most of the decoration is of knotted interlace.

The pinhead is of the Tara type, heavily decorated with interlace patterns. The pin itself carries on its front a long "incision" whose parted lips reveal an elongated interlace design.

The plate is semicircular with a broad but shallow indentation along the top. A series of arcs lie parallel to the heavy rim. These are broken by transverse ridges into panels filled with interlace. Near the upper corners are two settings for studs; one of these still holds a silver stud into which triangular wedges of glass have been inserted. The triangles that lie to the right and left of the center of the plate have been most ingeniously built up into stylized duck bodies. The wings spring from spirals and are covered with a design suggesting feathers. Metal has come away from one plate, revealing a decorated material described as bone. The thin metal plates of the bird bodies were embossed on a decorated former. The erstwhile gap between the terminals is suggested by the ridges that continue the vertical lines of the central rectangular plate. In the center is another duck, facing downward; it has a rounded back, an upturned tail, and boldly marked wings. Below the rectangular plate is a base for another fitting. Possibly a fourth duck lay here.

On the back a faint incised line borders both the plate and the ring, which runs abruptly into the plate. As on the front, the back of the plate has symmetrically placed rimmed sectors of circles on either side; these hold copper-gilt kerbschnitt plates, each with a crouching interlaced beast. Protrusions mark the position of the rivets or pins of the fittings on the front of the plate, and near the lower margin is a perforated lug for tying the plate to the pin.

This brooch is probably contemporary with the two chalices of the Ardagh hoard.

Bibliography: CAAI, pls. 54, 55; CACP, pl. VII; IA I, pl. 39; TI, p. 94, fig. 60.

41. Silver-gilt pseudopenannular brooch

Early Christian period (second phase), eighth century
Silver, gilded, with added gold
L. 18.75 cm.
County Cavan (?)
NMI, W. 43

This is a pseudopenannular brooch of the same class as the Tara brooch, with connected expanded terminals that occupy about one-third of the circumscribed area. The ring is semicircular in section and decorated with two bands of interlace. At the top of the ring two animal heads face outward. Between them is a subrectangular area bearing a recessed rhomboid. The lines of the ring are carried onto the terminals by two more animal heads, which appear to grip the terminal plates in their jaws.

The pinhead takes the shape of a rounded triangle with three animal heads on its rim. Between the heads are three-dimensional crescents bearing interlace ornament. In the center of the head is a gold plate, with appliqué pellets surrounded by a circle of beaded gold wire. In the center of the plate are four symmetrically arranged peltae. The pin is decorated with an interlace knot at the junction of the head and a strip of interlace halfway down its shaft.

Each terminal is triangular, with two straight and one curved side, defined by a raised rim. Where the terminals meet the ring the rim coils and ends in a small birdhead. Most of the remainder of the terminal plate is occupied by a round-angled triangle almost identical to that on the pinhead. The four remaining spaces are occupied by self-interlaced ribbon-beasts with biting jaws clutching their crosshatched bodies. Every area not filled with an animal body is filled with interlace. The terminals are connected by a strap flanked by two small human faces, upright above, inverted below; locks of hair, which terminate in spirals, frame the faces.

The back of the plate is decorated with animal heads in silhouette.

Bibliography: CAAI, pp. 130-131, pl. 22; IA I, p. 111, pl. 44; TI, p. 94, pl. 28.

42. Penannular brooch
Early Christian period (second phase), eighth century
Silver, with added gold and enamel
L. 16 cm.
Kilmainham, County Dublin
NMI, W. 45

A brooch of the Tara type but penannular with quadrilobate terminals. The ring is straplike in cross section.

Nearly all of the pinhead was broken off; the base alone survives, and this bears a semicircular setting probably originally for red enamel.

At the top of the ring is a boldly bordered oval com-partment containing a central circular cell that still carries traces of enamel. Gold plates, bounded by twisted wires and ornamented by a simple interlace pattern, lie on either side.

The ring is decorated in high relief; it is outlined by double ridges that enclose a flat area for decoration. The space is filled with square cells and gold plates adorned with spiral filigree, twisted gold wire, and beaded spirals. A pair of reflexed animal heads appear where the outer ridge joins the terminals.

Each terminal is in the shape of a quatrefoil built up from a central square with semicircular lobes rising from its sides; small circular cells lie at the outer corners of the square; the three free lobes each bear a semicircular cell at the highest point of the arc; the fourth lobe is attached to the crescent-shaped ring end; the angle of attachment leaves the terminals inclined to one another. All the cells on the terminals were originally filled with red enamel. The edges of the central square are built up to form a three-dimensional setting for a gold plate with a margin of twisted wire surrounding a simple quatrefoil knot; in the center of the knot is a circle of filigree. The semicircular spaces surrounding the central square also contain gold plates bordered by twisted wire; two spirals turned inward, pelta fashion, rise from the base; centered above them is a circle of wire.

On the back, which is essentially flat, the oval compartment at the top of the ring is repeated and contains two engraved affronted interlaced dogs, each with only one fore- and hind limb.

The quatrefoil terminal recalls the opening page of St. Luke's Gospel in the Book of Kells (*fol.* 188R, **37/38f**); the layout of the ring recalls the flange around the foot of the Ardagh chalice (**33**). The brooch too is of the eighth century.

Bibliography: CAAI, pl. 22; IA I, p. 95; TI, p. 96, pl. 25.

43. The Book of Armagh
Early Christian period (second phase), early ninth
 century
Vellum
H. 19 cm.
Library, TCD, 52

The Book of Armagh is well named as it seems always to have been associated with that important ecclesiastical center. On *fol.* 53v it is stated that the book was written by Ferdomnach, under the direction of Torbach, Abbot of Armagh, who held office for one year only in A. D. 807.

The book is small and contains a complete New Testament text in Latin and St. Patrick's *Confession* and his *Letter to Coroticus,* both considered authentic. Also included are a number of documents asserting St. Patrick's connections with Armagh and Sulpicius Severus's *Life of St. Martin.* All are written in Irish minuscule with three full-page pen and ink drawings and many pen-drawn initial letters; yellow, red, blue, and green are the colors employed.

Impeccable ultimate La Tène spiral motifs occupy some of the initial letters; the comb of the four-winged eagle (here carrying a fish) that represents St. John resembles the combs of the birds of the Book of Dimma (**35a**).

Though it is technically a product of the ninth century, the book is clearly in the eighth-century tradition.

Bibliography: IA II, pp. 100-102, pls. 18, 29, 30, 33; J. Gwynn, *Liber Ardmachus, The Book of Armagh,* Dublin, 1913.

44. Bronze bell of Clogher
Early Christian period (second phase) late eighth century
 or later
H. 25 cm.
Donaghmore, County Tyrone
NMI, P. 1004

This simple cast-bronze bell is subrectangular in cross section. Such bells are difficult to date; this one may be as early as the end of the eighth century. Tradition holds that it was given by St. Patrick to St. Mac Carthainn of Clogher. The name PATRICI appears on the front and the date 1272 on the back.

The tradition is clearly older than the extant bell; the name and date were probably added long after the bell was made.

Bibliography: CAAI, p. 144, pl. 46; CACP, pp. 66, 67; IA II, p. 124.

45. St. Patrick's bell
Iron, with added bronze
H. 20 cm.
NMI, R. 401

This iron bell is subrectangular in section and was formed of two thin sheets bent to appropriate shape and riveted together. The handle was separately shaped and brazed into place. The completed bell was then dipped in bronze. The tongue appears to be a later addition.

Such simple bells, of the type hung around the necks of some domestic animals, have a long history. A smaller bell of sheet iron, with traces of bronzing inside, was found at the rath at Feerwore, County Galway, where the excavated material appeared to belong to the pre-Christian Iron Age. High crosses and other carved stones often depict ecclesiastics with bell and crozier.

Such a bell—perhaps this one—could have been used by St. Patrick and buried with him in his grave. The *Annals of Ulster* for the year A. D. 552 record that St. Columba removed three relics, including the Bell of the Will, from St. Patrick's tomb.

Bibliography: CAAI, p. 156, pl. 78; CACP, p. 47.

4 The Viking Impact
Máire de Paor

In this year terrible portents appeared in Northumbria and miserably afflicted the inhabitants; these were exceptional flashes of lightning and fiery dragons were seen flying in the air. A great famine followed these signs; and a little after that in the same year on the 8th January the harrying of the heathen miserably destroyed God's church in Lindisfarne by rapine and slaughter.

This entry in the *Anglo-Saxon Chronicle* for the year 793 records, in the doomful prose that was to become typical, the first attack of the Vikings on an Irish monastery. The annalist was a Christian monk, and his account spares no emotion. It was the beginning of a long series of pirate raids on the monasteries of both island and coast. Lambay, off Dublin, was raided in 795, as was Iona; and in quick succession, in the early years of the ninth century, came attacks on Inishmurray, Bangor, Downpatrick, and many other monasteries, heralding two centuries of warfare between the Irish and what a later chronicler called "foreign, wrathful, purely pagan people."

The monasteries were the chief centers of art and learning and were, in many cases, rich and powerful. They were the repositories of much of the wealth of the Irish kings and the only major centers of population. The early attacks, which came from the sea, brought with them the added terror of the unknown. Later the plundering and burning of Irish churches was sometimes carried out by Irishmen or Irishmen and Vikings together. The raiders were people who differed in language, religion, and custom from the monks who wrote about them, and the sudden onslaughts on defenseless monasteries are eloquently reflected in the Irish records.

Is acher in gáith in-noct
fu-fuasna fairggae findfolt:
Ní ágor réimm mora minn
dond láechraid lainn úa Lothlind.

("The wind is rough tonight, tossing the white hair of the ocean; I do not fear the fierce Vikings, coursing the Irish sea") wrote a monk in the margin of a manuscript he was copying—a manuscript now preserved in the St. Gall Library in Switzerland. The twelfth-century *Wars of the Irish with the Foreigners (Cogadh Gaedhel re Gallaibh)* presents a graphic if somewhat highly colored picture of

immense floods and countless sea-vomitings of ships and boats and fleets so that there was not a harbor nor a land-port nor a dun nor a fortress nor a fastness in all Mumhan without floods of Danes and pirates . . . so that they made spoil-land and sword-land and conquered land of her, throughout her breadth and generally; and they ravaged her chieftainries and her privileged churches and her sanctuaries; and they rent her shrines and her reliquaries and her books.

This was the time when many objects were carried off to Scandinavia as loot or merely as souvenirs and later found their way into Norwegian museums.

The first Scandinavian raiders came in small groups, mainly from the fjords of western Norway. They were expert shipbuilders and adventurers whose first forays were probably mere chance landings, but soon, as their raiding made them familiar with the coast and rivers, and with the suitability of the country for settlement as well as for trading, they began to establish more permanent bases.

At the same time they were building major trading centers in their homeland at such strategic sites as Kaupang, Hedeby, and Birka. There, great markets handled furs and walrus ivory from the far north, cloth from continental Europe, fish and silver from Moorish Spain, and textiles and luxury goods from the East. The Scandinavian merchants of the ninth and tenth centuries built up a system of seaborne commerce that extended their interests to bases and colonies far from their own shores. Though the Vikings were able to move inland and settle

in Britain and France, in Ireland the story was rather different. Here they contented themselves with a string of coastal settlements that became trading centers and eventually towns at Dublin, Waterford, Cork, Limerick, and elsewhere. When the Viking town at Limerick was raided by the Irish in the late tenth century the victors carried off the Vikings' "jewels, their saddles beautiful and foreign, their gold and silver, their beautifully woven cloth of all colors and all kinds; their satins and silken cloths pleasing and variegated both scarlet and green." Dublin was certainly no less wealthy. In 1023 the city is said to have paid a neighboring chief a tribute of twelve hundred cows, sixty ounces of gold, the same of silver, one hundred twenty Welsh horses, and a special trophy known as the sword of Carlus.

The excavations carried out over the past ten years by Breandán Ó Ríordáin of the National Museum of Ireland on the site of Viking and medieval Dublin have shown that it was a wealthy and important town in ninth- and tenth-century Europe, the hub of an extensive trade. This city and no doubt the other Viking towns of Ireland stood apart from native society but nevertheless had important influences on the art of the period.

For a long time it was accepted by scholars that the Viking raids had on the whole a damaging effect on Irish art, particularly on the art of the metalworker and manuscript illuminator. The ravaging of monasteries was thought to have disrupted the calm necessary to produce fragile and fine works of art. Little work apart from stonecarving seems to have been done in the ninth century, and what was done was cruder and coarser and by no means comparable to the exquisite masterpieces of the Golden Age. Undoubtedly, disruptions and destruction took place; monastic workshops were plundered; shrines were damaged and stripped of their ornaments; books, of no interest at all to the illiterate raiders, were "drowned" or otherwise destroyed. But this is the negative aspect.

The Vikings were responsible for changes in taste in Irish art and were instrumental in opening up new markets and bringing the Irish artist into contact with the current trends in England and continental Europe. In the light of recent research, a great deal of high quality metalwork can be assigned to the two centuries following the first raids.

Some of the ornamental styles, conventionally named for Scandinavian centers, made their way to Ireland, where they usually appear in a modified form. The Jellinge animal style, with its disjointed ribbon-beasts, appears in Ireland mainly on bossed silved brooches, although it occasionally occurs elsewhere—perhaps on some panels of the *Soiscel Molaise* (**57**). It was never so popular in Ireland as in the north of England or on the Isle of Man. This style existed in the tenth century, the early Viking period when Ireland was being developed as a center of long-distance seaborne trade. Perhaps the most important commodities in this commerce were silver (mostly from North Africa) and slaves (from Europe, including Anglo-Saxon England). The Jellinge style coincides with the increased use of silver in the manufacture of brooches and other objects in Ireland.

The Ringerike style, more distinguished by vegetable than animal motifs, is most typically characterized by the restless intertwining of free-ended lobed tendrils. It appeared in Ireland early in the second half of the eleventh century; possibly the Norman conquest of England in 1066 caused a migration of the London colony of Scandinavian craftsmen to the Norse city of Dublin. The vegetal elements were short lived in the Irish version of the Ringerike style, which became marked principally by animal elements. However, the "wild Ringerike locks," the distinctive loose, lobed terminals, were retained.

Finally, the Urnes style, based on the motif of a quadruped beast enclosed by a writhing, wiry serpent, began to appeal widely to Irish craftsmen at about the end of

the eleventh century, a generation or more later than its Scandinavian heyday. In Ireland the style was much more disciplined. Its full development came in the twelfth century on such splendid objects as the cross of Cong (63).

Little manuscript decoration survives from the Viking period, and it will never be known how many books were destroyed. Two examples survive from the eleventh century. The Psalter of Ricemarch (Fig. 28) was written in Wales by a scribe called Ithael and decorated by Iewan. Iewan was the son of the Welsh scribe Sulien who lived in Ireland for several years. Ricemarch differs from the purely Irish type of psalter since it contains the Hebrew version of the psalms. The book can be precisely dated to between 1076 and 1081. Its decorated initials in red, yellow, and green are mainly in the form of convoluted animals and although elegantly drawn have little variety. The loose lobed ends and foliage elements in the borders of some pages show Ringerike influence.

The Liber Hymnorum (Fig. 29) is one of two volumes containing Irish and Latin hymns. The other is in the Franciscan Library in Killiney. They are very similar—the present example can be assigned by its script to the late

Fig. 28. Decorative detail, *fol.* 20R, Ricemarch Psalter, TCD

Fig. 29. Decorative detail, *fol.* 35R, Liber Hymnorum. TCD

eleventh century; the Killiney book was made perhaps a little later. The main decorative scheme of the Trinity hymnbook consists of an enlarged capital at the beginning of each verse. The colors, though now rather faded, were originally brilliant red, yellow, green, and purple, varied by dotting and hatching. The capitals are again of twisted animal motifs but are surrounded with foliage patterns quite similar to those on eleventh-century croziers and book shrines. Although they are more carefully executed than on metalwork, they relate to the Irish Ringerike trend of the late eleventh century. The Killiney hymnal shows traces of the Urnes beast-and-snake combat theme which was popular on metalwork.

If the amount of surviving manuscript material is meager, this is not so of metalwork. A number of brooches, which have sometimes been rather haphazardly assigned to the eighth century, are now more appropriately and securely attributed to the early part of the ninth. The Killamery brooch and the two smaller Ardagh brooches (47-49) have linked terminals of the "pseudopenannular" type. They extend many of the traditions of the Tara type but are made of silver, have marginal animals, brambled bosses, and a kind of bird ornament, all of which help place them in the ninth century.

Fig. 30. Bossed silver brooch, NMI

Clearly there was a great wealth of silver in ninth- and tenth-century Ireland, which dictated a change in the fashion of ornament. Although Anglo-Carolingian influences are apparent here as elsewhere, the use of plain silver (in contrast to the polychrome effects of gilt-bronze, enamel, and gold filigree of the eighth century) is largely due to the existence of Viking trade, which resulted in the importation of vast quantities of that metal for the first time. The enormous wealth of ninth- and tenth-century silver is demonstrated by the 104 hoards and over 150 single finds of silver and gold from Ireland of the Viking period.

Some of the ornaments of the later ninth century show the type of art that developed in a Norse-Irish milieu. Most numerous of these are the bossed brooches (Fig. 30). The dominant decorative feature of these penannular silver brooches is an arrangement in the subrectangular terminals of a number of large bosses connected by bands, which provide a frame for the animal ornament. Some with panels of Jellinge-type animals are now firmly datable between A. D. 850 and 950. Whether the distinctive features of these brooches owe more to Anglo-Saxon or Norse influence is still a matter of debate, but the distribution of the type makes a strong case for a truly Irish origin, probably in the northern part of the country.

The fine piece long known as the "University brooch," (50) because of its deposition at Trinity College, Dublin, is now established as having come from a Viking burial on Rathlin Island, County Antrim. Although quite rightly included in the bossed-brooch type, it belongs to a small subgroup with subtriangular terminals and bosses with filigree ornament. An unusual feature is the crest of lobed loops on the outer margin of the ring. Its closest parallel is from Norway, and the Rathlin brooch may well have been made by Vikings in Ireland. The decorative devices on the University brooch are typical of the products of the Viking colonies in the region of the Irish Sea.

The silver "thistle" brooches (**51, 52**) are of Irish origin and derive from early-ninth-century rosette brooches. The fully developed form is penannular with spherical brambled terminals; the head of the pin, also spherical, often has a flattened top with geometrical ornament. The type appeared in Ireland in the late ninth century, and evidence found in coin hoards suggests that this type went out of fashion about the middle of the tenth century. Some of the later brooches are very large and elaborate, and in Scotland and Scandinavia, where the type was soon adopted, the terminals sometimes have flattened facets with incised animal ornament in the Jellinge style. The great size of some thistle brooches recalls the stipulation in the ninth-century legal tract, the *Seanchus Mor,* that the silver brooch reflect in size and value the rank and dignity of its wearer.

Numerous bronze cloak pins (a few were made of silver) with variously ornamented heads and sometimes ornamented shafts, belong to this period. The most elaborate type is that known as the "kite" brooch—very long pins with large pendant heads whose shape gives them their name. An example from Kilkenny (**53**) is adorned with fairly simple interlace and very stylized animal heads. These are absolutely in the Irish tradition, and again the interaction of native and foreign workshops may be seen.

The ninth- and tenth-century metal workshops often produced shrines and reliquaries as well as personal ornaments. Bells, books, and walking sticks, the insignia of the cleric, were often enshrined in jeweled metal cases. This custom, although it originated in the Golden Age, became more common in later centuries, and many of these shrines bear the decoration of more than one period. The surfaces of tenth-century croziers, instead of being decorated overall with filigree, enamel, and chip carving, are divided into boldly framed panels, each containing a pattern of animal ornament (Fig. 31) or interlace. This type of surface division may derive from the English style, but it is significant that there is a similar development in sculpture. Flat carving and coating with gold or silver take the place of chip carving and filigree, and the general design is bolder and more clear cut. The quality of the interlace shows an astonishing decline and spiral ornament almost ceases, but there is a liveliness and verve in animal ornament, which can also be seen on the back of some brooches (**47**).

The dating of these objects to the early tenth century on stylistic grounds has been supported by the discovery of trial pieces in recent Dublin excavations. A bone trial piece (Fig. 32) found at a tenth-century level has animal

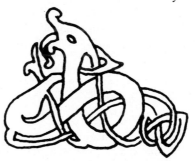

Fig. 31. Animal ornament on knop, Kells crozier, about A. D. 950. The British Museum, London

Fig. 32. Bone trial piece from excavations of Viking Dublin, Christ Church Place. NMI

patterns closer than any hitherto known to those on the Kells crozier (Fig. 31). This remarkable correspondence with the products of a Celtic monastery is repeated for the eleventh century. A bone trial piece, again from Dublin (Fig. 37, p. 189), bears a Ringerike-style pattern almost identical with that on the shrine of the *Cathach* (Fig. 36, p. 188). The shrine is firmly dated to the eleventh century by an inscription referring to the artisan Sitric Mac Maec Aeda, known to have worked then.

Several other trial pieces of bone and stone carry patterns related to the single animal figures or pairs of intertwined animals and rather inferior interlace found on the Kells crozier. The four-sided bone trial piece from Dungarvan (54) has finished, deeply cut designs and may have actually been used to make wax molds for bronze casting. The backward-turned heads and curled-out jaws of some of the animals are very close to those on the crozier, as are the paired creatures; a tenth-century date would be appropriate.

The latest appearance of these curly-jawed animals is on the book shrine known as the *Soiscel Molaise,* or Gospel of St. Molaise (57), presumably in reference to the book it originally contained. This reliquary was remodeled several times—it seems to have been originally a house-shaped shrine—but the main part of its decoration can be dated by its inscription to between 1001 and 1025. It is made of bronze and covered with silver plates. The front or cover is decorated with a cross and panels of interlace and animals in rather coarse gold filigree; the symbols of the evangelists appear in silver-gilt. The majestic figure on the back probably represents Molaise, who is surrounded by closely enmeshed animal interlace and four panels of similar animal forms. The vigor of the figural sculpture—so rare in Irish metalwork—is best paralleled on some tenth-century crosses. The figure of the saint is in an almost Romanesque style; the artists would soon return to their preoccupation with abstract themes.

During the ninth and tenth centuries some elements of foliage design were added to the traditional Irish repertoire of spirals, interlace, and animal patterns. These seem to be English or Anglo-Carolingian in origin and appear on certain panels of croziers and bell shrines and also on the bronze crucifixion plaque from Clonmacnoise (55). The framework of lozenges and vertical lines was a short-lived trend in Irish art, occurring only in the ninth and tenth centuries. The treatment of the Crucifixion with lance- and spongebearer is paralleled on Irish stone crosses, and the staring eyes and forked beard are close to the figure on St. Molaise's shrine. This plaque is one of a series designed to be affixed to wood or leather and perhaps used as book covers or paxes.

The only complete bell shrine related to these objects is that known as the *Corp Naomh* ("holy body," 56). Like so many other shrines, it shows the work of several periods. The front bears a stylized standing figure flanked by horsemen and birds, very similar to those on some crosses. The pair of animals on the back recalls pairs of lions and dogs on ninth-century Canterbury manuscripts. The figures of the riders with pointed beards are like the figures on the Clonmacnoise plaque (55); this part of the shrine may have been made in the tenth century.

It seems to have been during the Viking wars that stone churches with mortar began to replace wooden buildings on many monastic sites. In the absence of ornament or distinctive moldings it is difficult to be precise about the dating of these structures. Many of their distinctive features, such as the high-pitched roof and *antae* (the extensions of the side walls beyond the gable ends) derive from wooden buildings. While most of these simple single-cell churches would have had roofs of timber—shingled or thatched—a few solved the problem of roofing in stone by inserting a supportive semicircular vault under the roof. One of these—St. Columb's House at Kells—is thought to have been built to house the Co-

lumban relics brought from Iona in 814 after the destruction of that monastery by Viking raiders. Another small stone church, St. Kevin's at Glendalough, has an attached belfry (Fig. 33). This seems to have been an early experiment that occurred in a few other cases, but for the most part it was common to build a freestanding bell tower. These elegant tapering round towers, built of mortared stone, were perhaps based on early belfries such as that at Ravenna; more than sixty still survive on Irish monastic sites, though many are in ruins; thirty are complete. They usually have four or five stories with wooden floors and only one slit window to light each floor. The topmost story under the conical cap always has four or more windows, and from them the monk would have rung his hand bell to mark the canonical hours. Although they were built primarily as belfries (the Irish name for them, *cloicthech,* means literally "bell house"), they soon began to serve as places of refuge for monks and valuables. In almost all cases the doorways that faced the principal

Fig. 33. "St. Kevin's kitchen"; stone-roofed church with attached belfry and round tower, Glendalough, County Wicklow

church are ten to fifteen feet above ground level and could only be reached by ladder. The round towers vary in height from 70 to about 120 feet and continued to be built until the twelfth century, when a few were given decorated doorways and Romanesque moldings. The tower added unity to the scattered buildings of the monastery and remains the most significant early Irish contribution to architecture.

The most striking achievement in the art of the time was the development of stone sculpture. Up to now, the Irish stonecarvers had translated the abstract patterns of the painters and metalworkers into stone, and figural sculpture was subordinate or absent altogether. But beginning in the early ninth century, the sculptors of the high crosses began to depict biblical scenes, copying on stone what was shown elsewhere on ivories and frescoes. On the earliest cross, at Kells, carved shortly after the Iona community reached Ireland, scenes from the scriptures appear mingled with abstract ornament. Throughout the ninth and tenth centuries there were astonishing stylistic developments. The crosses became larger and more architectural. The shafts were divided into panels (a tendency also noted in metalwork) and an orderly and systematic iconography emerged. The scenes from the Old Testament and from the life of Christ seem to have been inspired not only by Carolingian influences but also by changes in the liturgy. A favorite prayer of the time, the *Ordo Commendationis Animae,* was known in Ireland from about A. D. 800 and is preserved in a contemporary martyrology as well as in the Stowe Missal (**36**) of about the same date. This prayer for the dying invokes God's help—the help that spared the faithful of the Old Testament and saved Isaac from the hand of his father, Daniel from the lions, Jonah from the whale. The carved crosses are a parallel of the texts. Though much of the iconography seems to have been developed on a group of granite crosses in the Barrow valley, at Moone (Fig. 34), Castle-

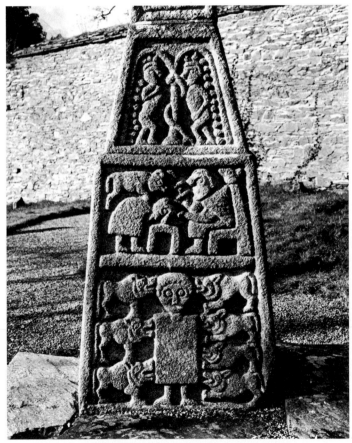

Fig. 34. Detail of base, Moone cross, ninth century, County Kildare. Bottom: Daniel in the lion's den

dermot, and elsewhere, the great sandstone crosses of the tenth century at Kells, Monasterboice, Clonmacnoise, and Durrow represent the apogee of the style. The best-preserved example—Muiredach's cross at Monasterboice (Fig. 35)—so called from an inscription that also dates it to the early tenth century, is an amazing achievement for its time. The cross is massive and nearly eighteen feet tall with the Crucifixion and scenes from the life of Christ on the east face, the Last Judgment and scenes from the Old

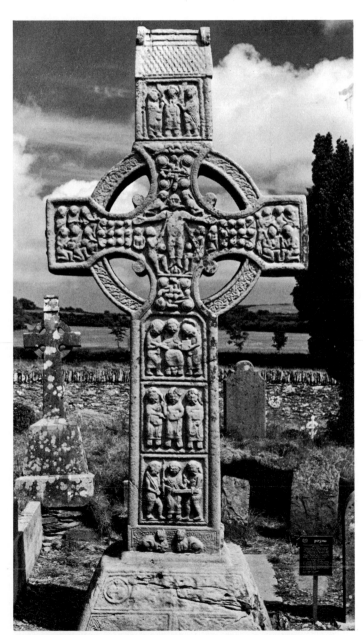

Fig. 35. West face of Muiredach's cross, about A. D. 922, Monasterboice, County Louth. Bottom: the arrest of Christ

Testament on the west. The carving is in bold, rounded relief, and details of dress, ornament, and weapons support the tenth-century dating. Viking-type swords and both kite and thistle brooches may be seen on the panel depicting the arrest of Christ. The elaborate Judgment scene, with its Coptic echoes in the Osirian attitude of Christ and the weighing of the souls by St. Michael, foreshadow the Romanesque style. The resemblances in carving and iconography among the crosses at Durrow, Kells, Clonmacnoise, and Monasterboice on the Midland plain suggest that they are the work of the same atelier.

One Irish monastery, Monasterboice, apparently escaped Viking plunder, although it was near Viking encampments; it has sometimes been suggested that in some way it was under Norse protection or had a special relationship with the east-coast Vikings. At any rate, it seems likely that by the end of the tenth century the Scandinavians in Ireland were already largely Christian, and this conversion was to have a general effect on their relationships with the Irish.

The Viking trading towns and their leaders were gradually brought into the Irish political system too, as tribute payers to provincial kings, whose power was expanding. Two significant defeats of the Dublin Scandinavians, at Tara in 980 and at Clontarf in 1014, checked that city-kingdom as a power in Irish affairs. At about the same time Limerick was brought to heel by the developing kingdom of Thomond, ruled in the eleventh and twelfth centuries by the descendants of Brian Boru, the O'Briens. Before the tenth century ended the Dublin Norse had begun striking silver coins in imitation of Anglo-Saxon coins; these were plainly for use in trade in England rather than in Ireland. The trading cities remained outward looking and maintained familial as well as commercial connections abroad. Their dealings with the Irish hinterland were not the only, or the most important, part of their activities. They became an important medium for the transmission to Ireland of new influences from abroad, and by the beginning of the eleventh century the first effects of these influences were already apparent. The Scandinavians sought to establish territorial bishoprics, on the English and continental rather than the Irish model, and they sent priests to England to be consecrated to the episcopate. This was to stimulate an important movement of organizational change in the Irish church. As centers of accumulating wealth and manufacture in which crafts and arts flourished, the towns catered to a growing market for luxury and display goods. The Norse were to make their greatest impact on Irish art when they assumed an integral role in the Irish scene.

46.
Pseudopenannular brooch,
near Roscrea,
County Tipperary

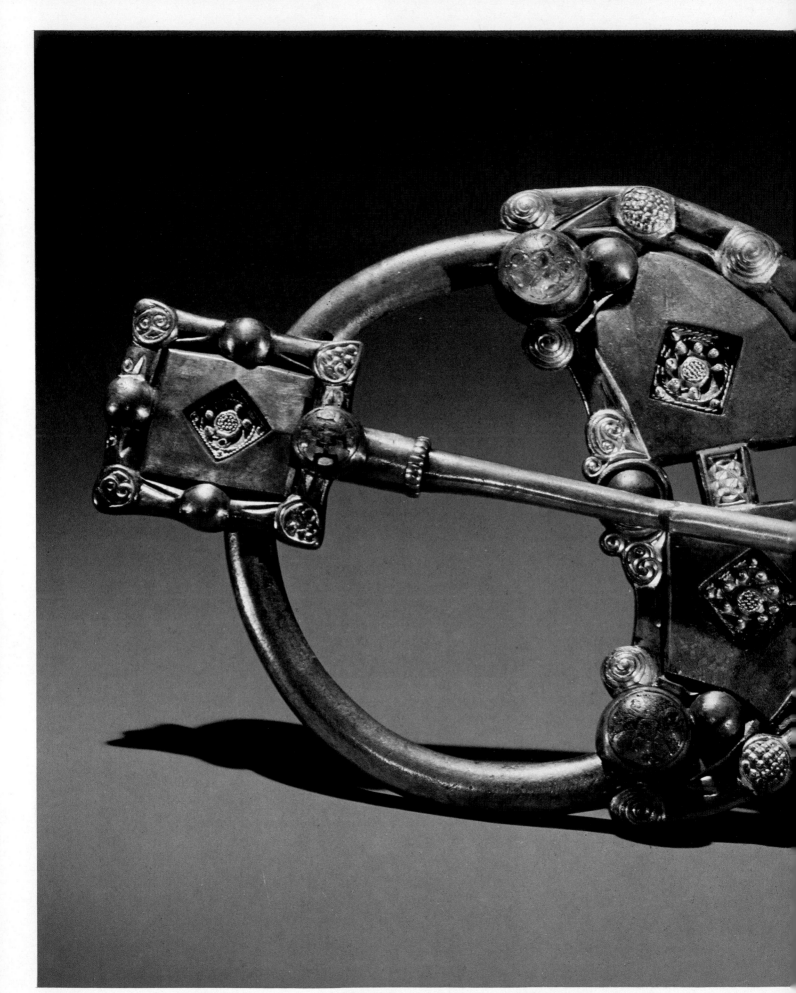

47. Pseudopenannular brooch, Killamery, County Kilkenny

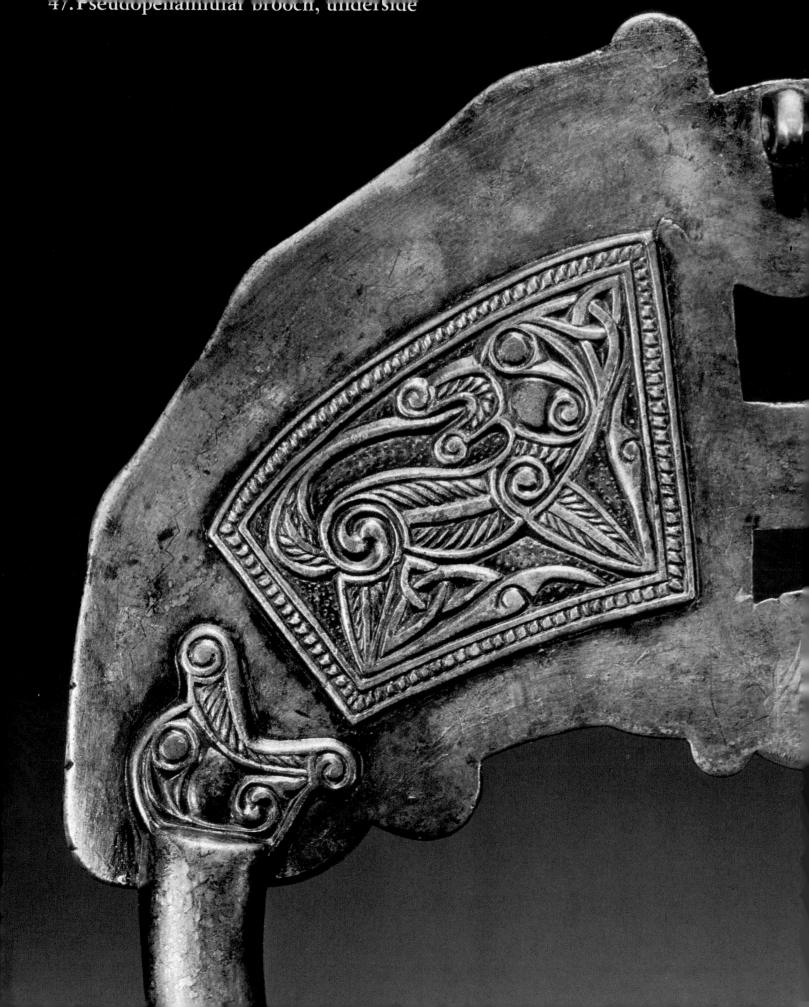

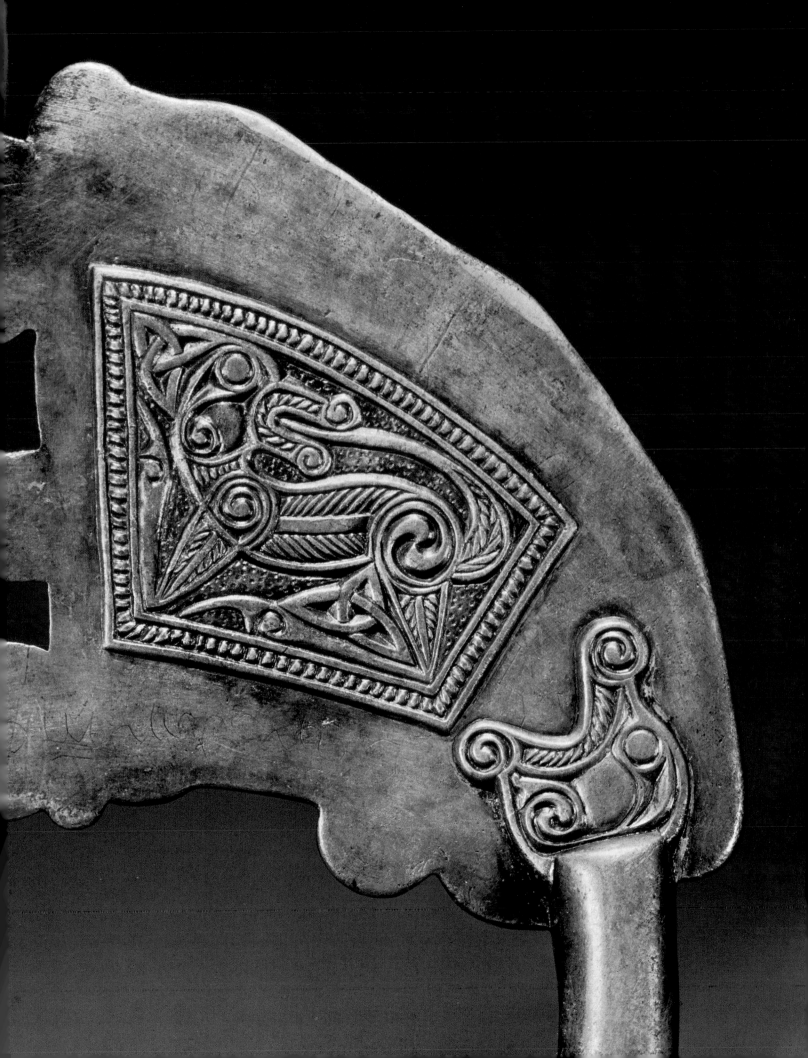

48.
Pseudopenannular
brooch,
near Ardagh,
County Limerick

49.
Pseudopenannular
brooch,
near Ardagh,
County Limerick

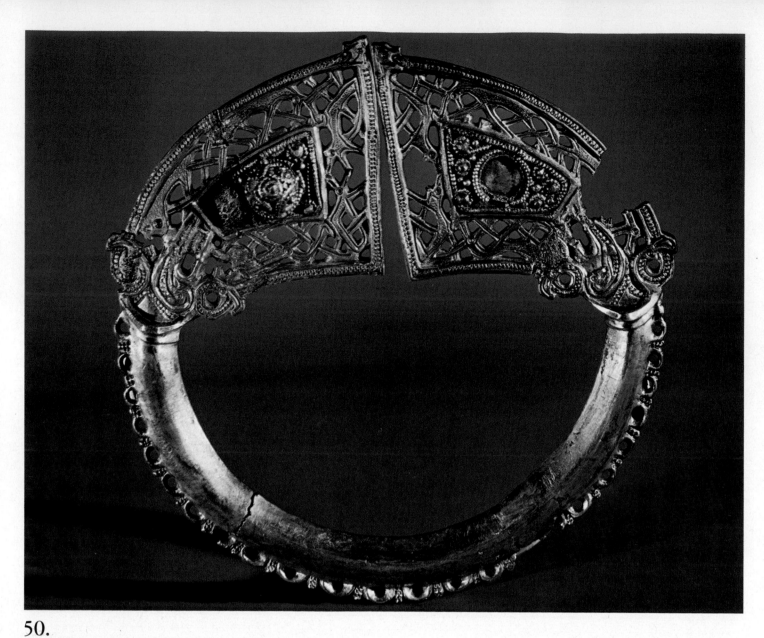

50.
Silver penannular brooch,
Rathlin Island,
County Antrim

51.
Silver-gilt thistle brooch,
near Ardagh,
County Limerick

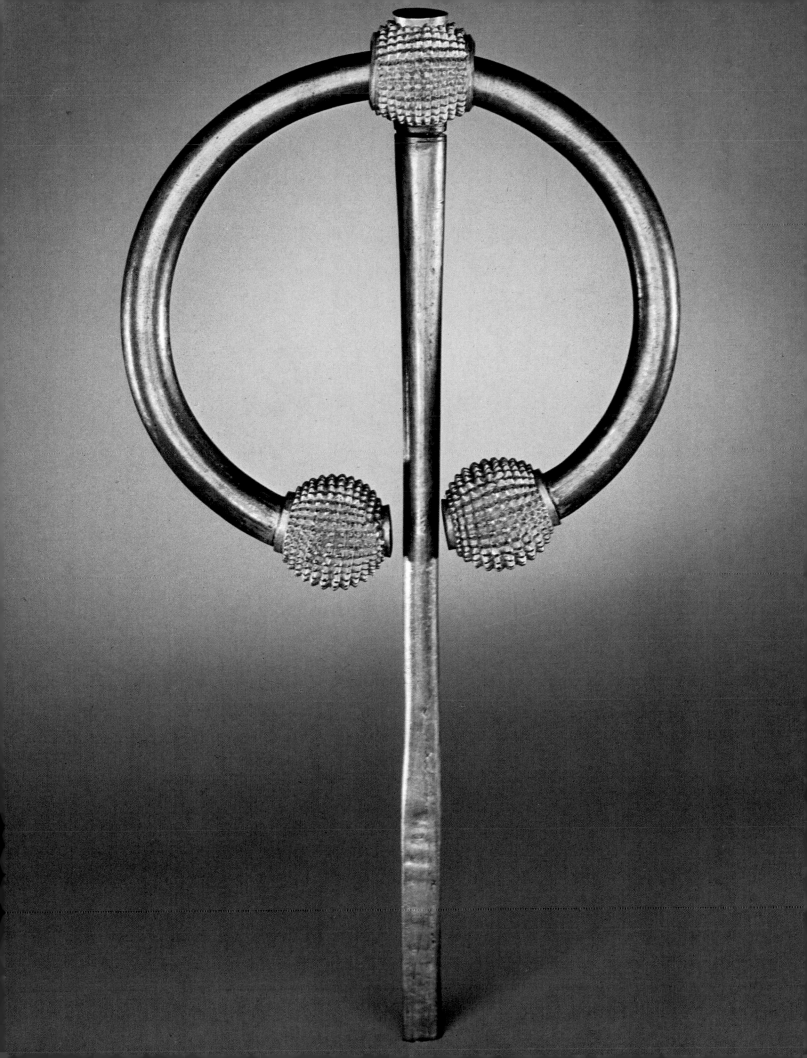

52. Silver thistle brooch, Cashel, County Tipperary

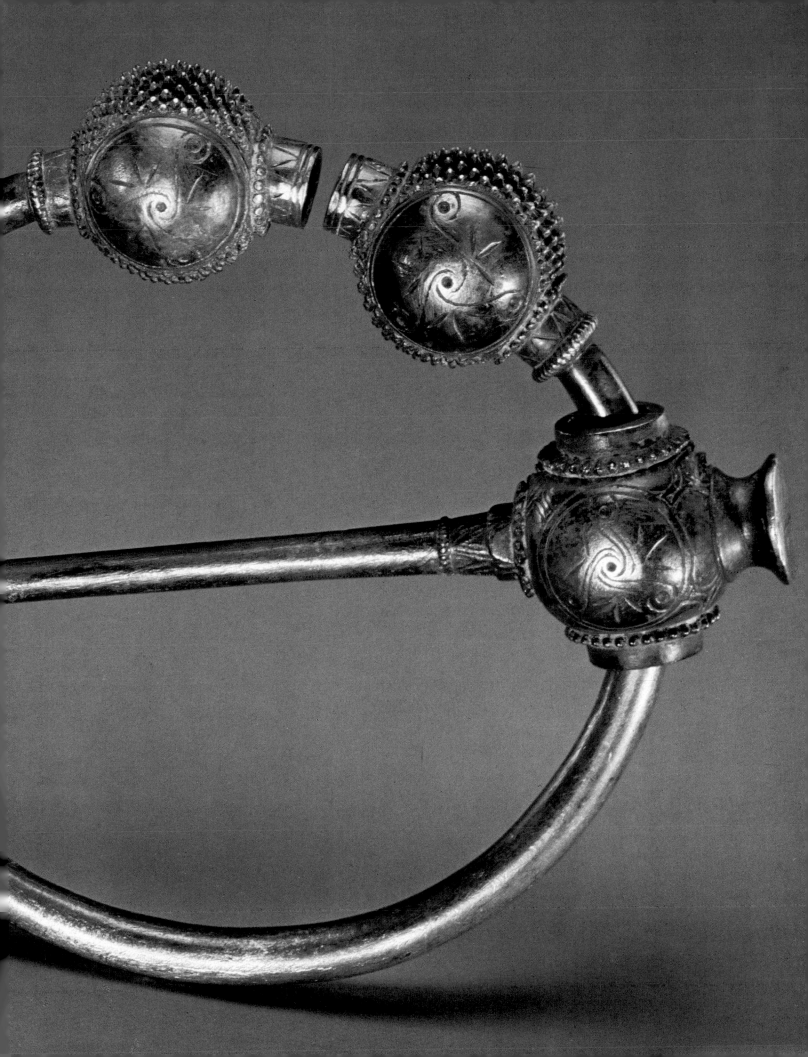

53.
Silver kite brooch,
County Kilkenny (?)

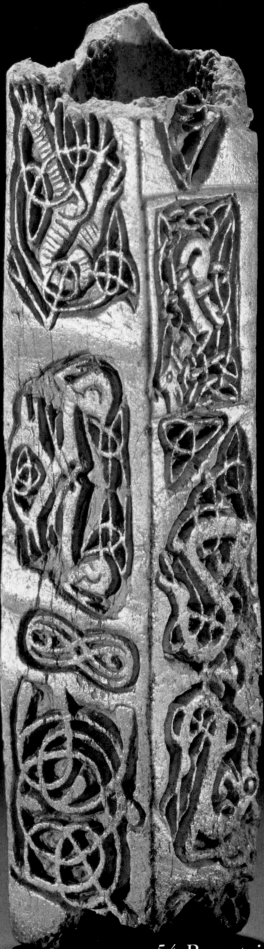

54. Bone trial piece, Dungarvan, County Waterford

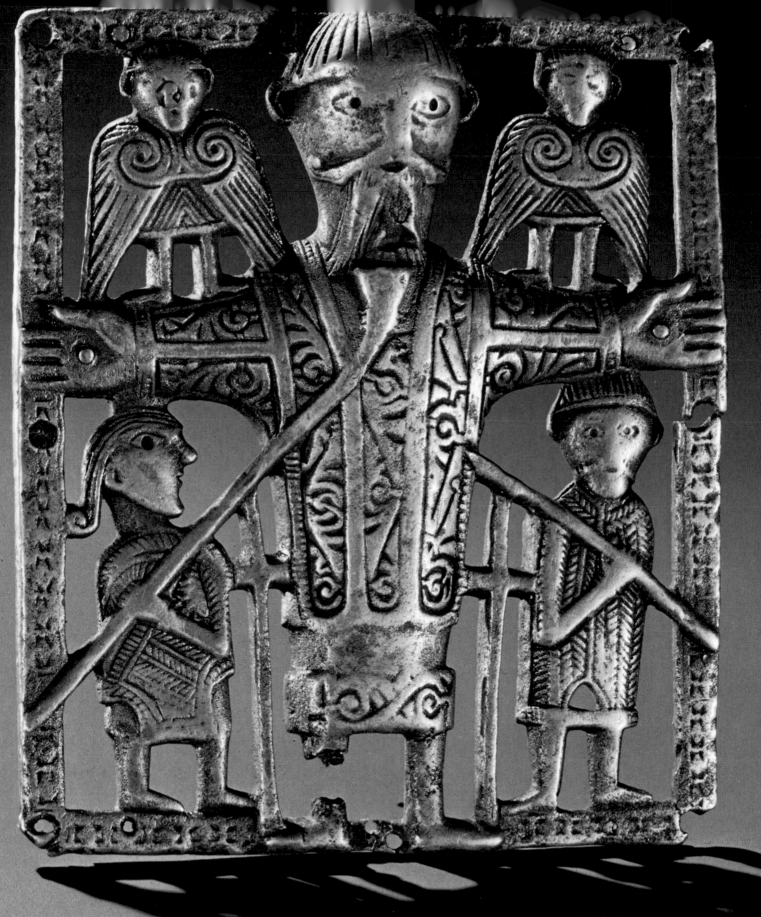

55. Bronze crucifixion plaque, Clonmacnoise, County Offaly

56.
"Corp Naomh" bell shrine,
Templecross,
County Westmeath

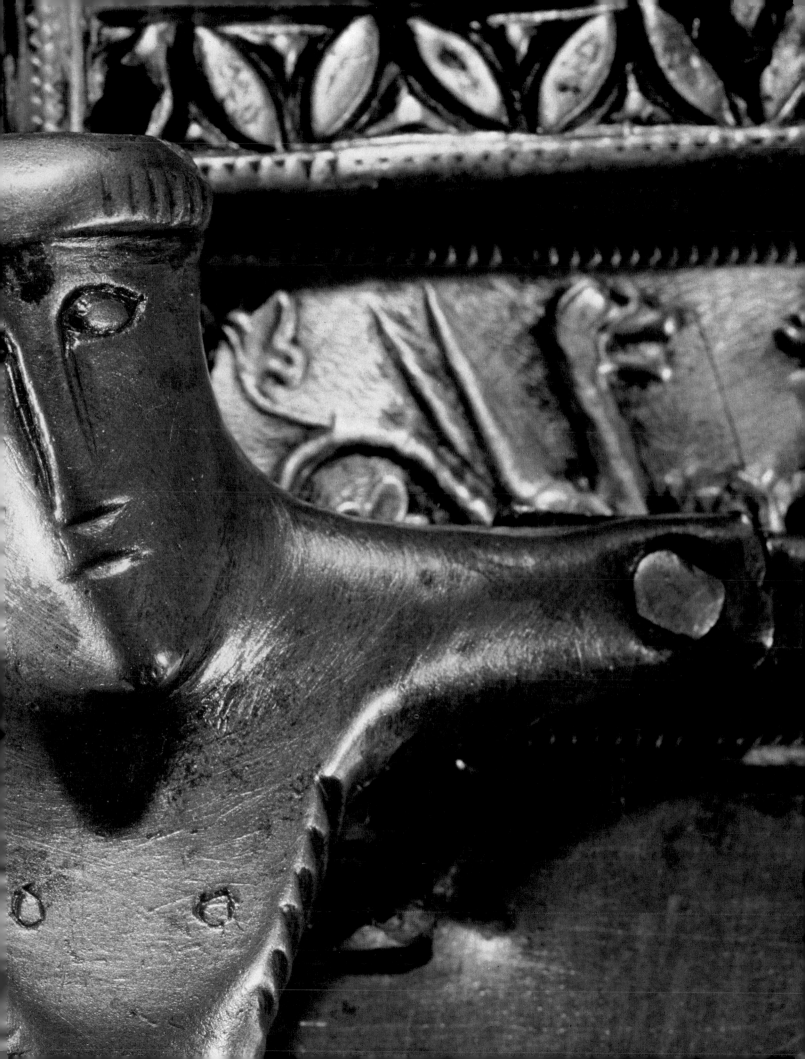

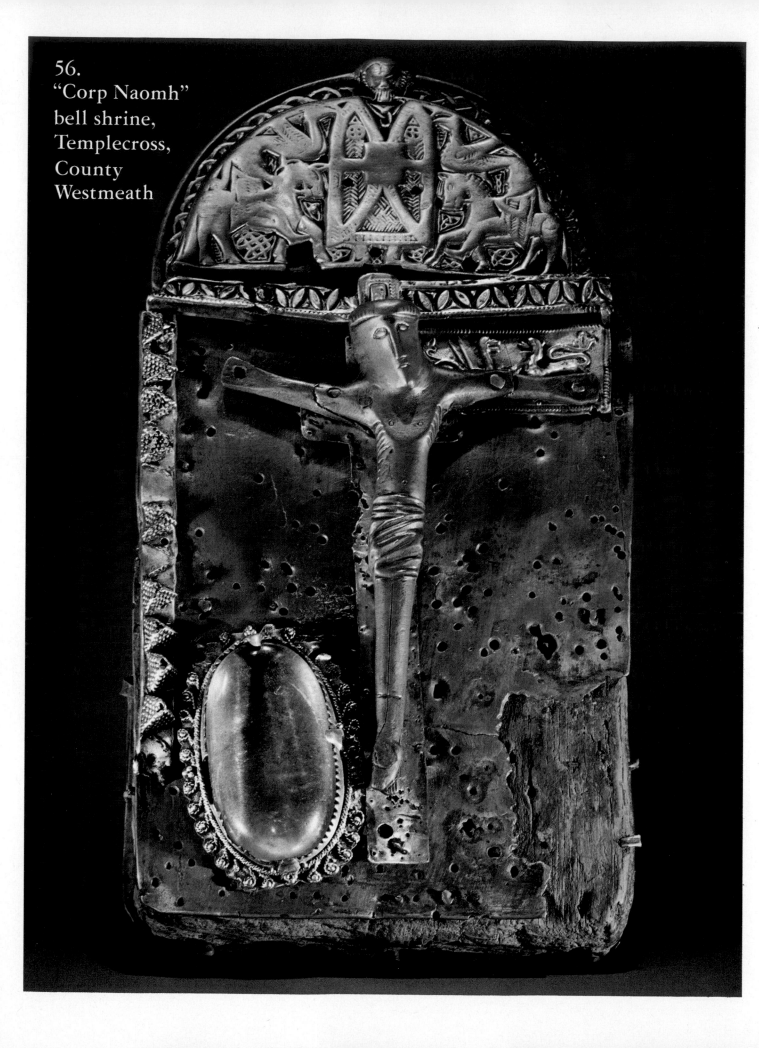

56.
"Corp Naomh"
bell shrine,
Templecross,
County
Westmeath

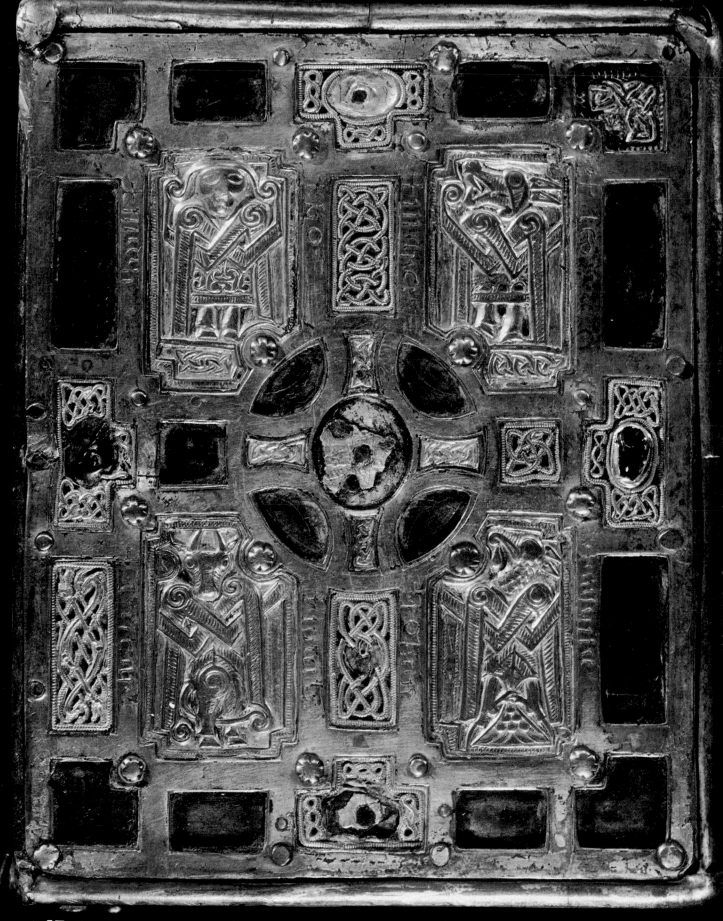

57. "Soiscel Molaise" book shrine, Devenish Island, County Fermanagh

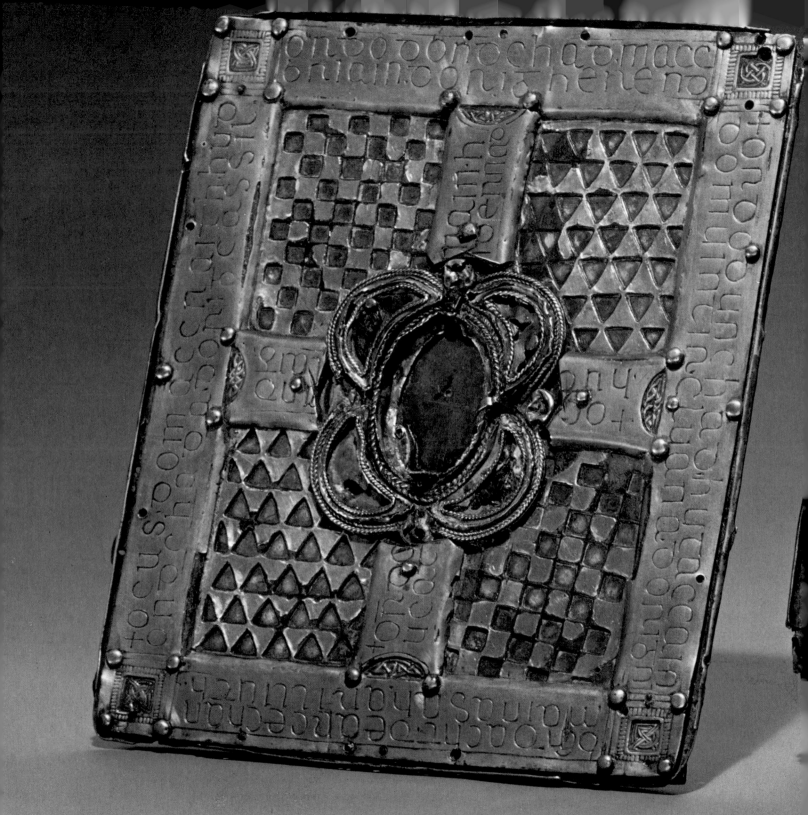

58. Book shrine of the Stowe Missal

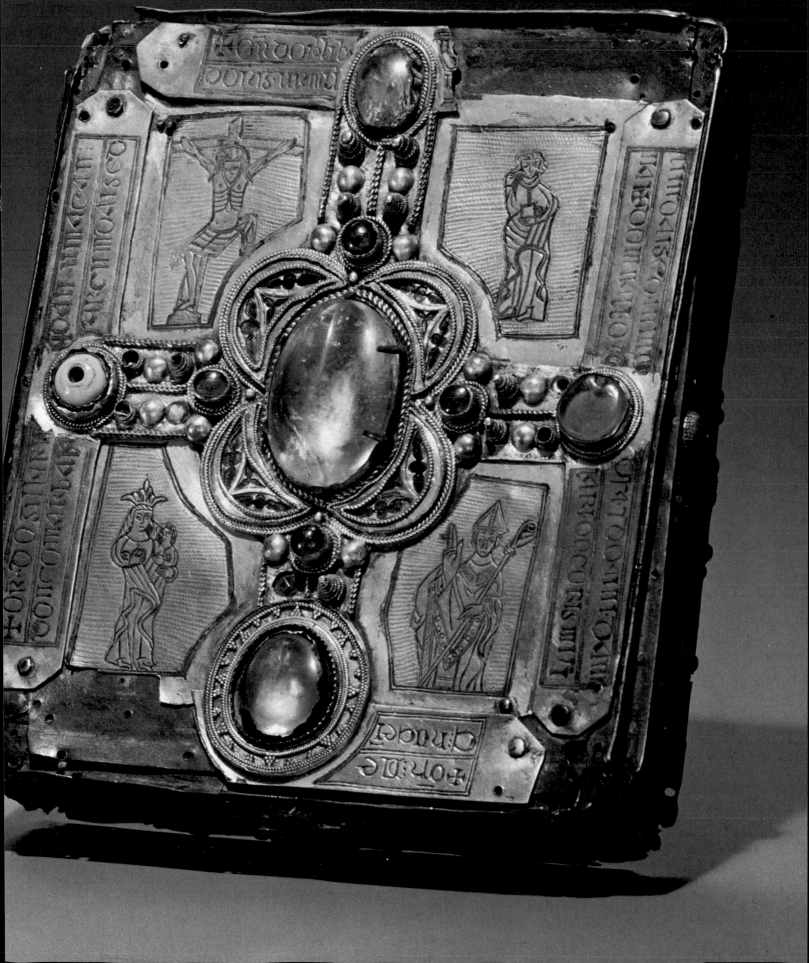

58. Book shrine of the Stowe Missal: two ecclesiastics with angel and musician

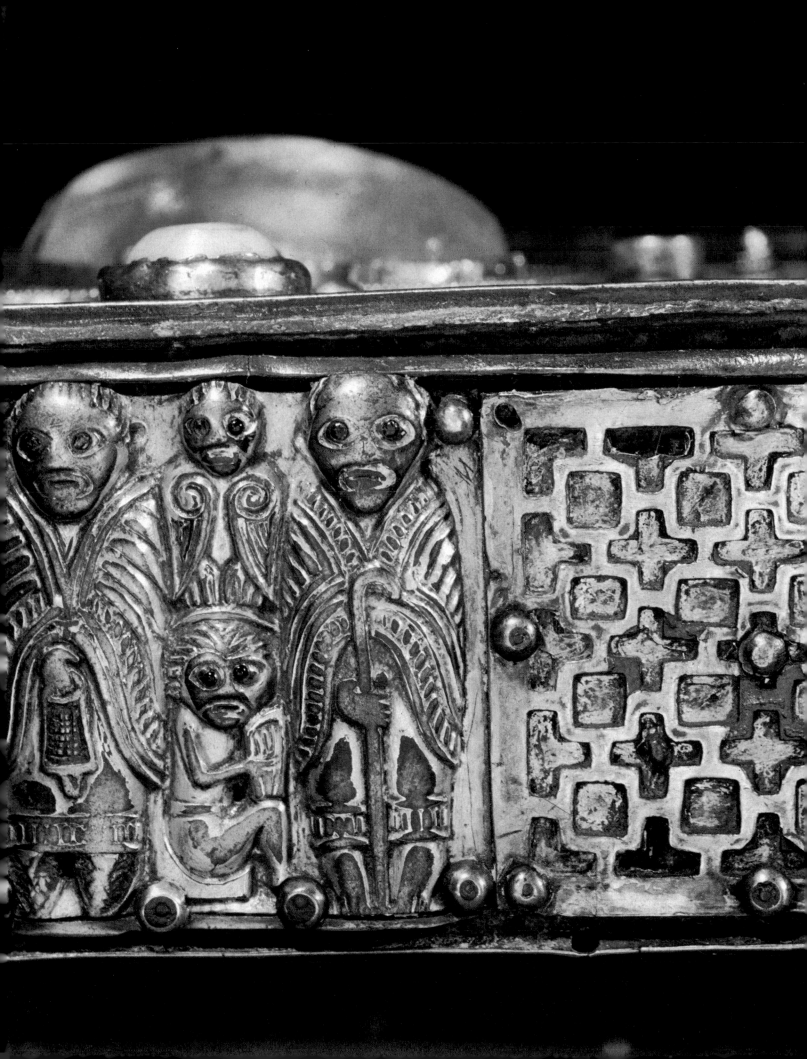

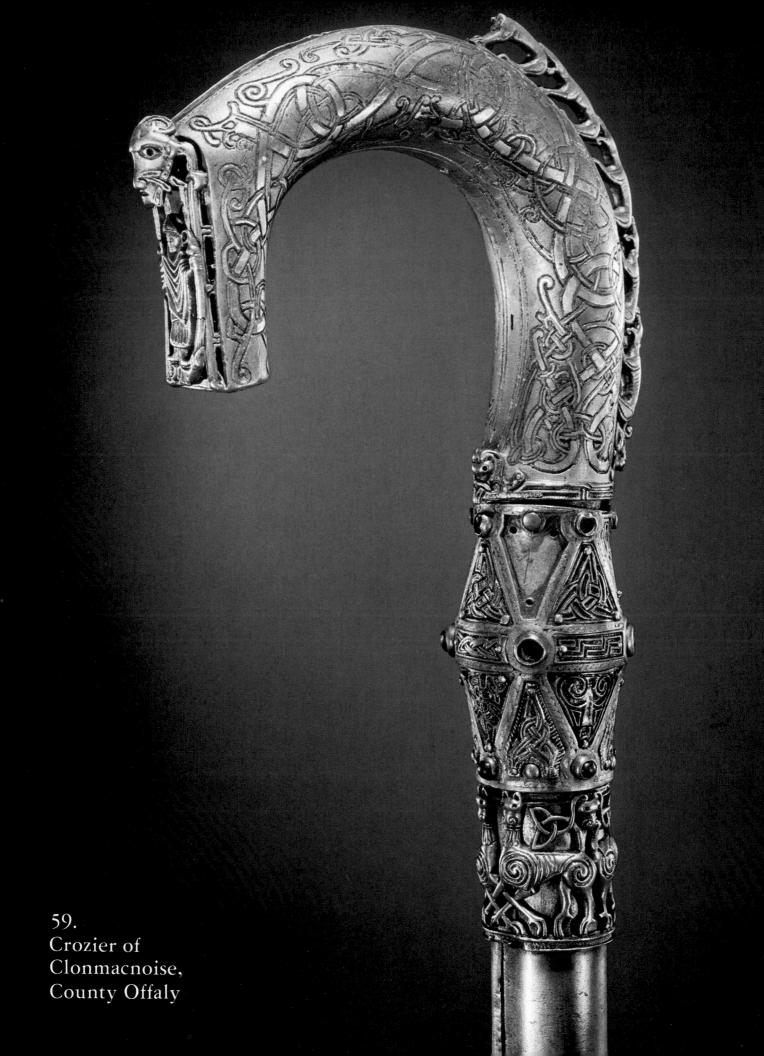

59.
Crozier of
Clonmacnoise,
County Offaly

Catalogue

46. Pseudopenannular brooch
Hiberno-Viking period (silver phase), early ninth
 century
Silver, with added gold and amber
L. 18.3 cm.
Near Roscrea, County Tipperary
NMI, P. 737

This brooch lies stylistically between the eighth-century gilt-bronze brooches of the Tara type with straplike animal bodies and the ninth-century silver brooches of the Killamery type with tubelike animal bodies (47). The increased popularity of silver is probably a result of its introduction by the Vikings as a medium of exchange.

The triangular shape of the head and the basal animal head (from which the pin emerges) recall the Tara brooch (32). But immediately inside the crest of rounded compartments with gold filigree is a second border of interlaced round-bodied newtlike animals of Killamery type, interrupted at the angles by amber settings. The raised trapezoidal center holds a gold plate with filigree.

The pin is flanged at the sides both back and front. The tip is missing, and on the front the remainder of the point bears an incised chevron design.

The plate is slightly broader than the semicircular ring, and a vertical central panel recalls the gap between the separate terminals of earlier brooches. Like the head, the plate is surrounded by a crest, interrupted by a Tara-type animal head at the bottom. As on the head, there is also a band of tubelike Killamery animals, interrupted by amber bosses at the ring ends and by two more bosses at the top and bottom of the vestigial gap. The gap also has a central rhomb with filigree. The ridge between the tubelike animals near the lower margin and the crest is itself a long animal body. The centers of the plates are occupied by trapezoidal areas with gold filigree plates, and straight vertical edges define the former gap.

The back of the plate is bordered, as is the head, by a row of dots and an incised line. Incised animal heads, with hatched gaping jaws, continue the line of the ring onto the back of the plate.
Bibliography: CAAI, p. 127, pl. 20; IA I, pl. 45; TI, pp. 93, 94, pl. 25.

47. Pseudopenannular brooch
Hiberno-Viking period (silver phase), ninth century
Silver, with added gold, glass, and amber
L. 31.5 cm.
Killamery, County Kilkenny
NMI, R. 165

This is the prototype for the brooch style that became popular at the beginning of the ninth century. Its appearance is directly due to the presence of the silver-loving Vikings.

The pinhead is now rectangular instead of wedge shaped, with a bold rim, essentially circular in section. The rim surrounds an inner rectangle, plain except for a gold plate with filigree, and is interrupted at the upper corners by circles containing spiral devices. The lower corners are marked by pointed ovals bearing stylized faces or clusters of grapes. The centers of the top and the sides contain a simple boss, with a hemisphere of clear glass set in a basketlike silver rectilinear grill below (a device new to Irish jewelry). The segments of the rim between these features form crude piglike animal heads.

The ring is cylindrical and meets the plate rather awkwardly, off center of a glass stud with looped oval silver bands. The terminal plate holds two trapezoidal silver plates, with square depressions elaborately decorated with gold filigree. Between the trapezoids are silver bosses with a strap of interlace between them; the rest of the space is open. The trapezoidal areas are outlined by incomplete tubular animals and spiral bosses. The

stylized eye of the animal on the lower margin has spiral lobes; its protruding tongue touches the central boss. Bosses, both spirally coiled and brambled, adorn the body; a suggestion of a hind leg turns back between the body and the glass stud.

On the back the ring enters the terminal plate, flattens out, and takes the form of an animal head with gaping hatched jaws with spiral endings; the eyes are similar to those of the animals on the front. Within trapezoidal areas like those on the front, an animal with a hatched body is set against a stippled background. The head turns back to bite the tail, and the taloned legs run forward; a triquetra lies between the legs and the body. A faintly scratched inscription perhaps reads *Or Ar Chirmac* ("pray for Cormac"). At the lower margin is a perforated lug for a string.

Bibliography: CAAI, p. 147, pl. 40; IA I, p. 112, pls. 36, 45; TI, pp. 96, 143, fig. 61; J. Graham-Campbell, "Two Groups of Ninth-century Irish Brooches," *Journal of the Royal Society of Antiquaries of Ireland* 102 (1972), pp. 113-128.

48. Pseudopenannular brooch
Hiberno-Viking period (silver phase), ninth century
Silver, with gilding and added red enamel
L. 26.5 cm.
Near Ardagh, County Limerick
NMI, 1874: 101

This is another brooch of the Killamery type, indeed very similar to the Killamery brooch itself (**47**) and probably made at about the same time. It is part of the Ardagh hoard.

The square pinhead has a pronounced rim surrounding a square plate with a beaded margin and a central recess for a decorative plate, now missing. Around the rim are oval and circular cells with simple interlace knots on their floors; at the center of the base is a larger empty setting, perhaps once holding red enamel. Between these features are triangular stylized piglike snouts with pierced apertures below their chins.

The pin itself is at first cylindrical but becomes flattened about halfway down, where it has a long "incision," whose parted lips reveal a panel of interlace; there is a similar, smaller incision near the tip; two corresponding incisions on the back are undecorated.

The ring is semicircular, and its ends slip into sockets in the top corners of the plate.

On the terminals the freestanding tubular animals are more prominent, and the links between the two sides of the plate are more slender than those on the Killamery brooch. The decorated sockets that receive the ring ends terminate in circular settings for red enamel, and these in turn abut the central trapezoidal areas with their beaded rims and depressions for decorative plates. A tubular animal stands above each trapezoid.

These beasts are highly stylized. The locks in front of the eyes meet to bridge the gap between plates. The neck is collared; the front and back legs spring from brambled bosses; the rump is prolonged upward and backward to abut the socket for the ring and seems to give rise to a further limb; a curious device, perhaps a stylized animal head, sits on each rump. Another similar animal body extends along the lower margin of each terminal plate. Locks of this beast's hair also bridge the gap between plates as does a strap with interlace decoration.

Bibliography: CAAI, pl. 56.

49. Pseudopenannular brooch
Hiberno-Viking period (silver phase), ninth century
Silver-gilt, with added gold, amber, and glass
L. 25.5 cm.
Near Ardagh, County Limerick
NMI, 1874: 102

This is another brooch of the Killamery type, which, like **48**, was also part of the Ardagh hoard.

The rectangular pinhead has a central panel of the same shape bordered by rope molding. Within the molding is a rhomboid with concave sides which originally held a decorated plate. The border of the plate contains cells decorated with a cross-in-circle device; in the center of the base is a setting containing traces of amber. At the corners the border contains animals with reflexed heads and bodies bent at right angles; beads of pale green glass fill the eyes. The top of the pin is fitted into a melon-shaped ridged protuberance.

The pin is cylindrical and below the terminals and near the point carries, front and back, elongated rhomboid "incisions." The upper front incision is decorated with four incised petals.

The sides of the plate are united by only three narrow straps and can almost be regarded as separate terminals. In each corner of the plates is a curious concave pointed oval design. Circular cells for amber lie near the upper corners. A central trapezium is bordered by rope molding. It contains a rhomb-shaped depression that holds a cast openwork panel of interlace. Above each rhomb is a bird with reflexed head and crosshatched body. On the lower right a fish with a green glass eye appears to be swallowing something; a creature—perhaps a lamprey—with two glass eyes and a tapering tail lies across its body. On the left a similar fish is being attacked by a beast whose head only is visible; a glass-eyed lampreylike creature lies across its body also.

Bibliography: CAAI, pl. 56.

50. Silver penannular brooch
Hiberno-Viking period (silver phase), ninth century
D. 12.3 cm.
Rathlin Island, County Antrim
NMI

This brooch has Killamery affinities, although here the animals' bodies are formed of incised openwork with ribbonlike interlace.

The pinhead, badly damaged, has recently come to light in the National Museum. The head was barrel shaped and was bordered by three bands of twisted silver wire separated by two bands of triangular incisions; it contained a small boss built up of spiral coils of beaded silver wire.

The ends of the crested ring form funnellike collars as they join the plates, and what appear to be complicated animal heads spring from the funnels. But ancient damage—and repair—make it impossible to follow the design in detail. The center of each terminal is occupied by a small trapezoidal plate with a central boss like that on the head, surrounded by whorls of beaded filigree. The remaining area is occupied by openwork zoomorphic interlace; the bodies are outlined by plain bands; the centers of the bodies are stippled.

The brooch has long been in the possession of Trinity College and has become known as the "University brooch." As it comes from Rathlin Island, it may have been made by Vikings in the ninth century.

Bibliography: CAAI, p. 127, pl. 48; R. Warner, "The Re-provenancing of Two Irish Penannular Brooches of the Viking Period," *The Ulster Journal of Archaeology* 36/37 (1973-1974), pp. 58-70.

51. Silver-gilt thistle brooch
Hiberno-Viking period (silver phase), tenth century
L. 17.8 cm.
Near Ardagh, County Limerick
NMI, 1874: 103

This type of penannular silver thistle brooch was common in the tenth century. As it was part of the Ardagh hoard, it can be inferred that the hoard was not concealed before the tenth century.

The head is formed by a silver-gilt ball, pierced horizontally to allow the ring to pass through. The head is topped by a low disc decorated with two concentric incised circles. The brambled decoration is cast.

The round pin tapers slightly downward and is flattened below where it passes through the gap in the ring. The tip of the pin is missing.

The silver-gilt balls at the ends of the ring are similar to the one on the head except that they lack the transverse tunnel for the passage of the ring, and their central discs are plain.

Bibliography: CAAI, pl. 55.

52. Silver thistle brooch

Hiberno-Viking period (silver phase), tenth century
L. 35 cm.
Cashel, County Tipperary
Library, TCD

The long pin has on its head a hollow silver ball, pierced horizontally to allow movement of the ring. A gap divides the circular ring, and after the pin had been threaded on it, silver balls were attached to the ring on both sides of the gap. The balls have collars on either side, and the junctions of the pin and the top ball are similarly collared. The surfaces of the balls are brambled. A circle on the back of the balls defines a smooth area (presumably to prevent the brambles from tearing the garment on which the pin was used), which bears an incised triskele design; between the arms of the triskele are three leaflike forms. The flat top of the pin carries a cross design inside concentric circles; the quadrants between the arms of the cross carry a motif of pleated ribbon, probably originally nielloed. A design in similar technique appears on each flat end of the ring. The back of the ball at the top of the pin is also decorated with a triskele-in-circle design.

Bibliography: CAAI, p. 149, pl. 48; IA II, p. 128.

53. Silver kite brooch

Hiberno-Viking period (silver phase), tenth century
L. of pin 51.5 cm.
County Kilkenny (?)
NMI, 1874: 73

This type of brooch is called "kite" because the head is a trapezium with concave sides. The top of the head is hinged to the top of the pin so that either the front or the back of the head could be displayed.

For about twenty centimeters the pin is circular in section and undecorated. Below this level it is octagonal, with alternate narrow and broad faces, all bearing an incised parallel line. The three front faces carry a zigzag line of short strokes.

The head is pierced by a heart-shaped aperture; the dimple in the top of a conventional heart is enlarged to project down into the aperture as a sharply pointed triangle on a waisted stem. All the margins, both external and internal, front and back, are bordered by two shallow grooves. The front surface of the head is decorated by an incised strand of simple interlace with a line of dots, struck with a triangular punch, running down the center of the ribbon. Another line of dots follows the outline of the projecting triangle, which is otherwise plain.

At the lowest point of the pinhead is a stylized animal head with open mouth and fanged jaws. Minor animal heads are seen on the right- and left-hand points of the head.

Bibliography: CAAI, p. 162, pls. 21, 40; CACP, fig. 37.

54. Bone trial piece

Hiberno-Viking period (bronze phase), tenth century
L. 10 cm.
Shandon Quarry, Dungarvan, County Waterford
NMI, 1947: 237

The long bone chosen for this trial piece was carefully

squared with a file to form four flat panels. One end shows a clean cross cut; the other is broken. A series of designs, some in rectangular cartouches, others irregular, were cut deeply into two of the four sides. Interlace and animal ornament appear; some of the animals are like those on the *Soiscel Molaise* (**57**) or on a crozier. Smaller simpler designs, such as figure-eight interlace and triquetras are also seen. The two plain faces were crudely decorated by the finders.

Bibliography: IA II, pls. 56, 57; M. MacDermott, "The Kells Crozier," *Archaeologia* 96 (1955), pp. 59-113.

55. Bronze crucifixion plaque

Hiberno-Viking period (bronze phase), tenth or eleventh
 century
H. 8.4 cm.
Clonmacnoise, County Offaly
NMI, 1935: 506

This hollow-cast bronze openwork plaque is of relatively crude workmanship. It was probably part of the ornament on a larger object—perhaps the central panel of a book cover.

Christ is depicted in a long-sleeved tunic. The stylized foliage pattern, of Ringerike style, suggests an eleventh-century date. The prominent basal hem, in the same style, may have been meant to represent embroidery. The cross is not visible, though the palms of the hands are pierced by nails; the fingers reach the frame; the feet, splayed out against the frame, are not pierced. Christ is pictured alive. Nearly identical supporting angels stand on his arms; their wings are attached to the underside of their bodies. The spirals at the points where the wings are attached form perfect peltae.

The spongebearer is shown in profile. A long lock of hair falls behind him; both his feet are turned sideways; he appears to be wearing a decorated cloak. He has only one arm, with which he offers the sponge. The lancebearer is shown full face, with splayed-out feet; he wears a decorated tunic; he too has only one arm and clutches a lance, which pierces the side of Christ. The crosses of the malefactors stand on either side of the Christ. The frame is decorated with a punched geometric design.

A wide range of dates has been suggested, but the tenth or eleventh century seems the most plausible.

Bibliography: IA II, pp. 123, 161, pl. 8; TI, p. 120, fig. 82; M. MacDermott, "An Openwork Crucifixion Plaque from Clonmacnoise," *Journal of the Royal Society of Antiquaries of Ireland* 84 (1954), pp. 36-40.

56. "Corp Naomh" ("holy body") bell shrine

Hiberno-Viking period (bronze phase), tenth century;
 fifteenth century; and later
H. 23 cm.
Templecross, County Westmeath
NMI, 1887: 145

The shrine has been very much damaged both by the passage of time and by deliberate alteration. The upper semicircular part, cast in one piece, is early. There are decorated plates in front and behind, and an openwork crest of interlace runs around its top. The head of an ecclesiastic, his face framed by a beard, projects up from the front plate and interrupts the crest. His tunic is decorated with crosshatching and with a prominent hem. Over this he has a cloak embroidered with herringbone design, a small cross-in-circle at the shoulder level, and broad hatched bands. A triquetral knot covers the throat. A book is shown, though the hands are not seen. The feet are out-turned. On either side at shoulder level is a bird with an eaglelike beak facing inward; these bear herringbone designs and spirals where body meets wing. Below, on either side, a pony and rider approach the figure. The riders are seated at a low level, and their legs stretch for-

ward to clasp their mounts' shoulders; they wear decorated cloaks. Any small spaces in the crowded scene are filled with awkwardly shaped panels of crude interlace. A strip of bronze that runs around the semicircular top is a later addition.

A band of geometric design runs around the margins of the back of the semicircular upper plate. In the remaining space two crouching quadrupeds confront one another; their hind limbs are stretched forward almost to touch the forelimbs. The animals are enmeshed in a few strands of interlace, which terminate in club shapes.

The lower rectangular part has on the back a bronze plate, now much damaged and reduced to a grid by multiple apertures of interlocking small crosses affixed to an underlying bronze plate. On top it has a damaged cross-shaped plate. Evidence remains of niello, some circular ornaments, and perforated lugs. The arms of the cross were once decorated with panels of engraved interlace.

What survives on the front of the shrine is of later date. A sadly damaged crucified Christ in bronze is mounted asymmetrically on a metal plate. The head sags in death; either a crown or a mass of hair surrounds the head; the chest is flat and the ribcage strong; the straight body is naked except for a loincloth; the ends of the arms are missing and have been replaced by crude rods, flattened at the end. At the top right a fragment of a fifteenth-century plate with embossed confronted animals can be seen behind the arm. Some later embossed silver decoration survives. A chevron design of raised dotted tetrahedra runs down the left margin. A degraded floral pattern runs across the top; it is interrupted at the center by a rectangular block, perhaps the top of a now missing cross. At the bottom left is a large oval jewel held in a setting with a denticulated edge.

The damaged cross on the back recalls that on the *Soiscel Molaise* (**57**), and the ecclesiastical figure, almost concealed by the broad edges of his cloak, recalls the symbols of the evangelists on the same shrine. A late-tenth-century date is suggested for the older parts. The embossed silver decoration is of the fifteenth century; the figure of Christ may be later still.

Bibliography: CAAI, p. 157, pls. 68, 69; IA II, pp. 125, 126, pl. 55; IA III, pp. 80, 86; TI, pp. 108, 109, fig. 70.

57. "Soiscel Molaise" book shrine

Early Christian period (second phase), eighth century;
 Hiberno-Viking period (bronze phase), eleventh
 century; late medieval period, fifteenth century
Various materials
H. 11.5 cm.
Devenish Island, County Fermanagh
NMI, R. 4006

This ornamented case has had a long history. As the "Soiscel Molaise" ("the satchel of St. Molaise"), it is firmly linked with the saint from Devenish Island in Lower Lough Erne.

The inner bronze box is probably the original container. It had a hinged fitting at either end, to which a strap or chain could be attached for carrying. One original hinge survives on the right-hand side. The lower plate, surrounded by interlace, has a sunken center, which carries L-shaped panels of red enamel; it ends in a stylized animal head. Some enamel in L-shaped panels also survives in the center of the upper plate, which has a hole at the top for the carrying thong. Several house shrines (or reliquary boxes) have such hinge fittings, and the model for this shrine was perhaps an eighth-century house shrine.

Today the shrine is sheathed in more recent openwork plates of silver or silver-gilt with lengths of split silver tubing binding the edges. On the assumption that the edges with the hinges mark the top, the plate at the opposite side, the bottom, carries an inscription saying that the

shrine was redecorated under the direction of Cenne-faelad, the successor of Molaise. Cennefaelad became abbot in 1001 and died in 1025, so that the refurbished shrine dates to the opening of the eleventh century. The plate is pierced by rectangular, *T*-shaped, and *L*-shaped apertures, all of which have lost their settings. The surviving straps of silver-gilt, which define an inner rectilinear area, carry panels of interlace and of animals with tube-like bodies enmeshed in finer interlace. This whole plate was once concealed beneath a late medieval embossed silver plate, now almost totally disintegrated.

On the left-hand silver side a modern hinge plate fills the early V-shaped notch. The remaining decorated panels carry simple and animal interlace as on the bottom.

On the opposite right-hand silver-gilt side the original hinge plate and the decorated plate for the large rectangular aperture have survived. The plate shows the figure of an ecclesiastic in a long tunic and a decorated cloak. In his left hand he carries a book, in his right a long-handled object, round at the top, with cords at the base; it is presumably a scourge. On each side of him a monstrous entwined tubular body hangs from the top of the frame; its open mouth with recurved jaws are at the level of his waist. Below, an entwined animal stands at either side of the figure, terminating in catlike heads with erect ears just below the level of the monster's jaws. Similar catlike animals occur on the Clonmacnoise crozier (**59**).

The front of the box is the most elaborate and best-preserved feature. The apertures at the centers of the four sides originally held jewels surrounded by coarse gold interlace; only one jewel survives.

Within the inner rectangle is a cross, its center bound by a circle. Outside the circle the arms of the cross are pierced and hold settings of coarse gold interlace; inside the circle curve-sided apertures are filled with simple interlace. At the intersection of the arms is a circular aperture, now empty, except for part of a gold backing plate.

The spaces between the arms of the cross are filled with decorated plates representing the evangelists. The name of each evangelist and his symbol are shown on the side panels. Each figure is contained behind two strands of ribbon bent at acute angles.

The hair of the man (St. Matthew) falls into long spirals on either side and runs on into the ribbon; he is clothed in a tunic decorated with ultimate La Tène peltae and a prominent hem. The lion (St. Mark) has enormous fangs and donkeylike ears; he too wears an ornamented tunic with a hem. The head of the ox (St. Luke) is naturalistic; one hind leg with a spiral joint is seen, as well as a second foot and a heavy tail, which runs on via a spiral into a ribbon. The eagle (St. John) has a spirally coiled beak, from which something hangs, and large pointed ears; two feet with enormous talons protrude below the body; a broad wedge-shaped tail appears between the talons.

The back is a relatively plain silvered plate. Inside two inscribed rectangles are many small symmetrically placed apertures—cross shaped, *T* shaped, *L* shaped, and square. It appears that these were never filled with plates, and the surface of a copper plate exposed on the floors of the apertures has been engraved with interlace and geometric ornament. Pointed ovals, contained by two bordering lines, lie diagonally in the corners. Two carry tenth-century Viking chain knots, while the other two have stylized faces below a floral design.

This shrine has had three phases of elaboration: in the eighth century it was a carrying box; at the opening of the eleventh century a new outer box was built around it; in the fifteenth century embossed silver plates were added, but, except for one scrap on the bottom, these have totally disappeared.

Bibliography: CAAI, pp. 119-121, pls. 57, 58; IA II, pp. 120-122, pls. 58, 59; TI, p. 127, fig. 84, pl. 35.

58. Book shrine, usually known as that of the Stowe Missal

Hiberno-Viking period (bronze phase), late eleventh
 century; late medieval period, late fourteenth century
L. 19 cm.
NMI, 1883: 614a

This shrine was originally created to hold St. Maelruain's Gospel, but has in recent years been known as the shrine of the Stowe Missal.

It is an oak box decorated with silver plates. Though a central quatrefoil was added later, the silvered bronze plate on the bottom bears an inscription that dates the box to about 1050. Small squares, decorated with gilded interlace, lie at each corner. An almost equal-armed cross spans the center of the plate; the plain arms, which also carry inscriptions, have concave ends, and where they abut the marginal band the gaps are filled with gilded interlace. The four remaining areas of the plate are recessed and pierced by regularly arranged geometric apertures though which bronze can be seen.

The front, back, and sides are decorated with a variety of applied panels. On the left side is a panel with a man and animals in the center. The man's costume suggests the very short trousers worn by the soldiers arresting Christ on Muiredach's cross at Monasterboice (Fig. 35); an animal stands upright on either side of the man, reaching the level of his elbows; its eye is enameled. Above this animal, a smaller one stands on the side of the frame; its hind limb has a spiral joint.

To the right of the man a rectangular panel shows a warrior in profile with a spear and a small round heavily dished shield. There are also two abstract panels, one regularly pierced with square and cross-shaped apertures, the other with coarse interlace with club-shaped endings springing from a central upright stem.

On the right side the geometrical panels are similar to those on the left but are floored with gold foil. In the center a crowded scene represents two ecclesiastical gilt-bronze figures separated above by a small angel and below by a smaller seated figure playing a lyre. The ecclesiastics are very similar, save that the one on the left holds a bell, the other a staff. Their postures and their garments strongly recall the ecclesiastical figure on the *Corp Naomh* shrine (**56**).

The seated figure is shown in profile, while the head, with blue glass eyes, is shown full face; there is a belt around the waist, but no other clothing can be seen. The composition is very close to that of the Virgin and Child in the Book of Kells (*fol.* 7v. **37/38a**). On the left a rectangular panel holds an upright stag being attacked by two dogs.

The front has a circular panel with a gilt-bronze angel in the center and geometric openwork plates over gold foil. The angel's arms are transformed by spirals into short triangular wings filled with blue enamel and inset silver. The circular frame is composed in part of two animal bodies, one left, one right, whose gaping jaws press against the ears of the angel. The eyes of the angel and beasts are filled with studs of blue glass.

On the back only two plates survive. A central circular figured plate is identical to that on the front; on its left is a geometrical plate.

The medieval top was made in at least two stages. It now carries a large appliqué cross whose arms extend almost to the margins of the box with a quatrefoil at the crossing of the arms. The quatrefoil holds a central oval jewel on a gold and red base; within each of its arms is a crescentic area outlined by twisted wire. The area is divided into triangles filled with Gothic cusping with green and blue enamel. An identical quatrefoil, badly damaged, is attached to the bottom of the shrine.

The arms of the cross carry metal bosses, steeply conical whorls made by wrapping a bronze ribbon with vertical nicked edges around a central silver nail, and jewels.

Larger jewels lie at the ends of the arms. The oval jewel at the lower end of the cross is larger and more elaborate than the others. On its right-hand lower side a strip of metal, whose shape follows that of the jewel, carries a short inscription; the portion of the plate on the other side of the jewel is missing. The inscription is in outline without niello.

Similar strips of lettered metal run around the other three sides of the top of the shrine; these letters are nielloed and are in a different style from the one at the bottom. Since the other arms of the appliqué cross rest on and partly conceal these plates, the cross must be more recent. Between the arms of the appliqué cross an engraved silver-gilt plate with four decorated panels can be seen. In the top left panel a haloed Christ, clad in a loincloth, is seen sagging in death from a cross; at the top right is an abbess holding a book; below right is a bishop in full ecclesiastic dress with a ring, mitre, and crozier; below left the virgin crowned with a floral wreath suckles the Child, who has his right hand raised in blessing. The background to all the figures has been scored with wavy parallel lines.

The bottom and sides of the box were made in the mid-eleventh century; the top and the cross attached to the base are probably of the late fourteenth century.

Bibliography: CAAI, pp. 154, 155, pls. 65-67; IA III, pp. 82-83, pls. 28-30, 32, 48; TI, pp. 128-130, figs. 85, 86.

59. Crozier of Clonmacnoise

Hiberno-Viking period (bronze phase), first half of twelfth century; altered in fourteenth century
L. 98 cm.
Clonmacnoise, County Offaly
NMI, R. 2988

This splendid crozier of the abbots of Clonmacnoise enshrines a wooden staff and is built up of two parts: the curved crook and the straight staff, both in bronze. The staff is decorated by ornamental knops and terminates in a spiked ferrule.

The flanks of the crook are inlaid with ribbonlike interlaced snakes, bound down by more slender threads with spiral endings. The ribbons and threads are of silver, bordered on their edges by strips of niello. These patterns show strong Scandinavian influence. The Ringerike style of the late tenth century abounded in tightly curled interlaced ribbons that cut sharply through one another. These gave way in the eleventh century to the figure eight and slender tendrils of the looser Urnes style. In Ireland the two styles are subtly blended in the decoration of this crozier.

At the front end of the crook is an inserted panel of metal cast in strong relief. At the top is a grotesque human head with pierced eyes, small ears, large nose, and heavy moustache and beard decorated with silver niello. Curtainlike folds, or an opened shroud, form the sides of the panel. Within the panel is now a small fourteenth-century figure of a mitred bishop with one hand raised in blessing, the other holding a crozier that impales an animal beneath his feet.

The flat terminal of the crook is decorated with a champlevé design of two spirals separated by a vertical bar with commas outside them; the design is colored with blue, green, and yellow enamel.

A cast crest started behind the grotesque head and ran back along the top of the crook. Much of this has broken away, but there remains a procession of doglike animals, each grasping with its jaws the buttocks of the preceding animal.

The base of the crook is decorated at front and back with grotesque Irish Urnes cast animal heads, which flow into acanthuslike ribbons; both heads and ribbons are decorated with pellets, ribbons, and crimped wires of silver set in niello.

The upper and lower knops carry a profusion of blue glass studs. These interrupt a medial horizontal band of interlace with triangular panels above and below it, some with champlevé geometric or foliate patterns, others with embossed interlace. The panels and the band are fastened to the knop by small rivets, and the bronze between them has plaitlike insets of copper and silver.

On a cylindrical collar below the upper knop are two pairs of affronted catlike animals, with upright necks and ears and intertwined front legs decorated with inlaid silver and niello. The heavily taloned legs spring from spirals. The tails knot into triquetras and stretch back to approach the tails of the opposite pair of animals. A grotesque animal head hangs from the joined ends of the tails. Similarly confronted pairs of animals can be seen at the bottom of the side of the Cross of the Scriptures at Clonmacnoise, County Offaly, and on Muirdedach's cross at Monasterboice, County Louth (Fig. 35).

The middle knop is barrel shaped with an open geometric interlace of silver bands edged with niello; patterned panels protrude from the upper and lower edges.

Below the lower knop the shaft narrows and passes into an encircling ring; below the ring is a long basal point.

Bibliography: CAAI, p. 159, pls. 87, 88; CACP, pl. XV; IA III, p. 101, pl. 20; TI, figs. 75, 76, 78.

60. Ring-headed pin
Hiberno-Viking period (bronze phase), eleventh century
Bronze, with silver and niello
L. (with head extended) 13.3 cm.
Clontarf, County Dublin
NMI, 1907: 116
Not illustrated

This type of plain ringed, polyhedral-headed pin, on which the ring clips to the sides of a solid head, has long been known in Ireland. This specimen can be dated fairly closely because of the Scandinavian influence on its decoration.

The pin expands in thickness from the top almost to its midpoint, then tapers away to the tip. Decoration is confined to the upper part of the pin, which suggests that below this level it was concealed in a garment. An interlaced band runs around the pin, and from this, freestanding lobed tendrils protrude in Ringerike style. To form the bands narrow shallow grooves were filled with niello and strips of silver.

On the front, top, and back of the head are short parallel ridges, bounded above and below by bands of silver. The horseshoe-shaped outline of the head is edged by a continuous band of silver, and the area confined by the band is filled with niello.

The pin can be dated with reasonable confidence to the eleventh century. Perhaps it was lost at the Battle of Clontarf, fought nearby in 1014.

Bibliography: CACP, p. 36, fig. 47; T. Fanning, "Some Bronze Ringed Pins from the Irish Midlands," *Journal of the Old Athlone Society* 1 (1975), pp. 211-217.

5 Irish Art in the Romanesque and Gothic Periods

Roger A. Stalley

The closing years of the eleventh century and the early decades of the twelfth constituted a prolific episode in the history of Irish art. Such masterpieces as the cross of Cong (**63**) and the shrine of St. Patrick's bell (**61**) were made at this time and provide a magnificent finale to the early Irish tradition. Metalworkers, painters, and stone-sculptors all contributed to this artistic crescendo, which is usually explained by the return of more peaceful conditions after the Viking invasions. A major artistic theme is the integration of Scandinavian styles into the repertoire of the Irish craftsmen. This trend is particularly apparent in metalwork.

The objects on which the metalworkers lavished most care were the book shrines, bells, croziers, and other relics of the early saints. The croziers created in Ireland in the early Romanesque period are without parallel elsewhere in Europe. A reverence for croziers, like that for ancient bells, had long been a distinctive characteristic of Irish Christianity; croziers served both as precious reliquaries and as symbols of religious authority. In many cases the wooden staff that forms the core of the object had belonged to one of the saints, or so it was believed. By providing a tangible link with the past, the crozier reinforced the role of the abbot and bishop as successors to the saints.

Some of the other reliquaries of the period have more obvious European counterparts. The shrine of St. Lachtin's arm (**62**), the oldest surviving arm reliquary in Ireland, can be compared to a series of continental shrines. Documentary sources indicate that other examples of this bizarre type once existed in Ireland; a Gothic version known as the shrine of St. Patrick's hand still survives. More precious than St. Lachtin's arm was a relic of the true cross acquired in about 1122 by Turlough O Conor, king of Connacht. This was taken from a larger fragment that was brought on a tour of Ireland in 1119 and evidently provoked intense religious excitement. The

shrine made for Turlough's relic, now known as the cross of Cong (**63**), is, happily, preserved almost intact; the annals make it clear that it was one of the most important shrines ever produced in Ireland.

Reliquaries inevitably form the bulk of surviving objects, since their very sacredness helped to ensure their preservation. But they present a misleading picture of the output of Irish craftsmen, a point revealed by an account of a robbery at the monastery of Clonmacnoise in 1129. Among the objects stolen from the high altar were a model of Solomon's temple, an engraved silver chalice decorated with burnished gold, a drinking horn, a silver cup, and three gifts of Turlough O Conor—a silver goblet, a silver cup adorned with a gold cross, and a drinking horn embellished with gold. The list represents only part of the treasures of Clonmacnoise, and there is no reason to suppose that other major monasteries were any less well endowed. If the silver cups and decorated drinking horns had survived, our picture of twelfth-century Irish metalwork would certainly be more complete.

Most works were made by professional craftsmen, and the names of several of them are known from inscriptions. Sitric Mac Maec Aeda worked at Kells at the end of the eleventh century; Nectan made the Lismore crozier; Cúduilig Ó Inmainen and his sons were active in Armagh in about 1100; and Maelisu MacBratdan U Echan enshrined the relic of the holy cross at Roscommon about thirty years later. These were artists of the highest stature, though little is known about them apart from their names and the works they created. While important monasteries like Kells, Armagh, Lismore, Roscommon, and Clonmacnoise evidently maintained their own workshops, the art of metalworking was not monopolized by the monastic cities. Evidence of bronzeworking has been found in recent excavations in Dublin. The Dublin workshops produced not only such utilitarian objects as pins, but, to judge from over thirty trial pieces with intricate

ornament, they manufactured elaborate artifacts as well.

The techniques used by Irish craftsmen at this time combined traditional methods with certain interesting novelties. Bronze was the basic metal and formed the foundation for other ornament. Of these gold filigree was popular. It was extensively used on the shrine of St. Patrick's bell (**61**), and it probably filled the now blank panels on the Lismore crozier. On the bell shrine filigree was combined with millefiori glass studs; this is a late example of a method with a long history in Ireland. Champlevé enamel was another familiar technique, usually employed with restraint in simple patterns of red and yellow. On the cross of Cong circular enameled plaques and glass beads give a colorful accent to the large areas of gilded bronze. Some of the finest Irish shrines contain sections of openwork casting, usually in bronze, but on the shrine of St. Patrick's bell, in gilded silver. Equally attractive are the inlay techniques used by Irish artists. One method, which involved fitting twisted silver and copper wires into grooves cut into bronze, can be seen on the Clonmacnoise crozier (**59**). Another form of inlay involved silver ribbons framed by strips of niello. The result was an attractive black and silver pattern set against a gilded bronze base. The method was exploited in an ambitious fashion on the shrine of St. Lachtin's arm (**62**), on which silver inlays were also used to set off the saint's fingernails!

By contemporary European standards, Irish metalwork of this period was proficiently executed in a variety of techniques. But in contrast to the extraordinary delicacy of Irish work of the seventh and eighth centuries, it seems heavy and coarse. A glance at the Ardagh chalice (**33**) or the Tara brooch (**32**) reveals the enormous gulf. Yet, though it lacks the earlier subtlety, the bolder ornament of the twelfth century often provides a more immediate visual impact.

Predictably, the inscriptions on many surviving ob-

jects give prominence to the names of the ecclesiastics and laymen who commissioned the works. Like most medieval patrons, though anxious to glorify the memory of the saints, they were not unconcerned about commemorating themselves. The presence of names provides a reliable chronological framework and permits approximate dating of the works, an impossibility for earlier phases of Irish art. Consequently there is more certainty about the way styles evolved in the Romanesque period, as Irish artists reacted to imported Viking ideas.

The Viking cities established on the coast of Ireland continued to be channels of Scandinavian influence. Thus during the eleventh century Ringerike motifs appear in Irish art, and they are prominent on the book shrine of the *Cathach* (Fig. 36), made between 1072 and 1098, almost certainly at Kells. It may be no coincidence that the craftsman responsible was called Sitric, a name of Viking origin. The side panels of the shrine are decorated

Fig. 36. Cast metal panel with Ringerike animal ornament from shrine of the *Cathach,* late eleventh century. NMI

with broad scrolls or stems, which, in typical Ringerike fashion, appear to cut sharply through each other rather than weaving over and under as in most interlace. Stylized leaves and lobed tendrils are also conspicuous in the design. The excavations in the old Viking city of Dublin have yielded further examples of the style. One of these (Fig. 37) is a bone trial piece with carved areas of stunning delicacy and precision. Its design is remarkably similar to panels on the *Cathach* shrine. Ringerike themes were also adopted by stonecarvers and may have persisted into the twelfth century, although by 1100 the style was on the decline. On the Clonmacnoise crozier (**59**) the Ringerike style merges with the Urnes; the ribbonlike bodies of the main animals are arranged with looser and more open interlace. One Ringerike feature, the shooting lobed tendril, continued to appear in the twelfth century, as on the cross of Cong (**63**).

Urnes ornament made its impact in Ireland about 1100, most clearly on the shrine of St. Patrick's bell (**61**), which contains several fine interpretations of the style. One of the magnificent openwork panels on the sides displays the smooth rounded snakes, which in typical fashion twist in even curves around large attenuated beasts. The heads of these animals are close to those on Scandinavian works, but the design of the interlace is markedly different. It is arranged in regular disciplined curves, often describing a figure eight. Since the term *Urnes* has been used to cover a wide range of decoration, some quite different from that on the small Norwegian church for which the style is named, modern scholars urge that the word not be applied too rigidly. As with Ringerike, Urnes was quickly integrated into Irish tradition, and it would be difficult to mistake an Irish work of the period for one produced in Scandinavia. On the cross of Cong, for example, the great beasts locked in a web of snakes are more substantial and closer in detail to traditional Irish animal ornament. Urnes made a powerful impression on

Fig. 37. Bone trial piece with carved animal ornament, about 1075, from High Street excavations, Dublin. NMI

Irish stonesculptors too; at Cashel a sarcophagus is superbly decorated with Urnes motifs. In the second half of the twelfth century it is possible to follow the modifications of the style in the delightful carvings on Irish Romanesque churches, on which masons used Urnes elements with freedom and originality. A window at Annaghdown, County Galway (Fig. 38), carved between about 1190 and 1200, has Urnes-type snakes looping around the head and feet of an enormous monster whose body forms the molding around the window itself.

Although they show abundant links with Viking art, Irish metalwork and painting reveal surprisingly little influence from England and the Continent. In the years around 1100 there were close relations between English and Irish ecclesiastics, as efforts were made to reform the Irish church by bringing its practices into line with those of the rest of Europe. The style of the Romanesque chapel at Cashel, built by King Cormac MacCarthy between 1127 and 1134, reflects this connection, not only in its architecture and sculpture but also in its mural painting, now sadly almost vanished. Hiberno-Romanesque sculp-

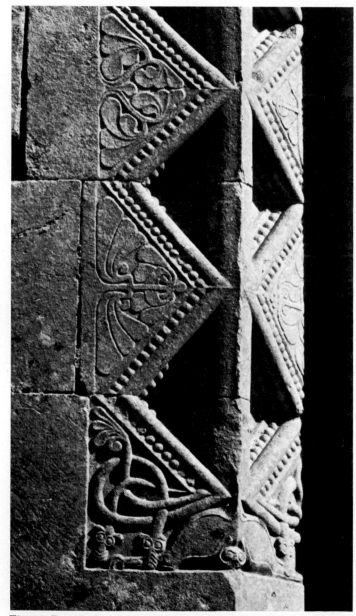

Fig. 38. Detail of carved window molding, about 1200, Annaghdown, County Galway

ture is a fascinating amalgam of Irish, Scandinavian, English, and French ideas, but Irish metalworkers and manuscript painters remained curiously immune to influence from contemporary Europe. Only occasional foliage patterns and such standard ornaments as filigree provide any visual link. It is therefore questionable whether Irish painting and metalwork of the period should be described as Romanesque, despite the chronological coincidence.

An illustration of this distinction between Irish and European art is the relative scarcity of human figures on Irish metalwork and a lack of concern for elaborate religious iconography. The sides of the book shrine of the Stowe Missal (58) are decorated with figures of a warrior, a man with a knife, two ecclesiastics, a harp player, and two angels, but no symbolic meaning can be assigned to them. The style of these figures is heavy and massive, recalling that on the tenth-century high crosses. Equally traditional are the figures on a badly damaged shrine known as the Breac Maodhóg (Fig. 39). During the twelfth century this conservative figural style was replaced by a new technique adopted by the workshop of Maelisu MacBratdan U Echan. It is best illustrated by the stylized and elongated figures of saints on St. Manchan's shrine, a large, portable house reliquary; these figures have large ovoid eyes, narrow mouths, and pointed chins. Several isolated figures of uncertain provenance are cast in a similar style, the origin of which is controversial (64). There are strong indications that it was derived from a crucifix imported from Germany.

As was so often the case in early medieval art, the metalworkers were in the artistic vanguard. In contrast, manuscript painting of the eleventh and twelfth centuries is conservative. The style of painting Sulien the Welshman learned when he came to Ireland in 1045 recalls European painting of the tenth century or before. Certainly the Ricemarch Psalter (Fig. 28, p. 146), which was decorated by Sulien's son in the late eleventh century,

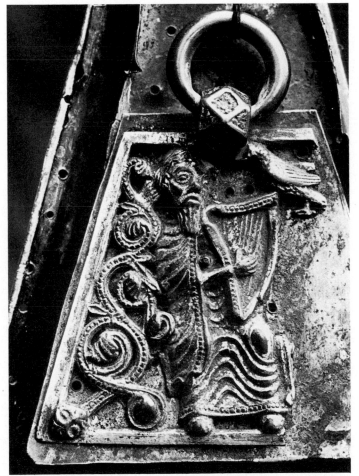

Fig. 39. David the harpist. Detail from Breac Maedhóg shrine, cast-bronze house-shaped reliquary, about 1100. NMI

at first sight appears older. Armagh, which was the source of the revolutionary Urnes ornament on the shrine of St. Patrick's bell in about 1100, continued in the twelfth century to produce gospel books with traditional evangelist symbols and initials. The Urnes theme of a great beast enmeshed in a roiling web of snakes does, however, eventually make an appearance in painting and is prom-

inent in a missal now at Corpus Christi College, Oxford. The style of its decoration is remarkably close to that on the cross of Cong. Of about twenty illuminated manuscripts produced in Ireland in the century before 1170, the finest is the Psalter of Cormac (Fig. 40). Immaculately preserved and richly colored, it is one of the last painted manuscripts from the early Christian tradition in Ireland, and, perhaps appropriately, its style is rooted in the past. Only the abundant foliage and the smooth curves of the interlace immediately betray its late date.

Cormac's psalter was evidently made for a Cistercian monastery, although it is hard to reconcile the extravagant ornament with the austere attitudes of the Cistercians. The arrival of the order profoundly influenced Irish art and architecture. The Cistercian monks introduced into the country new concepts of church building and monastic planning. The rapid expansion of the order weakened the hold of the ancient monasteries and indirectly helped to undermine native artistic traditions. Although the Irish Cistercians were not averse to receiving gifts of gold and other treasures, their ascetic rule of life forbade elaborate ornament and costly works of art. Thus Cistercian monasteries never became the centers of painting and metalwork that the ancient Celtic houses had been.

With the cross of Cong (63), made in about 1130, the sequence of accurately datable metalwork is broken, but this does not necessarily indicate a decline in production. Two important shrines, now lost, were made in 1166 and 1170, and parts of the shrine of the Book of Dimma (65) date from the middle of the twelfth century. Fortunately the lack of surviving metalwork from the second half of the twelfth century is compensated by the amount of splendid stonecarving that does remain. Hiberno-Romanesque sculpture was originally painted and must have looked like jewelry wrought on a massive scale. Some of the finest sculpture postdates the Anglo-Norman invasion of 1169–1170, and west of the Shannon River the

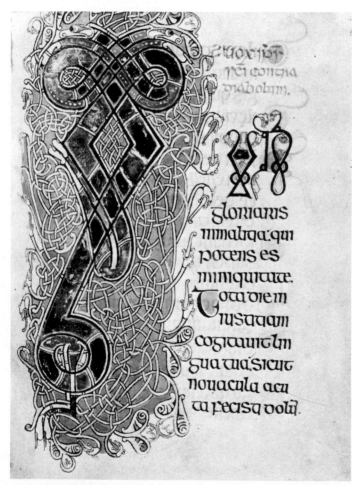

Fig. 40. Ornamental initial, *fol.* 60R, Psalter of Cormac, about 1100. Ms. 36929, The British Library, London

Hiberno-Romanesque style persisted until at least 1216–1224, when typical motifs were used to decorate the Augustinian abbey of Ballintober in County Mayo. The Anglo-Normans did not make a major impact in this area until after 1235, and it is important to realize that the arrival of the Anglo-Norman armies in 1169–1170 did not lead to the sudden annihilation of native tradi-tions. The colonization of Ireland was a slow process, and in artistic matters there was a long period of cultural "overlap."

Nevertheless, the ultimate effect of the invasion was the extinction of native styles and techniques. It is true that some of the invaders valued Irish craftsmanship—not least, Giraldus Cambrensis, who wrote a sensitive description of the Book of Kildare, an illuminated manu-script evidently much like the Book of Kells. But it re-mains a fact that no Anglo-Norman patron appears to have employed Irish artists in the decades following the invasion. The cathedrals and abbeys constructed after 1170 were English in style, and numerous English crafts-men settled in the conquered territories. Buildings like the two Dublin cathedrals, Christ Church (about 1186–about 1235) and St. Patrick's (1220– about 1260), were designed by English masons, and some of the stone used was even brought across the sea from quarries at Dundry near Bristol. Established metalworkers in Dublin—if they remained after the invasion—would have met competition from Anglo-Normans like Roger, William, Giles, and Godard of London, all listed as goldsmiths in Dublin at the end of the twelfth century.

A major flaw in the Anglo-Norman takeover was the failure to totally subjugate Ireland, and by 1300 serious weaknesses had emerged in the administration of the country. During the fourteenth century the authority of the Dublin government gradually collapsed; by the fif-teenth century the king's writ was directly effective only in the pale, that relatively small area around Dublin and Drogheda. Beyond that lay the three great Anglo-Irish lordships of Kildare, Ormond, and Desmond, and outside these power was fragmented among dozens of local chief-tains. A particular problem facing successive English governments in Ireland was the degree of assimilation between the settlers and the natives, especially through intermarriage. It was often remarked that there were

really three nations: the English, the Irish, and the "middle nation." The disintegration of centralized authority is starkly indicated by the hundreds of tower houses erected after about 1430. These miniature fortresses were first built to protect the pale against the onslaughts of the Irish but were quickly copied by them. In many areas they became the standard residence for any self-respecting Irish lord.

The complex political and social structure of Ireland in the later middle ages produced some curious artistic results. As English control waned, a distinctive Gaelic culture arose. Ancient manuscripts were transcribed and preserved in such large compendia as the Book of Ballymote, the Leabhar Breac, and the Leabhar Mór Leacáin. The Book of Ballymote, compiled about 1390 at the home of a Gaelic lord, includes numerous early texts—genealogies, histories, classical tales, legal treatises, poems, and even a tract on ogham writing. It provides an authentic Celtic touch through a series of brightly colored initials with interlace and animal patterns derived from the early Irish manuscripts being transcribed (Fig. 41). But after two hundred years of Anglo-Norman culture, the principles of early painting were forgotten. The intricacies of interlace frequently baffled the later artists, who thus

Fig. 41. Ornamental initial from the Book of Ballymote, about 1400. RIA

adopted simpler designs. Although they lacked sophistication, the results were not unattractive, and the Irish flavor of the ornament is unmistakable. The enthusiasm of the Gaelic revival was such that at least one copy was made of a leather satchel in which the ancient monks used to carry their books; at first sight the satchel of the Book of Armagh (67) appears to have been made in the eleventh or twelfth century, but in fact it is a product of the later middle ages. Several details of the interlace and animal ornament betray the true date, and the ultimate clues are the Gothic letters decorating one of the medallions. Nevertheless, parts of the ornament seem so authentic that until recently the date of the satchel continued to mislead scholars.

The Gaelic revival brought a renewed interest in ancient relics and shrines, many of which were restored during the period. Unfortunately the restorations were often crude and clumsy. Whereas painters could make tolerable copies of early Christian initials, gold- and silversmiths could not execute the techniques of the early Christian metalworkers without training. Apart from a coarse type of filigree, the methods used were quite different. Most of the additions were made in silver, decorated with figures either engraved or cast in relief. The Crucifixion was a prominent theme and other common subjects were the Virgin and Child, the apostles, and the saints of Ireland. The style of the figures is a debased version of European Gothic, often with the drapery flattened into semiabstract patterns. Further ornament was provided by inset gems, frequently pieces of rock crystal. The effect is rarely very beautiful, and all too often the gems are unpleasantly out of scale. It must be admitted that many of the later metalworkers are distinguished only by their incompetence. In the late-Gothic additions to such works as the *Corp Naomh* (56), Irish metalwork reached its nadir.

There are, however, exceptions to this generally de-

pressing picture. The animals that dart around the borders of such shrines as the *Domnach Airgid* (66) have considerable life and spontaneity, although they are stylistically derived from the repertoire of European motifs. The highest quality of craftsmanship is found not among the restorations but on a number of completely new works. Outstanding are the crozier and mitre commissioned in 1418 for Conor O Dea, bishop of Limerick. The richly jeweled mitre carries the name of the artist, Thomas O Carryd, who was presumably a Limerick goldsmith. The crozier is the finest piece of late medieval metalwork in Ireland (Fig. 42). Equally masterly is the Ballylongford processional cross (69), made by the goldsmith William Cornelius. Like the Limerick crozier, it is of gilded silver and bears an expressive figure of the crucified Christ. Shoulders and ribs are highly stylized, and the grim facial expression evokes that feeling of horror so often portrayed on late Gothic crucifixes. Both Thomas O Carryd and William Cornelius were accomplished artists, but there is nothing particularly Irish about their work. Unlike the painters of the Gaelic revival, the metalworkers depended almost exclusively on imported Gothic models.

Despite the chaotic picture of Ireland conveyed by documentary sources, the fifteenth century must have been a period of considerable economic prosperity. There was much ecclesiastical building, particularly by the friars in the Gaelic areas of the west, but in terms of quality the finest church architecture is found in the territories of the Earl of Ormond, centered at Kilkenny. In about 1450 the Cistercian abbey of Holycross was totally reconstructed and, although it is not ambitious in strictly architectural terms, the level of craftsmanship is stunning. The architecture of the abbey is strangely archaic; fourteenth-century "decorated" forms abound, with an occasional hint of the Romanesque. Holycross is another illustration of the retrospective culture of later medieval Ireland; the architect based his style not on contemporary English or

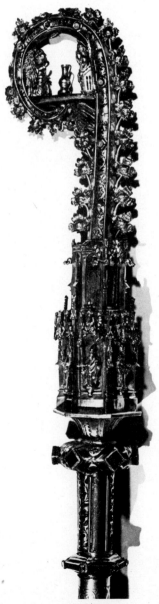

Fig. 42. The Limerick crozier, 1420

continental design, but on earlier buildings in his own locality. Above all, Holycross is distinguished by its carved stonework. Cut in dark carboniferous limestone are many foliage patterns, executed in crisp and bold relief (Fig. 43). A few decades later, at the end of the century, Irish stone sculpture reached its apogee in a series of tombs in the Ormond area. While the style of the figures depicted on the tomb chests does not much exceed the level of folk art, the quality of the stone cutting is frequently remarkable.

It is hard to discern much uniformity of outlook among the painters, metalworkers, and stonecarvers of later medieval Ireland, and only the painters systematically attempted to revive ancient motifs. But in one other art Irish tradition survived almost unbroken through the Anglo-Norman interlude. This was the quick and lively

Fig. 43. Detail of carved side panel, stone tomb chest, about 1450, Holycross Abbey, County Tipperary

technique of the Irish harpist. It is therefore appropriate that one of the greatest monuments to the Gaelic revival is a harp (**68**). Irish society accorded a high status to musicians; a glimpse of this reverence can be obtained from an entry in the annals for 1226. It records the death of Aed, son of Donnsleibhe O Sochlachain, of Cong, "a professor of singing and harp making—who made, besides, an instrument for himself, the like of which had never been made before." Harps were valuable, for they were constructed by an expert and the woodwork was often elaborately carved. At the courts of Gaelic chieftains and Anglo-Irish lords the verses of Irish poets were sung to the music of the harp. Consequently the instrument was viewed with suspicion by the English authorities, who regarded harpists, rhymers, and bards as seditious and dangerous individuals. In form the Trinity College harp is a late medieval type. It is decorated with interlace on the forepillar, and the broad strips and circles on the neck and soundbox are another ancient Irish motif. In contrast, the animals that fill the four medallions at each end of the forepillar are ultimately derived from European models. In its ornament the harp is thus a typical product of the Gaelic revival, diverse in inspiration with a strongly retrospective character.

Whatever its merit, Irish medieval art never attained the international quality so evident in the works of the Golden Age, though the quality was still apparent in the products of the twelfth century. The painstaking attempts two hundred years later to revive some of the forgotten skills merely underscore the enormous sophistication of early Irish art that had evolved through centuries of experience. The ancient traditions withstood the Viking onslaught and even absorbed Scandinavian styles, but there was no equivalent recovery after the Anglo-Norman settlement. Despite the efforts made during the Gaelic revival, most Irish artists after 1300 could not avoid the shadow of England and the Continent.

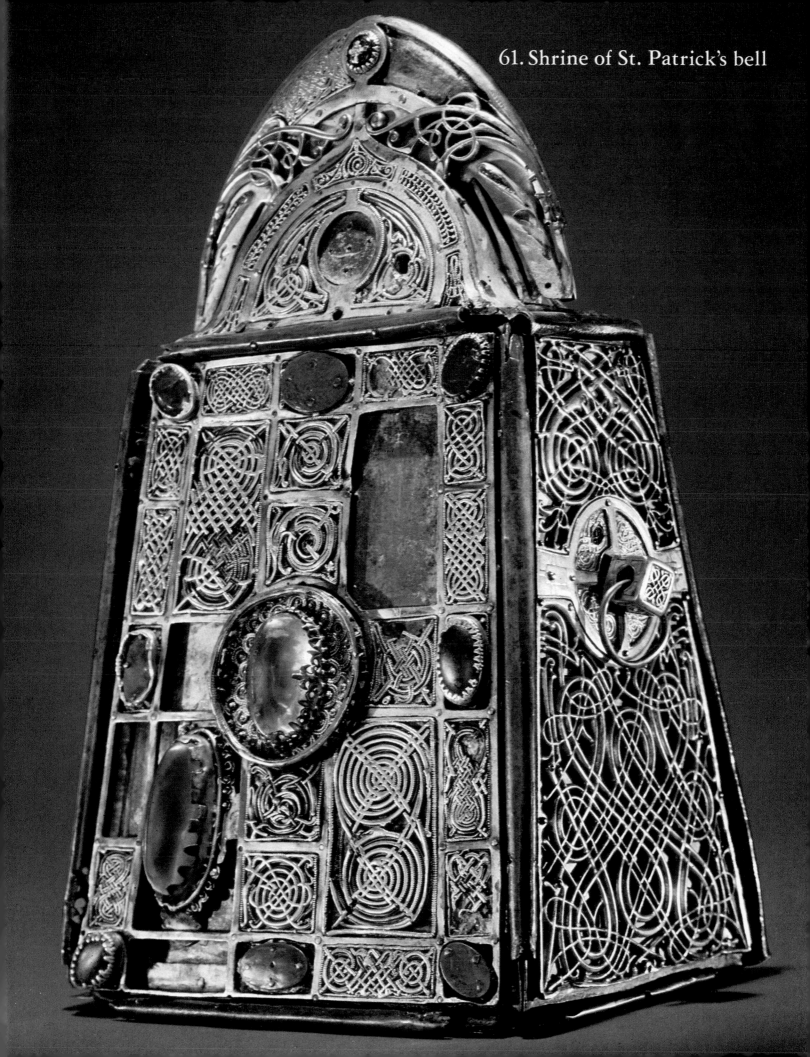

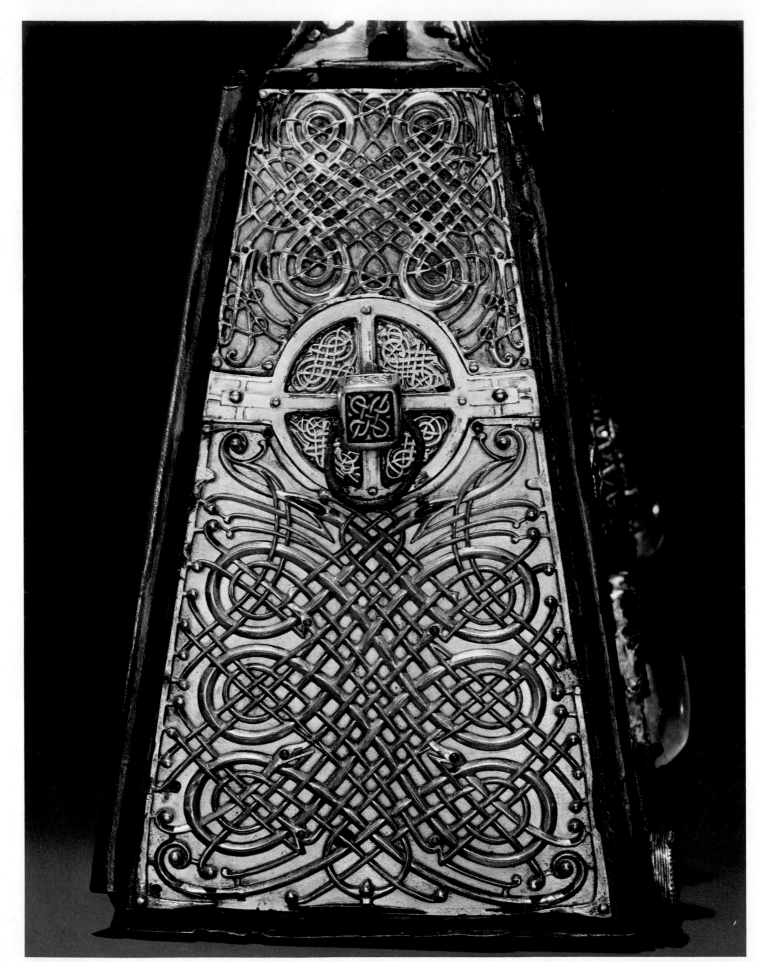

61. Shrine of St. Patrick's bell

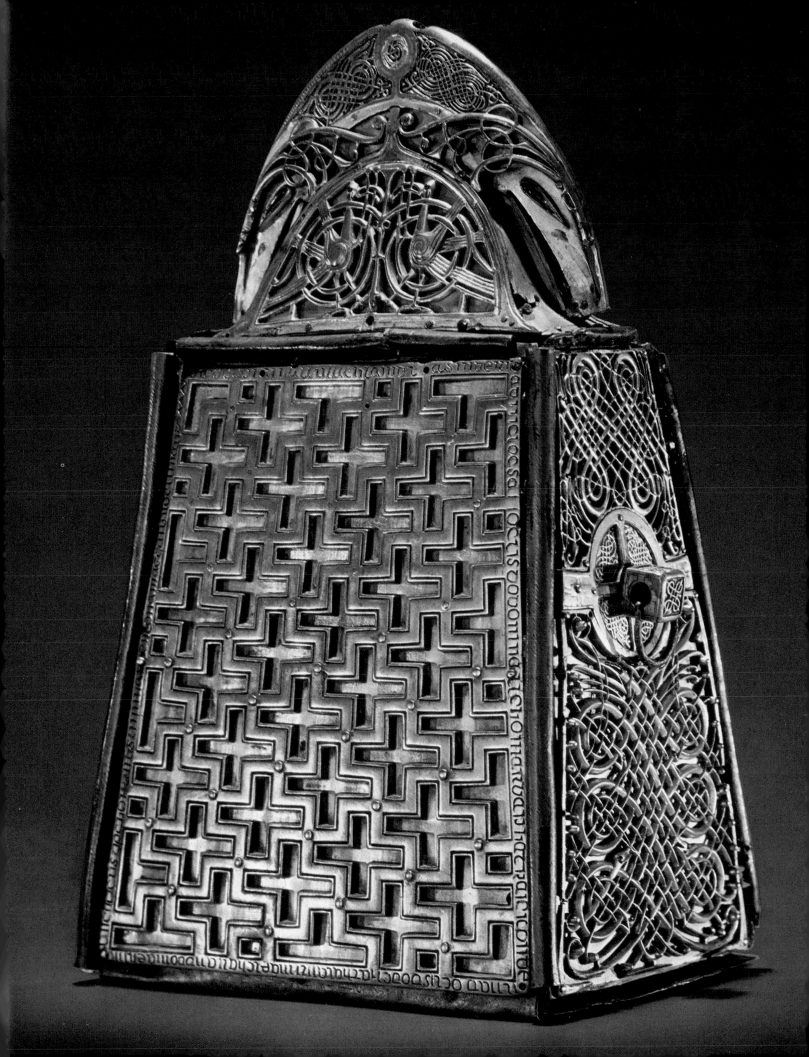

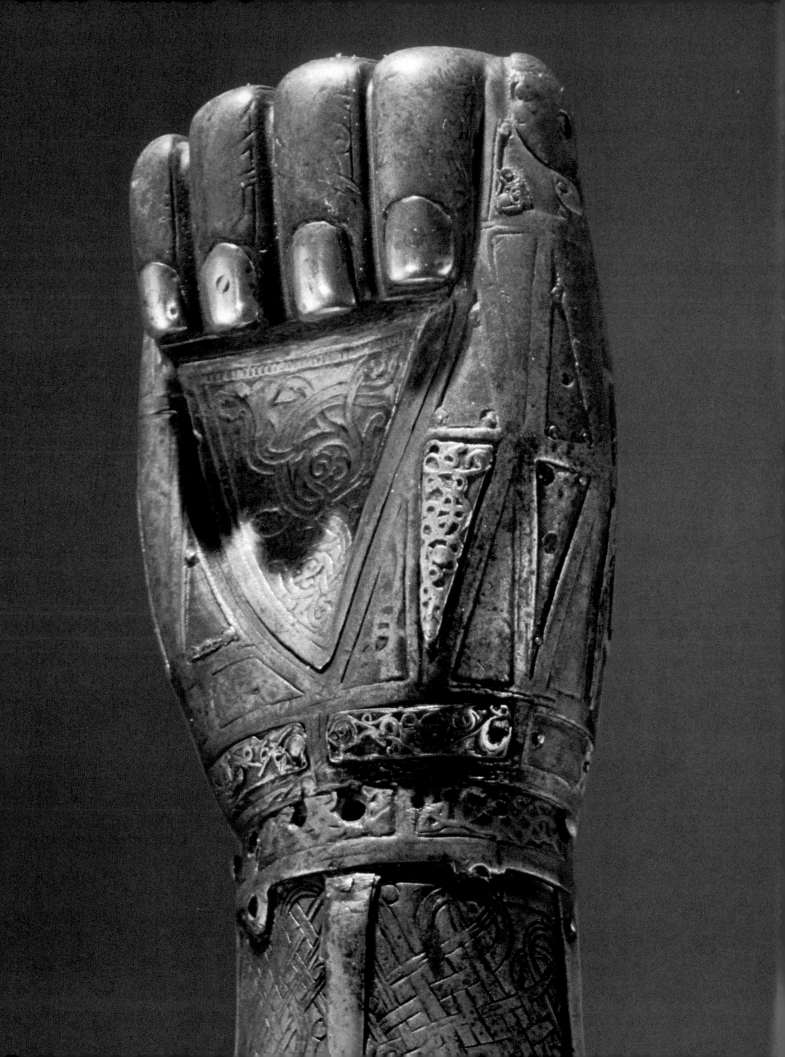

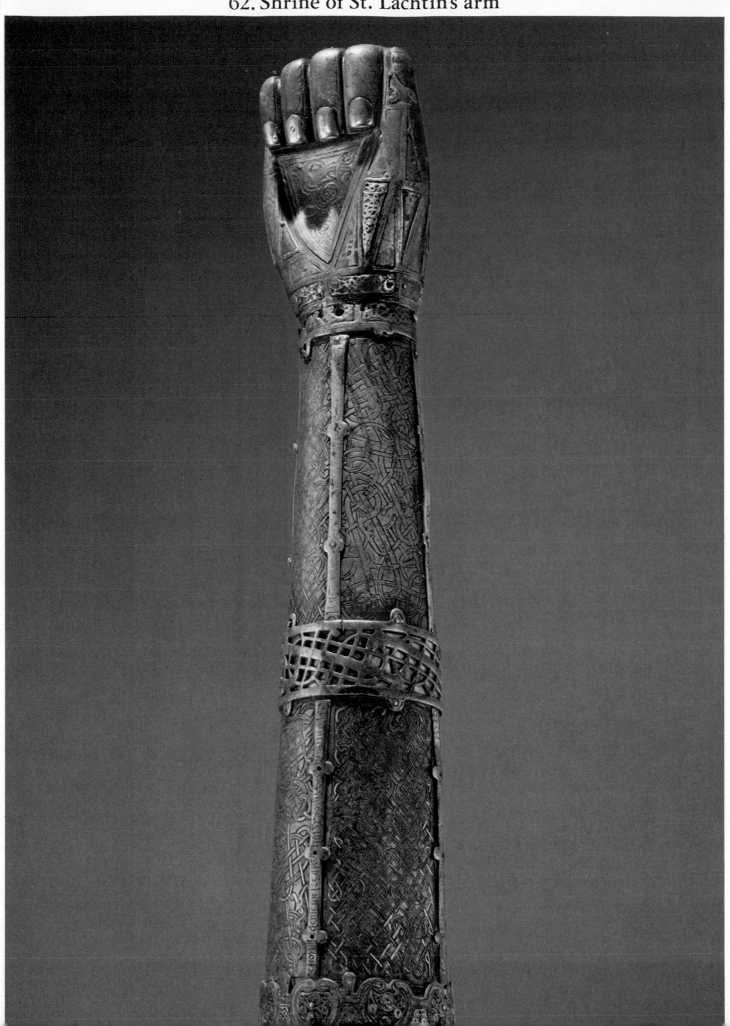

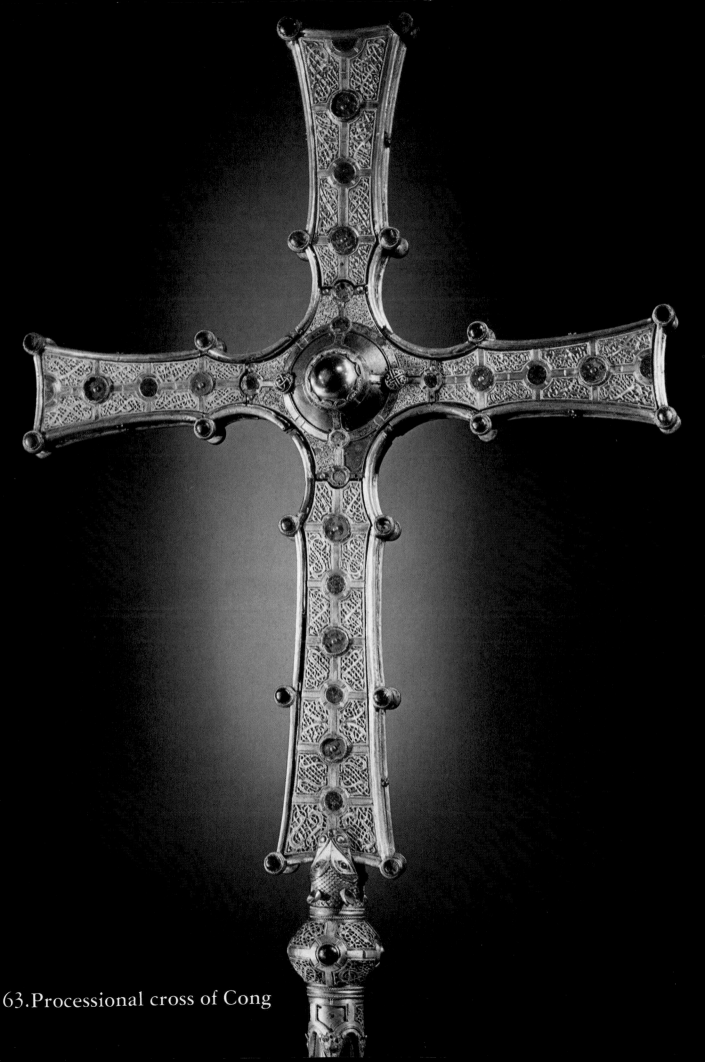

63. Processional cross of Cong

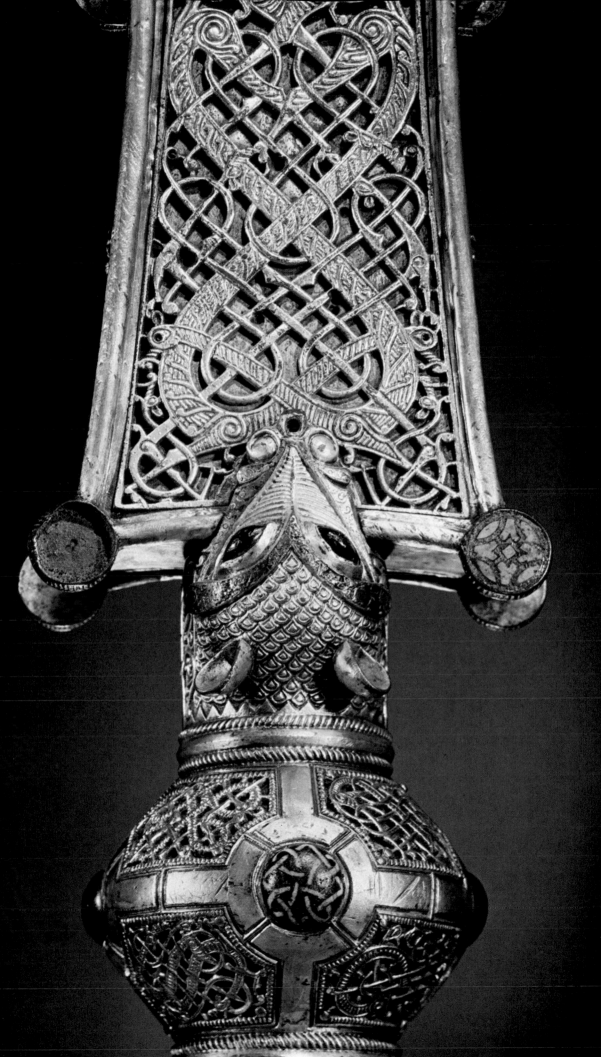

64. Gilt-bronze figure of a bishop

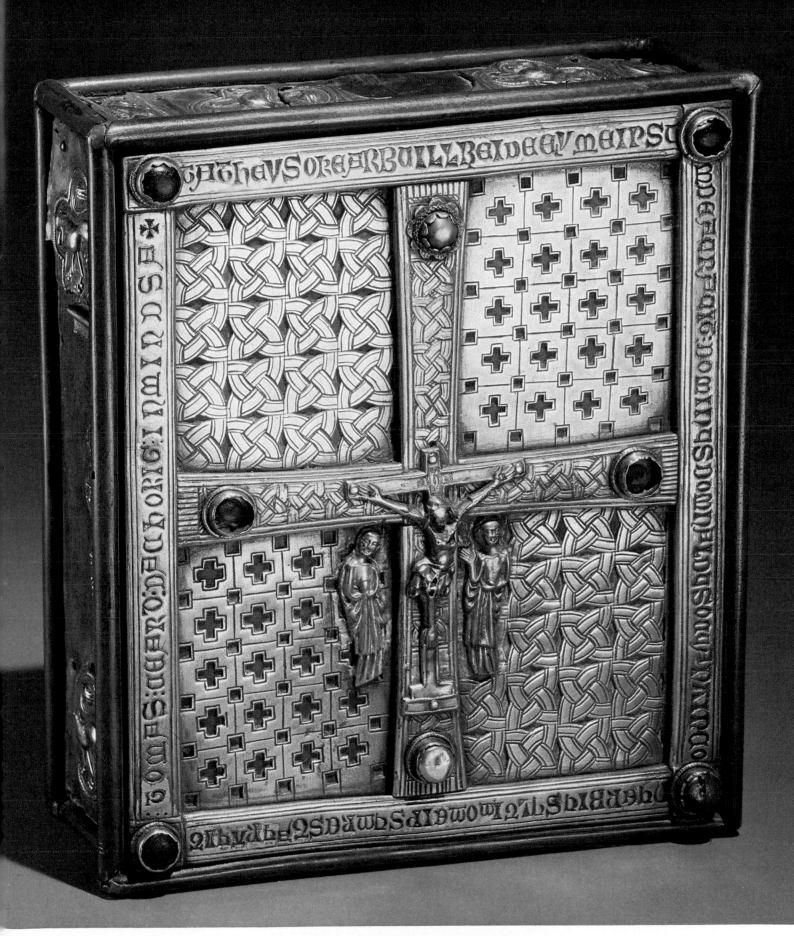

65. Shrine of the Book of Dimma

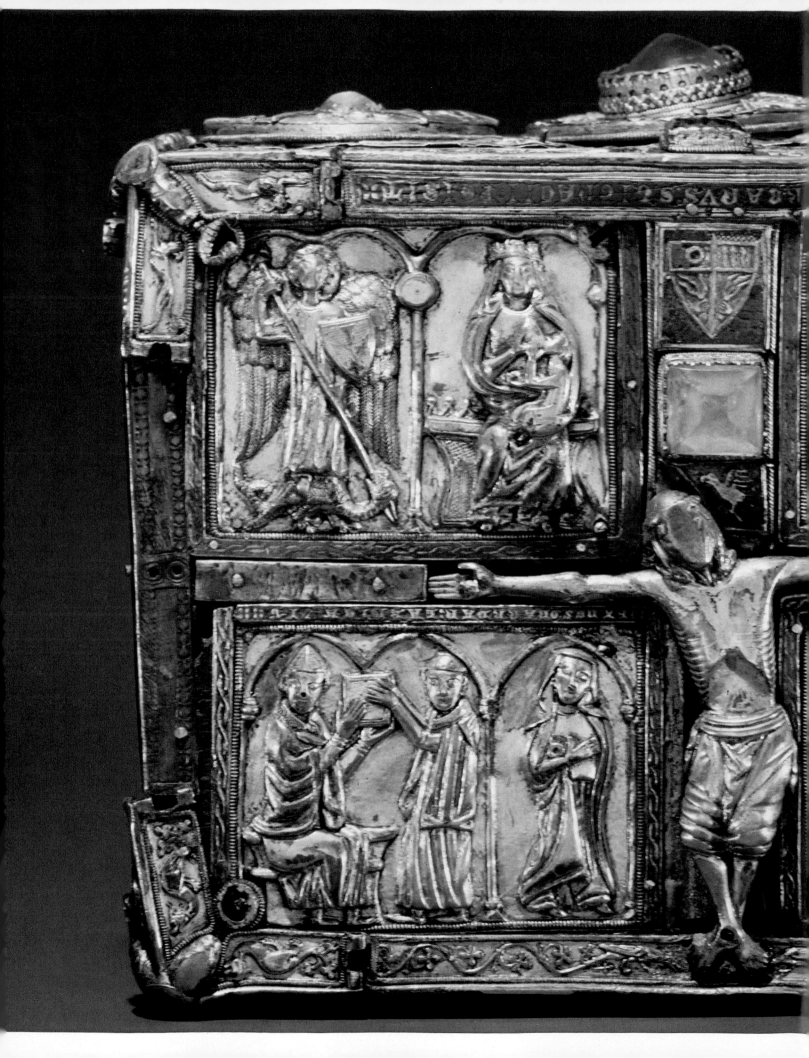

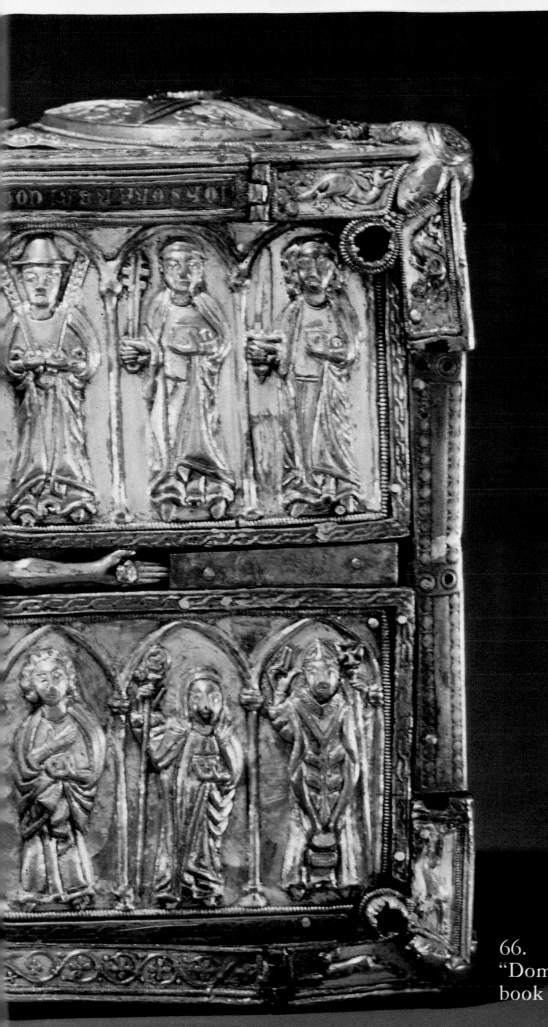

66.
"Domnach Airgid"
book shrine

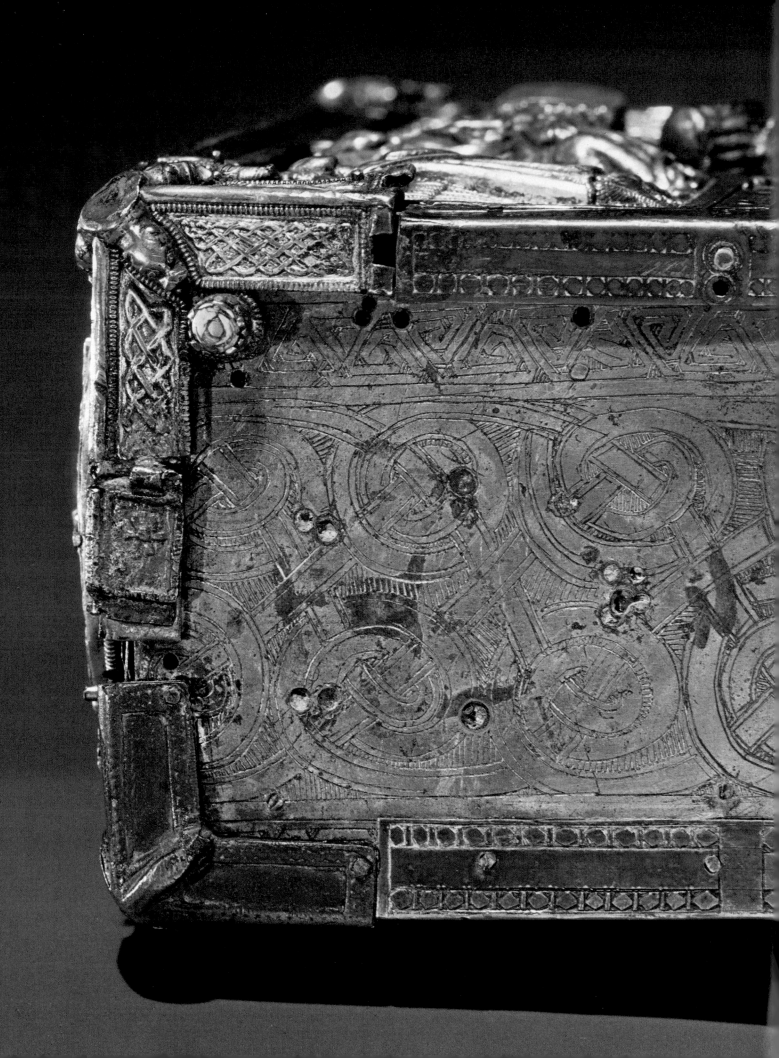

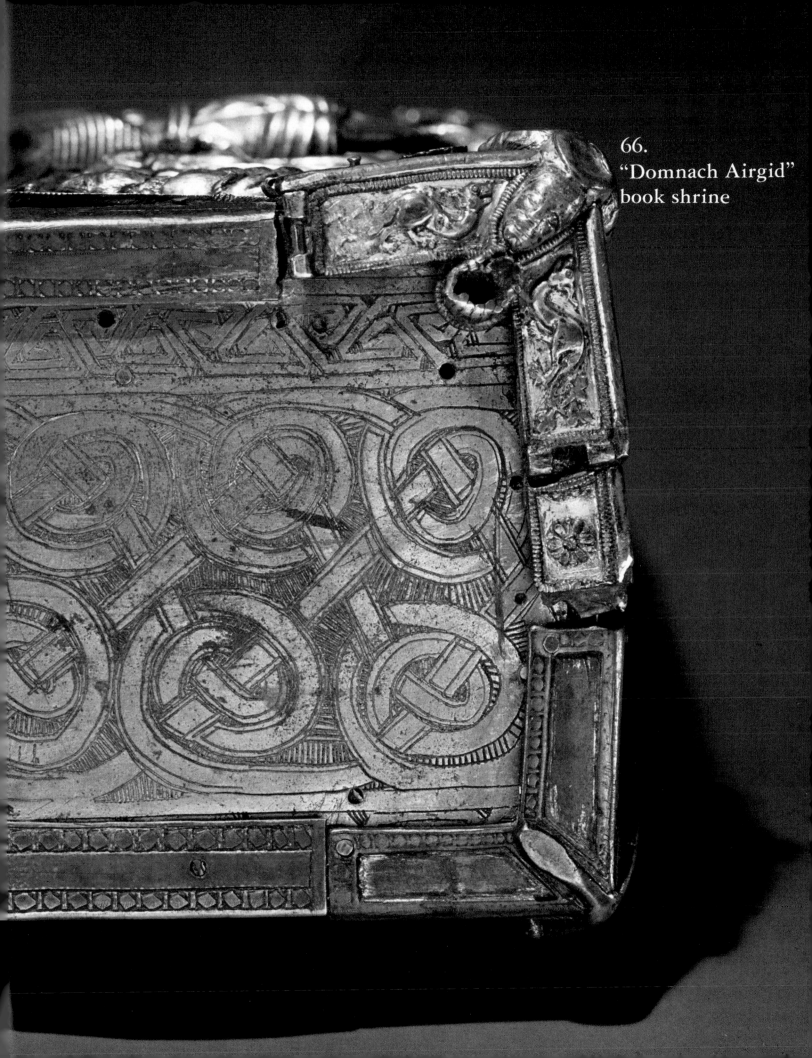

66.
"Domnach Airgid"
book shrine

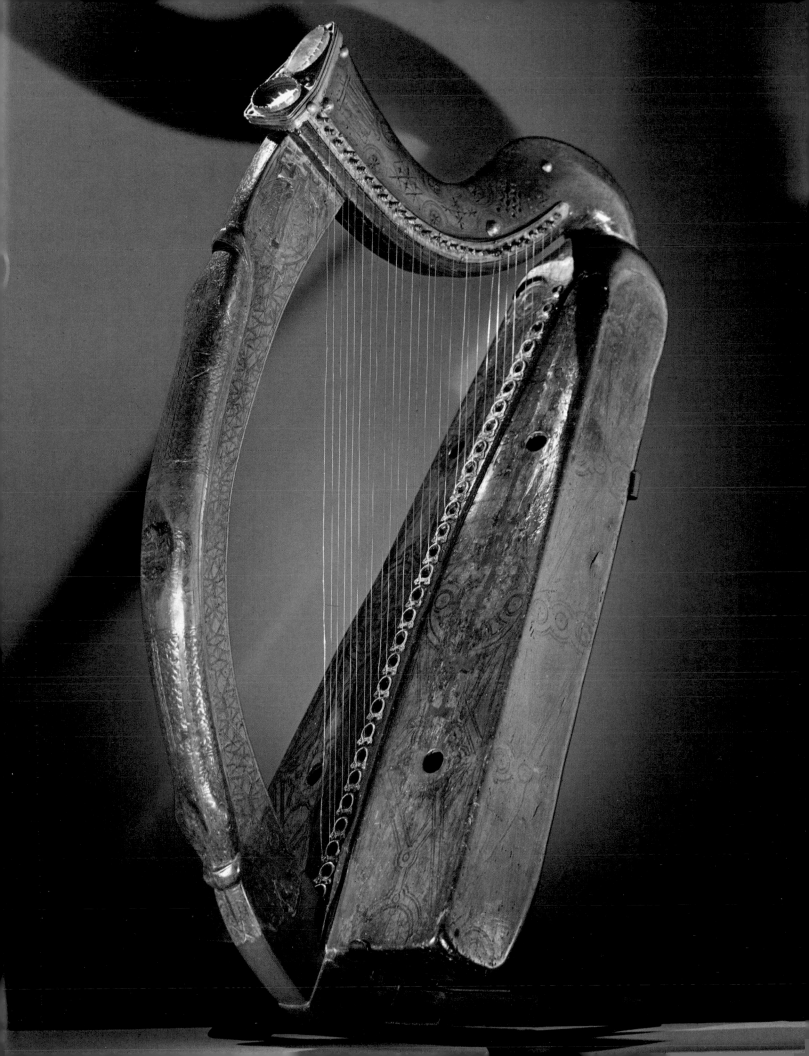

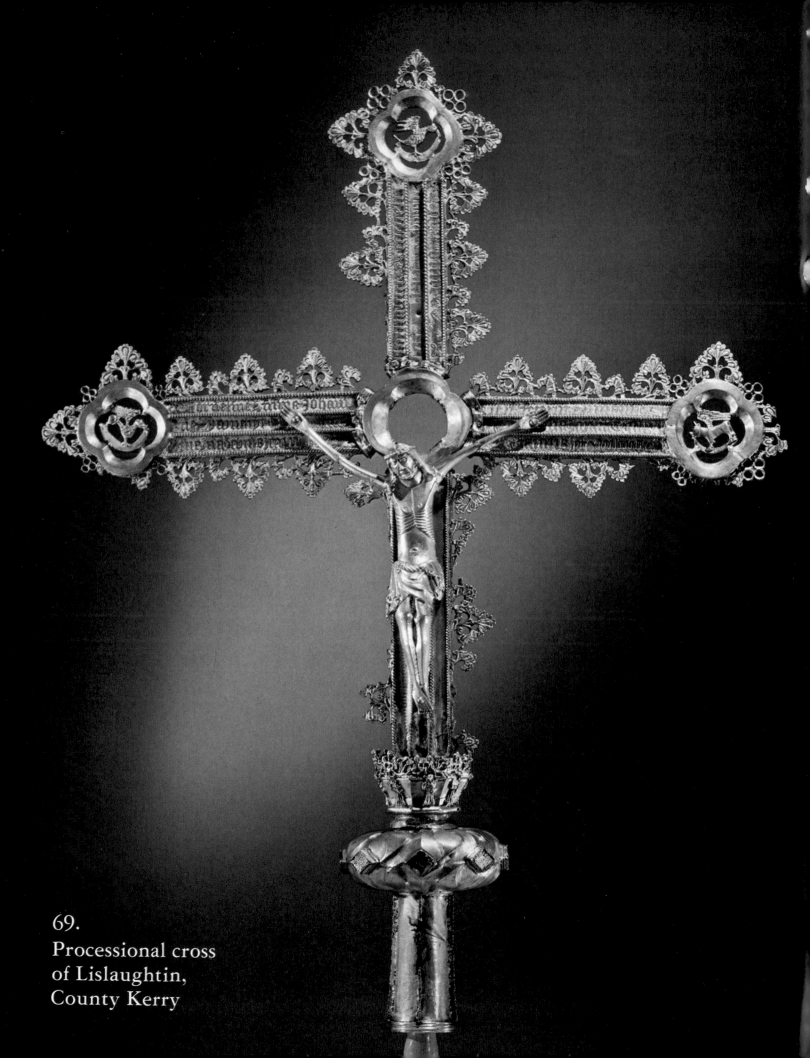

69.
Processional cross
of Lislaughtin,
County Kerry

Catalogue

61. Shrine of St. Patrick's bell

Hiberno-Viking period (bronze phase), early twelfth
century
H. 26 cm.
NMI, R. 4011

This shrine was made in about 1100 to house St. Patrick's
bell (**45**) and shows Irish Urnes-style ornament at its
highest level. It is a box with sloping sides made of
bronze plates bound by split tubes; the semicircular cap
surrounded the handle of the bell.

Attached to the front of the box is an openwork plate.
This holds around its margin a series of rectilinear deco-
rated plates. At the corners and at the center of the sides
later settings for oval jewels, some still full, some empty,
conceal or replace the original plates. Within this border
rectilinear apertures are arranged in the shape of a cross
with a circular setting for a jewel at the crossing of the
arms (a later jewel is now fitted here). Larger rectangular
apertures lie between the arms and the border. Two of
these apertures have lost their decorated plates; a large
oval jewel has been roughly inserted at the lower left. The
surviving plates of Irish Urnes style are of openwork
built up of tubular animal interlace with many free ends,
often spirally coiled. On some of the plates the interlace
is built up of bronze or copper wire, horizontally grooved,
with applied gold foil.

The silver plate at the back is pierced by interlocked
cross-shaped apertures and surrounded by a narrow rim
incised with a long inscription. The rim interrupts many
of the crosses, so that the apertures near the margin are
T shaped, *L* shaped, or square. An incised line surrounds
all the apertures.

The sides, though identical in principle, differ in lay-
out. They are divided into two compartments by a hori-
zontal band about one-third of the distance from the top.
On the band is a circle spanned by a cross with a circle at

the crossing of the arms. The areas between the arms and
the containing circle are filled with interlace dominated
by figure eights. A small bronze cube, pierced laterally for
a suspension ring, is attached to the central circle; the top,
front, and bottom carry small panels of interlace; the
sides are plain.

Above and below the division are silver-gilt cast zoo-
morphic interlaced plates. The animals have extended
jaws, a prominent eye (often filled with blue enamel),
and a body of one or two tubes (sometimes with a third
beardlike strand); the diameter of the tube may expand
and then contract again before ending in a spiral twist.
Finer tubes, ending in snake heads with bulbous eyes,
thread through the animals. The basic layout is figure
eights; on the right side the eights are horizontal in the
upper compartment and vertical in the lower; the reverse
holds on the left side.

The cap has a curved, ridgelike crest of two monstrous
animal heads back to back, with semicircular decorated
areas below on each side. From the upper border of the
areas spirelike projections, which terminate in discs, rise
to separate the heads. Each head has an attenuated snout,
freestanding lower jaw, and oval enamel-filled eyes. A
central ridge rises from the front of the snout, and behind
the head this gives rise to a mane of coarse interlace,
which hangs down on either side of the crest. The ridges
continue to the disc at the top of the crest.

A setting at the front of the disc contains blue enamel,
into which is inserted an enameled flower with red and
white petals; the petals are defined by vertical gold strips,
which may be executed in cloisonné enamel; at the back
the disc contains interlace. On the left side is an inter-
laced plate carefully shaped to fit between disc and mane;
the other plate is now missing.

On the front of the cap is an elaborate openwork plate
with a marginal band of filigreed panels. Their decoration

includes contorted spiral animals and spiral florets on either side of a central stem. The central area contains a circle which is now empty. The panels on either side have beaded borders and contain spirally interlaced animals.

On the back of the cap the semicircular panel is divided by a narrow central pillar. On either side are interlaced tubular beasts and affronted birds; their long tails suggest they are peacocks.

Bibliography: CAAI, p. 156, pls. 79, 80; ECI, p. 253, pl. 65; IA III, p. 95, pls. 22-24, 27; TI, pp. 109-113, figs. 71, 72, pl. 31.

62. Shrine of St. Lachtin's arm

Hiberno-Viking period (bronze phase), first quarter of
 twelfth century
Bronze with added silver, niello, gold, copper, and glass;
 wooden core.
L. 38.5 cm.
NMI, 1884: 690

Arm reliquaries are known in Europe from the middle of the eleventh century, and several have survived from the twelfth century. This shrine of St. Lachtin's arm bears an inscription by which it can be firmly dated to between 1118 and 1121.

It is made of bronze inlaid with silver over a core of wood and represents a forearm with the fingers bent down to meet the palm. A narrow plate below the fingers has free-running acanthus foliage.

The wrist, hand, and fingers are sheathed by bands and panels of various shapes with cast interlace or silver filigree. A triangular silver-gilt panel with a spiral pattern of foliage and tendrils covers the palm. The outside of the little finger was hatched and later covered in part by a small silver plate with wiry decoration. The nails are covered by silver plates.

The arm is divided into two parts by a central horizontal band of openwork cast-bronze interlace in Urnes style overlying a gilded base. Four equally spaced vertical strips, once gilded, divide the arm into eight panels. Some of the strips carry an inscription. The bronze panels are decorated with inlaid animal-headed ribbons of silver and niello again showing Urnes influence.

Below the lower panels are complicated straps and panels with spiral silver-gilt filigree, geometric and animal interlace (originally covered with gold foil), and glass studs.

The base is formed by a circular, partly conical plate with a large central aperture, which presumably held a rock crystal through which relics could be viewed. Two encircling bands are decorated by panels and bands with spiral scrolls of silver filigree (also once gilded), silver, niello, and short parallel ridges once covered with pressed-on gold foil. The original aperture has been reduced in size by the insertion in it of a second, pentagonal plate with a smaller aperture. This carries a beaded undulating copper wire (formerly silvered and gilded), with spirals of similar wire filling the bends. It probably came from a different shrine.

In this splendid piece we can see the Irish interpretation of the Urnes concept of interlace. The disciplined rhythmic interlace is distinctively Irish, quite unlike the Scandinavian model.

Bibliography: CAAI, p. 161, pl. 99; CACP, pl. XII; IA III, pp. 103-106, pls. 38-40; TI, p. 133, fig. 90, pl. 36.

63. Processional cross of Cong

Hiberno-Viking period (bronze phase), early twelfth
 century
H. 76.5 cm.
NMI, R. 2833

Much of the immediate impact of this magnificent processional cross is made by its subtly curved outline, emphasized by tubular silver edging and bossed rivets. Where

the arms cross on the front is a circular rock crystal, intended to protect a fragment of the true cross. The crystal is set in a conical silver mount, surrounded by a flange highly decorated with gold filigree, niello with inset wires and spirals of silver, and white and blue glass bosses at the cardinal points. From these bosses straplike bands of silver run down the centers of the arms, which bear more glass-filled bosses and circular plaques of niello with inset spirals. The surface of the cross is divided into decorative panels. Near the crossing the decoration is of pseudo-beaded spirals produced by setting a narrow coiled strip, one side of which had been notched and bent over to simulate beading, on edge on the plate. All the other panels are made of cast openwork bronze plates with S-shaped Irish Urnes ribbon-animals tied down by thread-like snakes.

The inscriptions, which date the cross to about 1125, appear in silver foil pressed onto underlying engraved bronze plates. These run along the sides of the cross, retained in the jaws of animals. On the back only four large cast animal plates were employed, and the three that have survived illustrate the Irish Urnes style at its best.

The projecting rivet heads are decorated with circular plates bearing red and yellow enamel with cruciform and step patterns similar to those on other late shrines.

The link between the cross and its supporting staff has been made in an elegant and ingenious manner by use of a central biconical knop like those on croziers. Silver bands and circles (the latter with blue glass bosses) separate small panels with animal interlace on the knop. Above it two confronted animal heads without lower jaws grip the base of the cross securely with their upper jaws, which are bordered with silver and niello. (These animals, with ribbed snouts, scaly heads, blue glass eyes, and pointed ears, are the same type of beak-heads that adorn Romanesque stone carving in Ireland and Atlantic France.) The V-shaped gap between the heads is filled by an elegant tree with spirally arranged foliage and tendrils. Below the knop four stylized animal heads, suspended from small panels containing animals, surround the top of the staff.

Bibliography: CAAI, p. 152, pls. 97, 98; ECI, p. 254, pls. 68, 69; IA III, pp. 106-110; pls. 41-43, 74, M, N; TI, figs. 91, 92, pl. 37.

64. Gilt-bronze figure of a bishop

Hiberno-Viking period (bronze phase), twelfth century
H. 19 cm.
NMI, R. 2940

This elongated figure of a bishop, wearing a decorated mitre and holding a crozier with a spirally coiled head and a pointed ferrule, probably comes from the side of a shrine. A group of related figures is found on St. Manchan's shrine. Like the bishop, these figures have large ovoid eyes, prominent ears, a heavy nose, and a strong chin or beard. The bishop wears decorated ecclesiastical dress; the floral design of the outer cloak is based on a single strand of acanthus on his right side and a double strand on his left: two circular designs (pierced for rivets) decorate the shoulders; each design shows an equal-armed cross with rounded ends surrounded by concentric circles; the inner tunic has geometrical fret. The feet, in decorated boots, point downward and inward. The ears have spiral lobes.

The elongated body and rigid posture represent a new style, which may have reached Ireland through an imported crucifix, perhaps from Germany. The patterns on the dress, however, essentially continue an Irish tradition.

Bibliography: CAAI, p. 162, pl. 106; H. S. Crawford, "A Descriptive List of Irish Shrines and Reliquaries," *Journal of the Royal Society of Antiquaries of Ireland* 53 (1923), pp. 74-93, 151-176.

65. Shrine of the Book of Dimma

Hiberno-Viking period (bronze phase), mid-twelfth century; altered in fifteenth and nineteenth centuries

L. 19 cm.

Library, TCD

The original shrine was perhaps slightly smaller than the present one. An inscription, interrupted by small squares at the corners, runs around a marginal strip on the back. This refers to Thaddeus O'Carroll, who died in 1152, and the style of the older parts is of the mid-twelfth century.

An almost equal-armed cross divides a lowered plate on the back into four sectors. The arms of the cross carry narrow panels of angular interlace, which end just short of the ends of the arms against a small square. Opposite quadrants of the lower plate carry identical designs. One pair bears interlaced circles. The other pair is ruled in squares with small square holes pierced where the rules intersect; the center of the ruled square is pierced by a small equal-armed cross. Small silver bosses, most of which are damaged or lost, in round settings with a beaded base, lie at the ends of the arms and in the corners; they do not seem to be original, as they overlap the squares in which they are set. One of them, at the top of the upper arm of the cross, has a petalloid base and was perhaps made in the nineteenth century.

On the front a quite modern margin and cross are obviously copied from the back; the margin carries a nineteenth-century inscription. Four pierced silver plates occupy the intervening spaces; the metal was cut away in a crude and irregular fashion to form animals with ribbon bodies coiled into figure eights. They are bound by ribbon-style snakes with bodies of the same width as the animal bodies. Some snakes have three-lobed heads; their bodies are decorated with pellets, short strokes or a thin zigzag line, and acanthuslike lobes. The pattern recalls the design on the great stone at Jellinge, in Denmark, dated A.D.

1000, on which a beast struggles with a snake. Two birds appear at the bottom of the right-hand lower panel of the shrine.

The narrow left side carries a damaged plate with a series of continuous plain ribbon figure eights with two S-shaped ribbon-bodied animals threaded through them in sinuous curves; the animal heads protrude at the surviving end of the plate. Short lengths of ribbon, ending in animal heads, are threaded laterally through the main pattern. The ribbons are outlined by a rocked tracer or a rouletted wheel, and the background is roughened by the same technique. The design is surrounded by a border of chevrons, made with the same implement (which was also used on some of the snake bodies on the front).

In the fifteenth century a representation of the crucified Christ flanked by the Virgin and St. John was added to the back of the shrine. A large piece of rock crystal surrounded by pieces of lapis lazuli and bosses were added to the front, and the sides were reencased with embossed silver plates. On the right side a quatrefoil stamp with a beaded margin contained a monster standing erectly on one foot; the top bears a line of three more quatrefoils between vertical ribs; the panel on the left contains an animal whose outline resembles a horse; the right panel contains a wyvern. The patterning of the silver plate is truncated below the rectangles, and what we see must have been cut from a still larger plate.

Bibliography: CAAI, p. 163, pls. 101, 102; IA III, p. 116, pl. 48.

66. "Domnach Airgid" book shrine

Seventh, fourteenth, and fifteenth centuries

L. 23 cm.

NMI, R. 2834

The *Domnach Airgid* (the "silver church") has a history of embellishment of almost a thousand years.

The first container was a hollow yew-wood box with a sliding lid. The box was covered with tin-coated bronze plates engraved with a central panel of broad-ribbon interlace surrounded by a border with triangular fretwork. Two of these plates, which were probably made in the seventh century, are still exposed on the sides of the box, and a third can be seen beneath a later plate on the top.

A silver and niello inscription along the top of the front tells how the shrine was remade in about 1350 by John O Bardan for John O Carbry, Abbot of Clones, who died in 1353. The fourteenth-century front has four rectangular silver-gilt plates with embossed figures of the Virgin, saints, angels, and clerics in high relief. On the lower left plate is a double panel probably representing a clerical scribe presenting a copy of the gospels to St. Macartin, first bishop of Clogher. The arrangement of the garments shows a blend of Gothic innovation and earlier Irish tradition.

The plates are surrounded by strips of metal now clumsily joined. The lower part of a central cross-shaped area between the plates is occupied by a silver-gilt figure of the crucified Christ, whose outstretched arms divide the upper and lower plates. In the rectangular area above the head of Christ is a pointed shield enameled with the emblems of the Passion and a square of rock crystal in a silver mount; through the crystal a reputed fragment of the true cross can be seen. An eaglelike bird, probably intended as a hovering dove, in a field of blue enamel, lies directly above the head.

The bottom contains three square plates, each with an attached figure in the same style as the Christ figure on the front.

On the top a rectangular silver-gilt plate holds three equal circles arranged in a line and touching one another. The central circle is decorated with a large oval crystal in

a mount, a star with interlace knots, and birds with long beaks pecking at a central tree or post. The flanking circles have smaller crystals, blue enamel stars, and figures of dragons and griffins. Galloping horsemen in vernacular Irish armor lie above and below the spaces between the circles.

The binding strips are also not of one period. The four corner pieces around the top are of the fourteenth century, and their panels carry either an animal ornament (beasts with floral tails or a hound chasing a hare) or interlace. Human heads or stylized animal heads unite the panels. One extreme corner is decorated with a Gothic trefoil; the others are worn smooth. The binding strips along the bottom and top of the front are hinged to the corner pieces. The one at the top bears a Gothic inscription.

Much of the back seems to have been lost after the fourteenth century. All that remains is a bronze sheet, which may be early. Attached to it is a rectilinear brass cross, once gilded, whose arms bisect the sides of the plate; in places the arms carry square expansions. The longer arms carry the names of the three kings in Gothic lettering.

New corner pieces and new binding strips were made to affix this plate to the shrine. The binding strips, which lack hinges, are of bronze, and their decoration is one or two rows of punched polygons (usually hexagons), interspersed with vertical strokes. These extensive replacements probably took place after the middle of the fifteenth century.

Bibliography: CAAI, pp. 115-119, pls. 115-118.

67. Leather satchel for the Book of Armagh
Late medieval period, fifteenth century
H. 32 cm.
Library, TCD

Though this satchel is traditionally associated with the Book of Armagh, it is much too large for that small book and too large also for a shrine of it.

The embossed decoration was made before the satchel was stitched together with leather thongs. Leather carrying straps (of which only fragments remain) were stitched to the tops of the sides.

Fastening devices were added. A generous flap overlaps two-thirds of the front and is pierced a little more than halfway down by a line of rectangular slots. The slots were bound by thin brass plates, fragments of which survive. Ten brass rings, of which three survive, were attached to the satchel; eight protruded through the slots in the flap when the satchel was closed; the remaining two appeared on either side of the flap. A rod passed through the rings would have kept the satchel closed. There is also a large brass lock, and this is mounted in such a position to make it impossible to pass a straight stiff rod through the rings. Above the lock, and aligned with the rectangular slot in it, is a V-shaped hinge, whose splayed-out arms end in stylized animal heads.

The decoration on the back of the satchel is of nine roundels laced to one another. These are embellished with interlaced animals, knotwork, and in one instance a clumsy attempt at Gothic lettering—possibly intended to represent, *alpha* and *omega* on either side of *Amen*. The left-hand side bears a panel of interlace, the right-hand side has a line of roundels enclosed by separated S-shaped curves with club endings. The "rosettes" in the roundels reflect a design, ultimately of Roman origin, which appears in stone on the eighth-century cross at Killamery, County Kilkenny, and at the mid-twelfth-century priory of St. Saviour at Glendalough, County Wicklow. The spaces within the roundels are filled with triquetras, knots, lunettes, and three pairs of interlaced links, a device that appeared in the fifteenth century as a mason's mark at Holycross Abbey, County Tipperary. The remaining panels are filled with interlace or diagonal lines.

The bottom bears interrupted S-shaped curves with a simple knot between them; such knots are also seen as masons' marks at Holycross and at the contemporary Kilcooley Abbey, County Tipperary.

The designs on the flap, and on the part of the front that it covers, are identical, presumably from the same engraved die: an equal-armed cross of interlace fills the center; panels of interlace lie on either side; the spaces between the arms of the cross bear either roundels with single animals or a crude pattern with two animals and no surrounding circle; at the top left is a knot pattern.

Below the flap on the front are four interlace roundels, two with single animals and two with knotwork; the remaining spaces are filled with Gothic foliage.

There seems little doubt that this is a fifteenth-century satchel.

Bibliography: CAAI, pp. 155, 156, pls. 84, 85; J. Gwynn, *Liber Ardmachus, The Book of Armagh,* Dublin, 1913.

68. Harp

Late medieval period, fifteenth century
Wood, with added brass and silver
H. 86 cm.
Library, TCD

Fifteenth-century Gaelic harps are extremely rare. This specimen, linked by popular tradition with Brian Boru, who defeated the Vikings at Clontarf in 1014, is remarkably similar to a harp in Edinburgh known as the Queen Mary harp.

The true harp is triangular, built up of the soundbox, forepillar, and neck. When the harp is played, the top of the soundbox rests against the left shoulder, and the left hand plucks the nearer strings; the right hand is free to cover the whole range of strings. The twelfth-century Breac Maodhóg shrine (Fig. 39) shows a harpist playing

just such an instrument, but all earlier Irish representations of stringed instruments seem to be lyres (**58**), and not true harps.

The curved forepillar is essentially rectangular in cross section. For most of its length it takes the form of a double-headed sluglike animal with prominent eyes and lips, which is a development of the double-headed animal on the crest of the shrine of St. Patrick's bell (**61**).

On each side of the flanks of the pillar is a roundel containing a beautiful carved design of either wolves, lions, dogs, bears, or monsters. These designs are derived from fabrics or gaming pieces. Also carved on the forepillar are leaves and tendrils, pointed ovals linked by twisted lines, small irregular triangles with curved sides, interlace, and geometric motifs. The pillar is morticed into the soundbox below and into the underside of the neck above.

The triangular soundbox is rectangular at the base and narrows upward to rounded shoulders, which have been repaired. It was hollowed from a block of willow and backed by another board, of oak, rounded at the top. A flat-topped raised rib runs up the center line of the top of the box and expands into thickened, recurved shoulders above. Above the point of expansion is a damaged decorative roundel.

The rib is pierced by twenty-nine holes for the insertion of the strings; the holes are reinforced by small horseshoe-shaped brass plates. The soundbox is pierced by four symmetrically placed holes. Just above the upper hole on the left-hand side, the edge where the top meets the side is considerably worn, presumably from rubbing by the sleeve of the harpist.

The flanks and top of the soundbox are decorated with circles linked by diagonal bands. The design was made by rolling a rouletted wheel along the surface of the wood. The impressed lines appear to have been colored to emphasize the pattern.

The deep and heavy *S*-shaped neck receives the forepillar at the front and is morticed into the top of the soundbox at the back. Near the bases of the sides a curved strip of brass is attached, pierced for the tuning pegs. Below the strips there was a line of silver-headed nails, some of which survive on the right-hand side. The base of the neck is grooved and ridged.

The decoration on the flanks of the neck—panels of circles and bands—was first impressed then carved. The layout is reminiscent of that on some Irish crozier heads. The basic pattern is composed of interlace, marigolds, a triquetra, crimped ribbon, and rectilinear designs; at the outer end of the left flank are some letters that suggest an abbreviated name. The decoration is worn away at the inner end of the neck.

The outer end is protected by a decorated silver plate with two settings, one still filled with rock crystal.

Bibliography: R. B. Armstrong, *Musical Instruments, Part I: The Irish and the Highland Harps,* Edinburgh, 1904; Françoise Henry, "Remarks on the Decoration of Three Irish Psalters," *Proceedings of the Royal Irish Academy* 61, C (1960), pp. 23-40; J. Rimmer, *The Irish Harp,* Dublin, 1969.

69. Processional cross of Lislaughtin
Late medieval period, late fifteenth century
Silver
H. approx. 68 cm.
Ballymacasey, near Ballylongford, County Kerry
NMI, 1889.4

This spendid processional cross carries a long inscription that states that it was made by William, the son of Cornelius, and includes a date that can be read as 1479. The O'Connor family built a Franciscan monastery at Lislaughtin during the 1470s, and the cross was almost certainly made for that church.

It is a typical late Gothic cross with a floreated outline. At the base is a conical socket for the staff decorated with four vertical, diagonally grooved ribs. Next is a twisted knop with inset rhomb-shaped panels of silver bearing floral decoration. Above the knop is an octagonal collar, whose faces slope upward and outward. In the center of each stands a figure, whose right hand is raised in blessing, and whose left holds a cross. A crest of foliage decorates the upper side of the collar.

The lower part of the shaft is occupied by a crucified Christ, whose face and torso are dramatically stylized. A twisted band, perhaps symbolizing the crown of thorns, encircles the drooping head. The arms are elongated. Rivulets of blood flow from the wound. The loincloth hangs in natural folds.

An empty quatrefoil at the center of the cross above the head of Christ presumably once held the symbol of St. Matthew, Quatrefoils, each holding an evangelist symbol—the lion, the ox, and the eagle—lie at the ends of the arms. The long inscription occupies the arms and the upper part of the shaft. Each area contains three lines of inscription separated by lines of coiled wire. Small gaps in the inscription are filled by interlace flowerets and animals, including a pelican, a fox, a hen, and a rabbit. One blank space, in the central line above the head of Christ, is pierced by a small hole.

Bibliography: CACP, p. 97, fig. 107.

Selected bibliography

AEIA J. V. S. Megaw, *Art of the European Iron Age,* Bath (England), 1970

AI P. Harbison, *The Archaeology of Ireland,* London, 1976

CAAI *Christian Art in Ancient Ireland,* vol. 1 (1932), pls. 1-80, A. Mahr, ed.; vol. 2 (1941), pls. 81-130, J. Raftery, ed., Dublin

CACP G. Coffey, *Guide to the Celtic Antiquities of the Christian Period Preserved in the National Museum, Dublin,* second edition, Dublin, 1910

CIGO E. C. R. Armstrong, *Catalogue of Irish Gold Ornaments in the Collection of the Royal Irish Academy,* Dublin, 1920

ECI M. and L. de Paor, *Early Christian Ireland,* London, 1958

IA F. Henry, *Irish Art,* vol 1 (1965), to A. D. 800; vol. 2 (1967), A. D. 800–1020; vol. 3 (1970), 1020–1170, Dublin

IL F. Mitchell, *The Irish Landscape,* London, 1976

IP M. Herity and G. Eogan, *Ireland in Prehistory,* London, 1977

TI A. T. Lucas, *Treasures of Ireland: Irish Pagan and Early Christian Art,* Dublin, 1973